NEW DESIGN :
TOKYO

ROCKPORT

GLOUCESTER MASSACHUSETTS

NEW DESIGN:TOKYO

series editor: **Edward M. Gomez**
associate editor: **Setsuko Noguchi**

ROCKPORT
PUBLISHERS

FIRST PUBLISHED IN THE UNITED
STATES OF AMERICA BY:
Rockport Publishers, Inc.
33 Commercial Street
Gloucester, Massachusetts 01930-5089
Telephone: (978) 282-9590
Facsimile: (978) 283-2742

DISTRIBUTED TO THE BOOK TRADE
AND ART TRADE IN THE UNITED STATES BY:
North Light Books, an imprint of
F & W Publications
1507 Dana Avenue
Cincinnati, Ohio 45207
Telephone: (800) 289-0963

OTHER DISTRIBUTION BY:
Rockport Publishers, Inc.
Gloucester, Massachusetts 01930-5089

ISBN 1-56496-561-9
10 9 8 7 6 5 4 3 2 1

Printed in China.

Designer: Stoltze Design
Cover Image: Photodisc

Acknowledgments

I am very grateful to my Tokyo-based associate editor and collaborator, Setsuko Noguchi, a specialist in graphic design who has worked on numerous surveys produced by leading Japanese publishers in this field. Her insightful background research, reporting, and administrative assistance have vitally enriched and helped shape the contents of this book.

I also thank my literary agent, Lew Grimes, for his energy and vision, and, at Rockport Publishers, editors Alexandra Bahl and Shawna Mullen, and art director Lynne Havighurst, for their keen attention and important contributions to the assembling of this volume and the development of the entire *New Design* series.

Most of all, on behalf of everyone involved in the production of *New Design*: *Tokyo*, I thank the many cooperative, thoughtful, and enthusiastic graphic designers who kindly have shared their work and their ideas with us, and who have allowed us to reproduce them in these pages.

—Edward M. Gomez

A note about names

In Japan, a person's surname is written before his or her given name. However, for easier understanding, in this book Japanese names are written in the Western manner, with each designer's first name followed by his or her family name.

CONTENTS

Rolling with the punches despite a late-1990s downturn, the unexpected antithesis of the previous decade's economic boom, Tokyo is still one of the richest financial centers on the planet, the hyperactive media capital of Japan, and, incomparably, one of the most fascinating cities in the world. It is towards this irresistible energy center that specialists in all areas of visual communications have gravitated. And it is from Tokyo that some of the most original and compelling posters, packaging, logotypes and advertising imagery anywhere have emerged to make their way into local—and international—markets and to make their marks in the global village's ever more complex visual culture.

More than a century ago, European artists' eyes were opened to the uniqueness of the Japanese visual language when the likes of the Impressionists and, later, of the painter and poster artist Henri de Toulouse-Lautrec discovered the then odd-looking perspectives and refined technical qualities of Japanese woodblock prints by Hiroshige, Hokusai, and other *ukiyo-e* masters. They skillfully adapted

aspects of this art into their own. Among their borrowings: bold outlines, flat expanses of bright color, and the vertical placement of words. (In the original prints, these were calligraphic or typeset *kanji*, the adopted Chinese ideographs with which the Japanese language, in part, is written).

So flourished the modern Western artist-designer's ongoing love affair with the Eastern aesthetic, and especially with the strong and distinctive Japanese design sensibility that can be seen in everything from exquisitely crafted, fifteenth-century tea bowls to the innovative comic-book layouts of Astro Boy creator Osamu Tezuka and the sleek lines of that miniaturized marvel, the Sony Walkman.

In the 1980s, from the West, the Apple Macintosh personal computer came to Japan. Eventually, as the Mac became the most common creative-productive instrument in

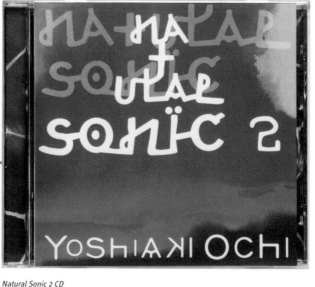

Natural Sonic 2 CD
ART DIRECTOR/DESIGNERS: Junichi Tsunoda

Mami Yamase CD Booklet
ART DIRECTOR: Yasutaka Kato
PHOTOGRAPHY: Koh Hosokawa

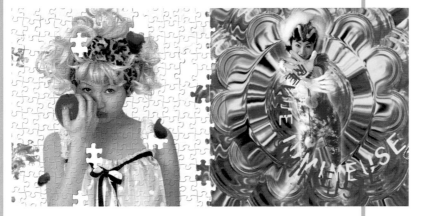

the publishing and visual-communications fields, and abundant foreign-language software and a Japanese-based operating system became available, Japan's graphic designers embraced this powerful new tool. Still, although graphic design's technology today may have become more or less standardized, what Japanese designers do with it and bring to it may differ considerably, aesthetically speaking, from their Western counterparts' handling of the same resources.

Therein lies one of the most interesting and, for some observers, confounding aspects of Japanese graphic design. As the French structuralist critic Roland Barthes wrote in his classic collection of essays, *Empire of Signs* (1970), based on his experiences in Japan, in much of what a foreign visitor encounters there in the daunting visual clutter of advertising, neon signs, costumes, and packaging, not to mention in everyday gestures and social customs, looks can be deceiving. Barthes and

Turbine-brand bag
CREATIVE DIRECTOR: Gabi Ito

Laforet poster
ART DIRECTOR/DESIGNER: Katsunori Aoki
CREATIVE DIRECTORS: Katsunori
Aoki, Ichiro Tanida
COMPUTER GRAPHICS: Ichiro Tanida

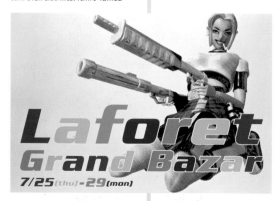

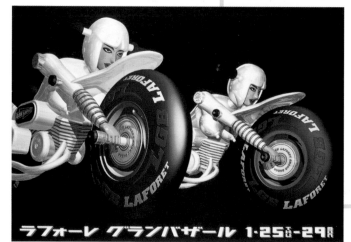

Laforet poster
ART DIRECTOR: Katsunori Aoki
CREATIVE DIRECTORS: Katsunori Aoki,
Ichiro Tanida, Yasuhiko Sakura
DESIGNERS: Katsunori Aoki,
Seijiro Kubo
COMPUTER GRAPHICS: Ichiro Tanida

other postmodernist semioticians who have had a field day examining Japan have noted that many a poster, slogan, or product that a Western viewer believes he "understands" may actually mean something completely different to its intended Japanese audience.

With this in mind, the ubiquitous presence of European or American models in everything from bank-loan brochures to TV commercials for cars, fashion, and skiing vacations, may have less to do with "imitating" the look of Western advertising than with Japan's on-going debate in which what comes from the West is perceived as modern or progressive. (More precisely, too, Western cultural imports, from punk hairdos to Bruce Springsteen records, Levi's, and even mass-produced, New England-style clapboard houses, offer, on a symbolic level, means of escape from group-oriented Japanese society's conformity-minded pressures.)

Still, there are times when buxom, futuristic robot girls like those in designer Katsunori Aoki's posters, who wield the space guns they'll use to hunt down bargains at Tokyo's Laforet fashion emporium, really are about

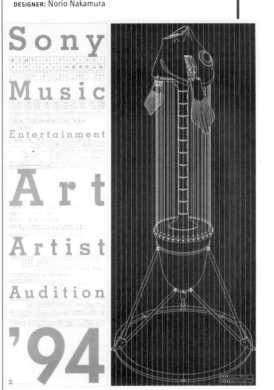

Poster for CBS/Sony-sponsored art exhibition
DESIGNER: Norio Nakamura

wacky, exuberant, sexy fun and not about a winking, self-conscious sense of irony masquerading as amusing irreverence. Likewise, some foreign observers may never fully grasp or appreciate the Japanese penchant for the *kawaii* (cute), which pops up all the time in stuffed animals—dangling from keychains, decorating store windows, sitting on bank-teller counters—and in corporate character logos and in beloved *manga* (comic book) heroes of all kinds. What a Western visitor may regard as super-kitsch, the Japanese, on a subconscious level, may respond to as symbols of sweet, adolescent freedom.

In modern societies, though, artists have been the odd men—or women—out. Thus, many of Tokyo's most interesting graphic designers, by the very nature of their activity, to some degree avoid becoming trapped by Japanese society's restrictive norms. Ichiro Higashiizumi, Hitoshi Nagasawa, Norio Nakamura, and many others featured in this volume, for example, operate one-person or similarly small studios, and through their work for clients in the music, fashion, and magazine-publishing industries, where an expansive sense of creativity and individuality prevails, have been able to maintain and project an independent image. Others may work in larger design firms or in the in-house design departments of publishing or record companies, but on the strength of their work become known for a singular style or artistic vision. Yasutaka Kato, now of Ghost Ranch Studio, started out this way years ago at Sony Records.

Most of Tokyo's young designers are well-versed in the particular vernacular of Japanese pop, the visual expression, in commercials, posters, merchandising, and art, of the nation's voracious popular culture. This is a force that devours and assimilates a constant influx of source material that is as astounding in its

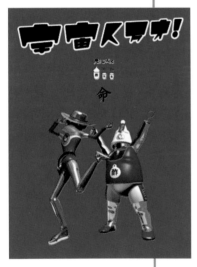

DESIGNER/ILLUSTRATOR: Hideyuki Tanaka

scope as it is in its output; it takes in and grinds up, for example, everything from Kentucky Fried Chicken and up-to-the-minute computer jargon to traditional Japanese ballads and wildly colored Hawaiian shirts. (Typically, someone like Higashiizumi, noting what had gone into some of his work, once wrote: "Grained textures. Walls. Daily life. Fantasies. Spring. A ringing in my ears.... The substance of so-called purity. Science. I have discharged what had been bothering me these days...")

In graphic-design form, Japanese pop coughs up a melange of psychedelic swirls, sixties pop-art colors, space-age retro curves and bubbles, goofy-cute cartoon characters, and, as in Hideyuki Tanaka's work for Frame Graphics Co., Ltd., some funny, funky type treatments, too. (Remarkably, Tokyo graphic designers work not only with two phonetic alphabets, *hiragana* and *katakana*, but also with *kanji* to write in Japanese; they must also routinely handle Roman letters to spell out headlines and text in English and other Western languages.)

Other designers, like the venerable Seiju Toda, go their own way in crafting their designs, giving new meaning and resonance to such standard media as the advertising poster, an enduring form of communication to which generations of Japanese artists have contributed so much. Toda began his career in the in-house advertising section of Takashimaya, the national department-store chain; his poster compositions, many of which employ photos of abstract, sculptural forms, can appear quite mysterious. Sometimes offering a stunning sense of the fantastic and the futuristic, as do his posters for a store called Vivre 21, they conjure up a mood more than they deliver a hard sell. Similarly, young Madoka Iwabuchi's magazine layouts, which display an intelligent absorption of the late-1990s, post-David Carson era's fondness for a distressed look in a deconstructionist mode,

Vivre 21 poster
DESIGNER: Seju Toda

Skool of Edge *magazine layout*
DESIGNER: Madoka Iwabuchi

Skool of Edge *magazine layout*
DESIGNER: Madoka Iwabuchi

are sometimes more exciting than their source material. For in working with Japanese typography and interpreting, in a different cultural context, what has become just another style, Iwabuchi rejuvenates it. In contemporary Japan's mass-media din, works like these can be seen as finely pitched visual poems rich in resonant, ambiguous meanings.

All of the selections featured in this book demonstrate a masterful understanding of form and style on the part of the designers who created them. After all, Japanese artists and designers are renowned throughout the world as skillful stylists and synthesizers of influences from myriad sources. It has been said that, as an island people, the Japanese have become adept at borrowing, interpreting, and refining ideas from abroad. And because appearances and form play such a big part in Japanese culture and society, from the correct use of honorific words in conversation to the right choice of colored *mizuhiki* string on a gift-wrapped package, some observers may often be tempted to view the style in Japanese design *as* its content.

These ideas and many others take visible shape in the varied and wide-ranging portfolios of thirty-five Tokyo-based designers or design studios that have been brought together here. To examine them is to savor something of the distinctive energy and creative spirit that are part of Japan's enduring allure. To appreciate this work, designers Yuichi Miyashi and Naoyuki Suzuki of Tycoon Graphics provide a cue. "Let's promote visual communication!" they proclaim. "Our motto is: 'Graphic adventure, every day!'" Their enthusiasm for graphic design is bolstered by its rich traditions in a culture that is centuries old—and it reflects the forward-looking spirit, on the eve of a new millennium, of a generation of artist-designers that is charging ahead with gusto to embrace the new.

Boycott fashion-label poster
DESIGNER: Tycoon Graphics
PHOTOGRAPHY: Itara Hirima

FOUNDED: 1964
NUMBER OF EMPLOYEES: 60

Sun-Ad Co., Ltd.
Palace Building 9F
1-1-1 Marunouchi
Chiyoda-ku, Tokyo 100-0005
TEL (81) 3-3274-5021
FAX (81) 3-3215-3246

KATSUNORI AOKI

Katsunori Aoki, one of the busiest young graphic designers in Tokyo today, also has one of the profession's most unusual entries on his curriculum vitae: he attended Musashino Junior College of Fine Arts for only three days. Turning his back on academic training, Aoki set out instead to educate himself on the job, working first for art-event producers, then in the offices of the established graphic designers Masayoshi Nakajo and Masami Shimizu. He joined Sun-Ad in 1989 and soon thereafter made his name with his advertising campaign for Okamoto condoms. There is often a subtle, unexpected edge to Aoki's designs, a quality that comes from his just-so tweaking of certain elements, such as the simultaneously cute—and slightly odd—cursive-letter initials on outlined teddy-bear forms in his Hiromichi Nakano fashion-company logos, or his spectacularly eye-grabbing, and ever-so-slightly sinister, posters for Laforet's Grand Bazar [sic] sales. Despite living and working in a culture in which a little symbolism goes a long way, Aoki has observed: "I have never really given a second thought to Japan's past. And I feel that symbolism in today's graphic design is not simply a result of tradition."

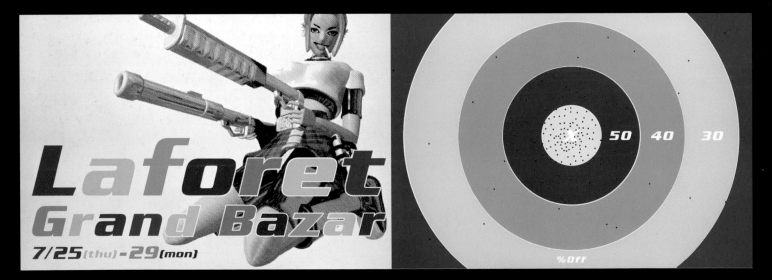

A space gun-wielding, robotic shopper-girl sets her sights on great bargains at Laforet's annual sale; on the right side of this poster, bold targets emphasize the percentages

HIROMICHI NAKANO TOKYO COLLECTION SPRING & SUMMER '98 at LAFORET MUSEUM HARAJUKU 11tue. NOVEMBER.1997

The doors open at 19:30/The curtainrises at 20:00

Illustrated by TAIYO MATSUMOTO

Aoki created a distinctive look for the Hiromichi Nakano fashion label using a modified, cursive-like typeface and logo variations incorporating kooky stuffed-animal figures in outline form.

ART DIRECTORS: Katsunori Aoki, Shigeru Sugisaki

CREATIVE DIRECTORS: Kotaro Sugiyama, Hiroshi Tashiro, Fabrizio Ferri

PHOTOGRAPHY: Fabrizio Ferri

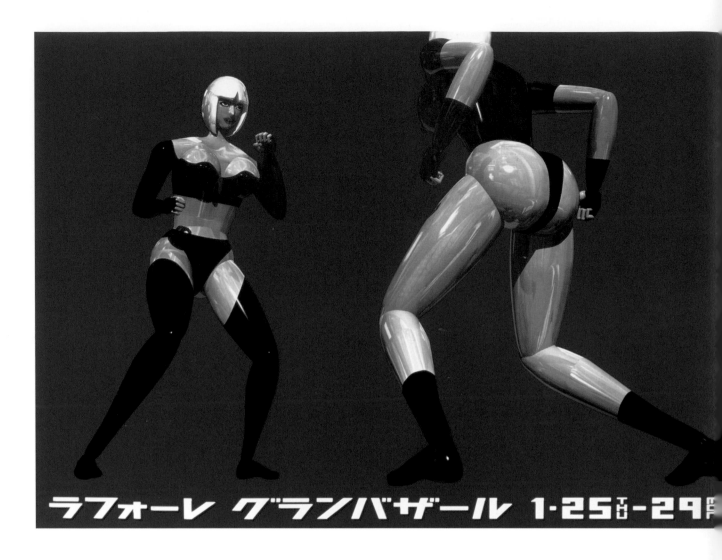

バザールファイター

A luscious red background and well-proportioned Bazaar Fighters (so named in the accompanying headline) reminiscent of characters in the futuristic scenarios of popular *manga* comic books distinguish this broad, horizontal-format poster for Laforet. The message: Shoppers should be ready to spar for the best bargains at one of this Tokyo fashion outlet's most popular sales.

ART DIRECTOR: Katsunori Aoki

CREATIVE DIRECTORS: Katsunori Aoki, Ichiro Tanida, Yasuhiko Sakura

DESIGNERS: Katsunori Aoki, Seijiro Kubo

COMPUTER GRAPHICS: Ichiro Tanida

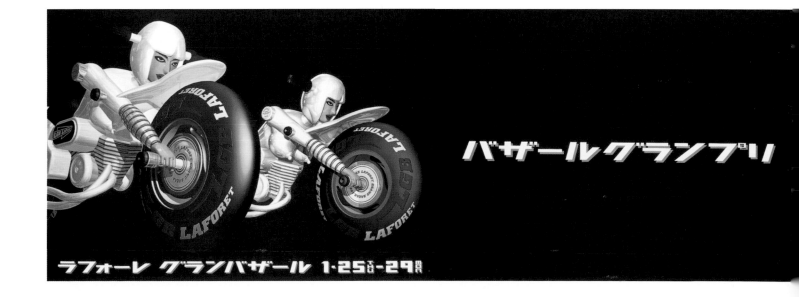

ベネトンの
いちばん
ちいさい服。

UNITED COLORS
OF BENETTON.

ベネトンのいちばんちいさい服。

UNITED COLORS
OF BENETTON.

1500

1500

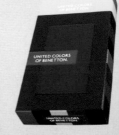

BENETTON CONDO

製造・販売／オカモト株式会社　東京都文京区本郷3丁目27番12号　〒113-91　電話03-38

An advertising campaign for colorfully
packaged Benetton condoms plays
with the tag line "The smallest outfit
available from Benetton."

ART DIRECTOR/DESIGNER:

Katsunori Aoki

CREATIVE DIRECTOR: Kenji Hanaue

COPYWRITER: Hiroshi Hasegawa

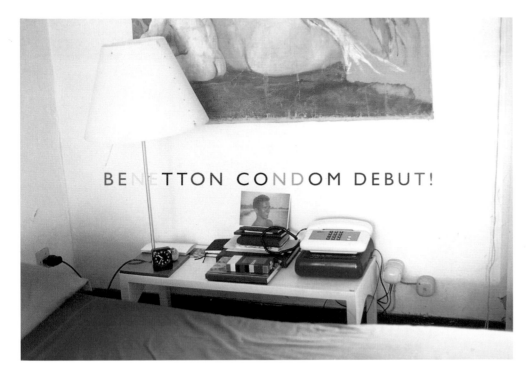

BENETTON CONDOM DEBUT!

SKINLESS
BY OKAMOTO CONDOMS
BIRTH CONTROL and PREVENTION OF DISEASES
clean-dom

Asked by Japan's own Okamoto
condom-manufacturing company
to create a lively package for its
product, Aoki used digital technology
to create a design with fine lines
made with four-color processing.

ART DIRECTOR/DESIGNER:
Katsunori Aoki
CREATIVE DIRECTOR: Kenji Hanaue
COPYWRITER: Hiroshi Hasegawa
PHOTOGRAPHY: Yoshihito Imaizumi

SAFE SEX

It's best to carry a condom
SKINLESS BY OKAMOTO

PRINCIPAL: Yuki Hikawa
FOUNDED: 1991
NUMBER OF EMPLOYEES: 4

7-8-305 Sakuragaoka-cho
Shibuya-ku, Tokyo 150-0031
TEL (81) 3-3464-8306
FAX (81) 3-3464-1970

APOLLO STUDIO

Yuki Hikawa was born in Yokohama in 1964, the year that marked a turning point for postwar Japan, as Tokyo hosted the Summer Olympics and the rebuilt nation stepped out again, with renewed energy, onto the world stage. Hikawa's generation was one of the first, in modern times, to cast its net wide—and unabashedly abroad—in its search for ideas, inspiration, education, and artistic influences. Some of her creative peers came of age, traveled, and stayed away; others, in Japan's prosperous decade of the 1980s, came and went as they pleased,

richly nourishing the cross-cultural spirit of some of the liveliest contemporary Japanese art and design. Hikawa studied at the Kanagawa College of Technology and at Chiba University, and began her career in the office of Yasuo Ohmichi. She moved to New York in 1988, where she created media campaigns for Parco, the style-savvy Japanese department-store chain that is renowned for its innovative advertising. Returning to Japan in 1991, she founded Apollo Studio. Her work for NTT Data Corporation, Parco, Kirin Beer, and other well-known, brand-name clients has won numerous awards for its precise execution, clarity of concept, and finely expressed understanding of both the corporate vernacular—in identity systems, logos, and so on—and of the importance of a neatly integrated, decidedly artistic touch.

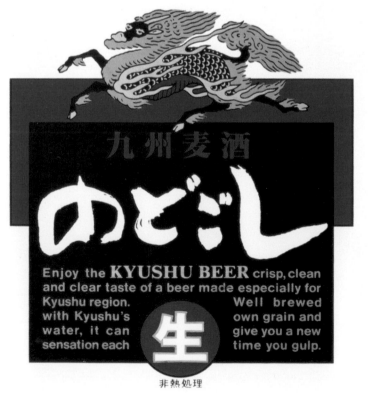

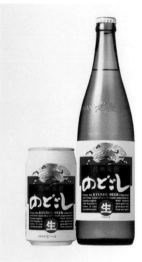

Apollo Studio's portfolio includes examples of designs created in the established corporate vernacular of Japanese consumer-goods packaging, such as these bright, emphatic labels for this special brew made by Kirin Beer.
ART DIRECTOR: Yuki Hikawa
CREATIVE DIRECTOR: Takeshi Terao

		March 3								4 April				
SUN	MON	TUE	WED	THU	FRI	SAT		SUN	MON	TUE	WED	THU	FRI	SAT
	1	2	3	4	5	6						1	2	3
7	8	9	10	11	12	13		4	5	6	7	8	9	10
14	15	16	17	18	19	20		11	12	13	14	15	16	17
21	22	23	24	25	26	27		18	19	20	21	22	23	24
28	29	30	31					25	26	27	28	29	30	

Hikawa created the typographic artwork for the cover of this edition of one of her popular promotional calendars for NTT Data Corporation; she used original typographic artwork by Shinichi Sekine for the printed piece's March-April page.

ART DIRECTOR: Yuki Hikawa

CREATIVE DIRECTOR: Hiroshi Matsuzaki

NEW PARADIGM
The Formula that changed the world.

Type Direction by

Kaoru Kanai

Shinichi Sekine

Malcolm Garrett

Toshiyasu Nanbu

Taku Satoh

Katsumi Asaba

1993 CALENDAR

カワセミのおすは
好きなめすがみつかると、

天然石のジュエリーでもなく、
一輪のバラでも

ぴちぴち
ぴちぴちの とれたての
魚を一匹、
プレゼントします。

受けとらないかが
それを受けとるか、
めすの返事です。

JANUARY **1**

SUN	MON	TUE	WED	THU	FRI	SAT
	1	2	3	4	5	6
7	8	9	10	11	12	13
14	15	16	17	18	19	20
21	22	23	24	25	26	27
28	29	30	31			

2 FEBRUARY

SUN	MON	TUE	WED	THU	FRI	SAT
				1	2	3
4	5	6	7	8	9	10
11	12	13	14	15	16	17
18	19	20	21	22	23	24
25	26	27	28	29		

1996 CALENDAR "Courtships of nature"

生きものたちのオペレッタ

In this promotional calendar for
NTT Data Corporation, brightly
colored, contemporary illustrations
and vertically placed type emulate
the look and feeling of traditional
brush painting and calligraphy.

ART DIRECTOR: Yuki Hikawa

CREATIVE DIRECTOR: Hiroshi Matsuzaki

ILLUSTRATION: Isao Makino

NTTデータ通信株式会社

よく晴れた日の
キャツ畑は、

ホンシロチョウたちの出会いの場。

紫外線の反射が見える彼らだから、
隠れためすをさがしだすことは

けっこう ハードなマッチングです。

めすをめつけると、
ひらひら、ひらひら、

MARCH **3**

SUN	MON	TUE	WED	THU	FRI	SAT
					1	2
3	4	5	6	7	8	9
10	11	12	13	14	15	16
17	18	19	20	21	22	23
24 31	25	26	27	28	29	30

4 APRIL

SUN	MON	TUE	WED	THU	FRI	SAT
	1	2	3	4	5	6
7	8	9	10	11	12	13
14	15	16	17	18	19	20
21	22	23	24	25	26	27
28	29	30				

Stylized *kanji*, whose erstwhile calligraphic brushstrokes have been interpreted in thick horizontal and vertical typographic strokes sometimes truncated at an angle, give a muscular character to this logo for NTT's mobile-communications network.
ART DIRECTORS: On Namiki, Yuki Hikawa
CREATIVE DIRECTOR: Takeshi Terao

One simple, hand-drawn character, in conjunction with a classic, serif typeface, enlivens this logo for a New York-based special-events producer.
ART DIRECTOR: Yuki Hikawa
CREATIVE DIRECTOR: Kohsuke Miki

Hikawa's simple corporate identity and packaging scheme for Marcy's, a Chinese restaurant known for its oh-so-casual cuisine, perfectly interprets and applies the basic lessons of American-style, fast-food packaging design.
ART DIRECTOR: Yuki Hikawa

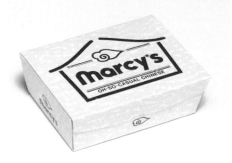

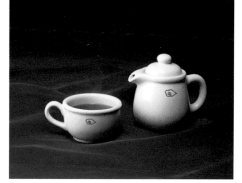

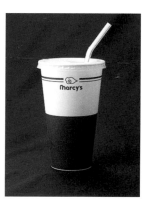

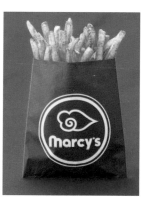

A painted human face becomes a strong graphic element in Hikawa's design of Yoshiharu Abe's + or – CD cover.

PHOTOGRAPHY: Bin-Shun

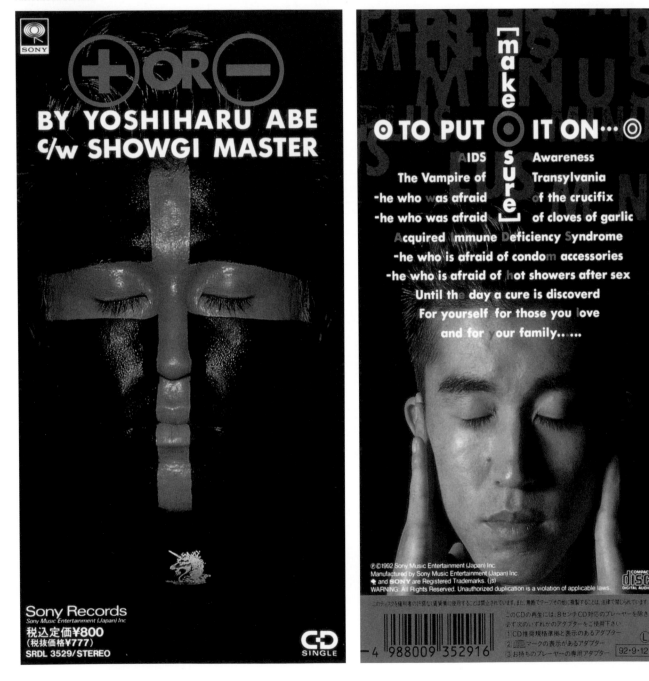

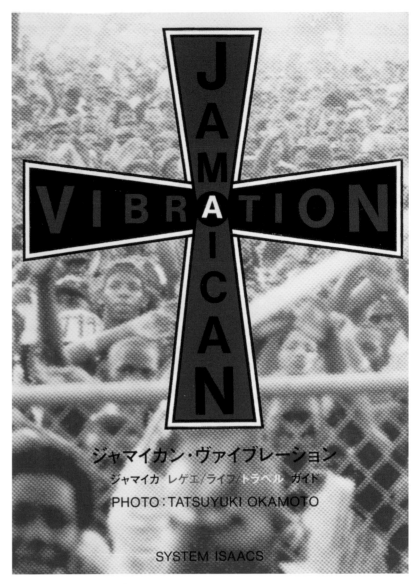

JAMAICAN VIBRATION

ジャマイカン・ヴァイブレーション

ジャマイカ　レゲエ/ライフ/トラベル　ガイド

PHOTO : TATSUYUKI OKAMOTO

SYSTEM ISAACS

A single, aberrant dot on the
uppercase I in the title for *Kingston
Love*, and a similarly bold palette
of black, white, and red set against
a photo tinted bright yellow, for
Jamaican Vibration, distinguish
Hikawa's cover designs for books
by Tatsuyuki Okamoto.
ART DIRECTOR: Yuki Hikawa
PHOTOGRAPHY: Tatsuyuki Okamoto

KINGSTON LOVE

Tatsuyuki Okamoto

KORINSHA PRESS

PRINCIPALS: Masazumi Mitsui, Shigeo Yamaguchi, Chisako Suzuki
FOUNDED: 1990
NUMBER OF EMPLOYEES: 3

3-10-12-402 Ebisu-minami
Shibuya-ku, Tokyo 150-0022
TEL (81) 3-5721-2924
FAX (81) 3-5721-2925

ART WORKS

For decades, rock 'n' roll has been the soundtrack of youth culture, a phenomenon that is now global in its proportions. Visually, many of its conventions, from tattered blue jeans to long hair, have become as common—or as cliché—as a chorus of "Yeah, yeah, yeah!" In their own ways, Japanese image-makers and marketers of pop-music recordings and related products have assimilated and fine-tuned the visual styles that have become the tools of this trade. Masazumi Mitsui of Art Works has brought an appropriate spirit of fun, irreverence, and rebelliousness to his designs for numerous pop or rock album packages for such local labels as Pony Canyon and Warner Music Japan. Strong on photography and often favoring clean, uncluttered, sans-serif display type, Mitsui's CD covers, booklets, and related promotional materials are immediately recognizable examples of a popular-design genre even as they all boast a certain corporate-savvy polish. Some affinities to a now-familiar, mostly minimalist approach to fashion advertising, and a seemingly reflexive understanding of the brand-identity-shaping potential of graphic design appear in some of Mitsui's works, such as his laserdisc-and-CD album set for singer Hiroko Kasahara.

Art Works' artwork for a promotional piece announcing the design studio features Mitsui's computer graphics.

Mitsui's bold, slinky, sans-serif type, in a fit of vivacious typographic expressionism, takes a silly walk of its own on one side of the fold-out insert for this compact disc by a band called Little Bach.

PHOTOGRAPHY: Masakatsu Ishikawa

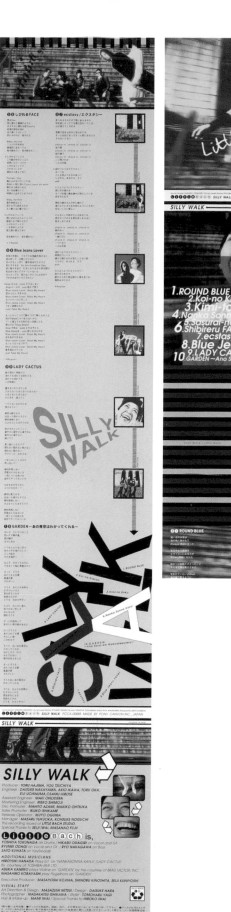

Small, rectangular covers for CD singles allow a designer little work room. Here, Mitsui uses single, central photo images enhanced by clear display type. Note the harmonious matching of the Japanese *hiragana* phonetic letterforms and the Roman characters in the headline on the Little Bach cover.

PHOTOGRAPHY: Keiichi Sakazaki, Junki Kawauchi CD; Takeo Ogiso, Little Bach CD

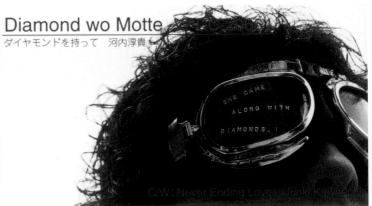

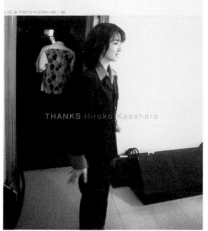

LASER DISC

THANKS Hiroko Kasahara

Affinities to the minimalist look
of a lot of contemporary fashion
advertising, and graphic design's
capacity to help shape and propel
the visual identity of a brand
(which, in this case, is the singer-
as-pop-product herself) are
apparent in Masazumi Mitsui's
laserdisc and CD album covers
for singer Hiroko Kasahara.
ART DIRECTOR: Masazumi Mitsui
PHOTOGRAPHY: Kenji Tsukakoshi

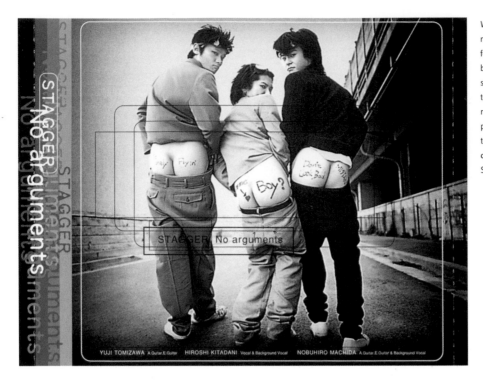

With images of classic rock 'n' roll rambunctiousness, Mitsui's designs for the covers and insert of a CD by the Japanese band Stagger also show an easy assimilation of the techno aesthetic, with its overlapping, repeated headlines and randomly placed, vaguely decorative, vaguely technical-looking hairlines.

CREATIVE DIRECTOR/PHOTOGRAPHY:
Susumu Saeki

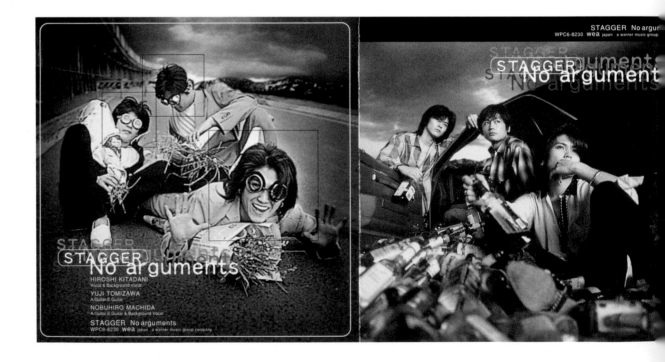

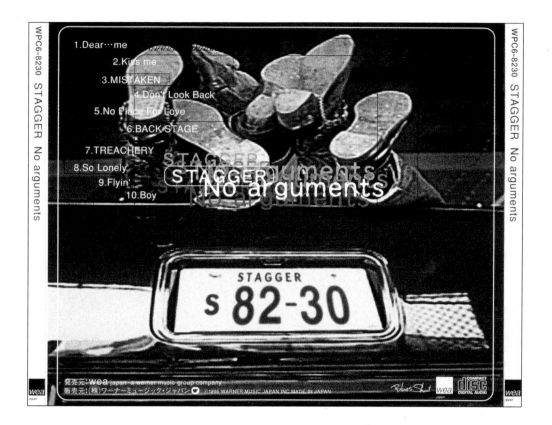

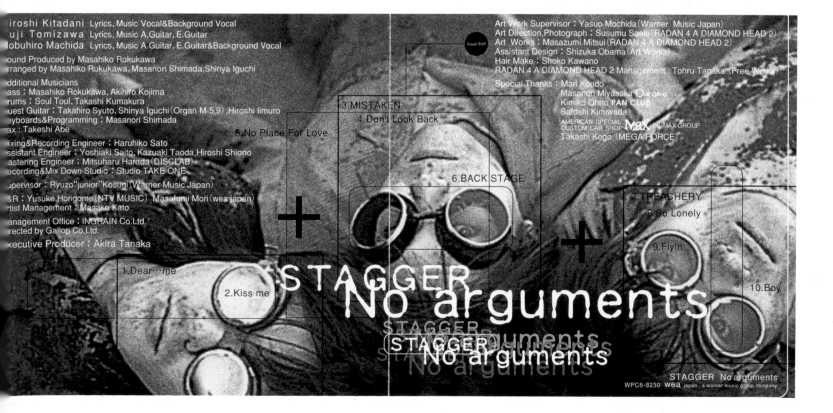

PRINCIPALS: Mitsuhiro Miyazaki, Kouji Oota, Aoi Hirai, Toru Shimizu, Yusuke Okamura, Senya Nemoto, Masashi Tomura, Mutsumi Matsuno
FOUNDED: 1996
NUMBER OF EMPLOYEES: 19

5-17-1 Roppongi
Minato-ku, Tokyo 106-0001
TEL (81) 3-5572-0810
FAX (81) 3-5572-0801

AXIS DESIGN

Japan's bi-monthly, thick, and glossy *Axis* magazine is unique among design publications: at once beautifully laid out and packed with news, information, and thoughtful critical analysis, it also has managed to maintain a tone that is refreshingly not too self-important. Instead, *Axis* offers a sense of discovery and excitement about designers' ideas and accomplishments, and about the challenges they face. This spirit comes across in the brightness and clarity of the magazine's own art direction, which is conceived and executed by an in-house team led by Mitsuhiro Miyazaki and Kouji Oota. Known collectively as Axis Design, this group's members regularly turn their attention to a wide range of subjects that must be represented and described in images and text, from the styling of the latest high-tech gadgetry to feature articles on traditional basket-weaving techniques in southern Japan. Axis Design also does work for outside clients, such as Toyota and Microsoft Japan, for whom it has created Web sites.

vol.66

March / April 1997

AXIS

living design concept

床屋の椅子

ジョン・カサード

薄墨桜と樹木医

ハリウッド・エンターテインメント・ミュージアム

アレックス・モールトン

Have a seat !

特集！「座る」

The refreshing tone and sense of excitement found in Japan's *Axis* design magazine owe a lot to the brightness and clarity that its art directors bring to the creation of its expressive, attractive layouts.

ART DIRECTORS: Mitsuhiro Miyazaki, Kouji Oota

DESIGNERS: Aoi Hirai, Toru Shimizu, Masashi Tomura, Senya Nemoto

PHOTOGRAPHY, *AXIS* **COVERS:** Yoshiaki Tsutsui

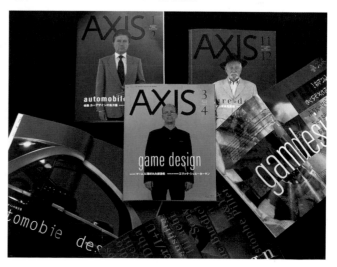

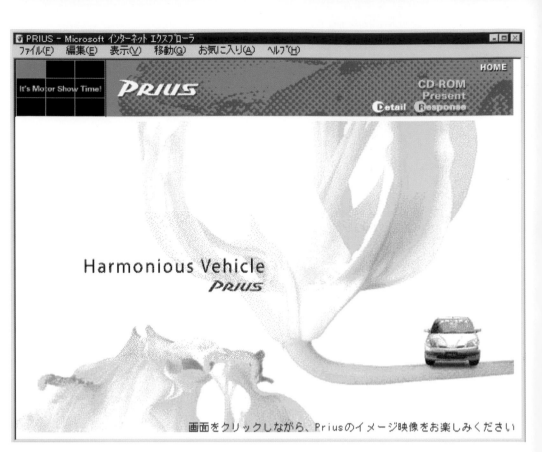

Starkly contrasting black or
white backgrounds are a key
element of Axis Design's Web site
pages for the Tokyo Motor Show,
an automobile exposition.
ART DIRECTOR: Mitsuhiro Miyazaki
DESIGNERS: Toru Shimizu, Masashi
Tomura, Mutsumi Matsuno
SYSTEM DESIGNER: Yusuke Okamura

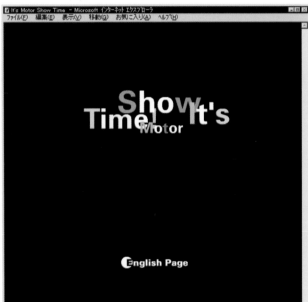

Axis Design used line drawings and
a simple color palette for the pages
of this Web site for Microsoft Japan
that allows users to hear sounds
from places all around the world.
ART DIRECTOR: Mitsuhiro Miyazaki
CREATIVE DIRECTOR: Yoshiaki
Nishimura
ILLUSTRATION: Aoi Hirai
SOUND DIRECTOR: Yoshihiro Kawasaki
DESIGNERS: Toru Shimizu,
Senya Nemoto
SYSTEM DESIGNER: Yusuke Okamura

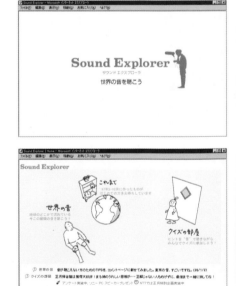

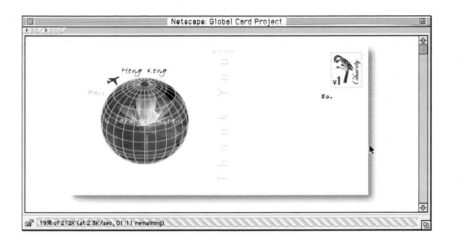

A whimsical touch and gentle visual puns set the cheerful mood for a series of greeting-card pages that Axis Design created for the Internet server offered by NTT, Japan's telecommunications giant.

ART DIRECTOR: Mitsuhiro Miyazaki
DESIGNER: Toru Shimizu
ART/ILLUSTRATION: Hirosuke Ueno, Akira Sorimachi, Ichiro Higashiizumi, Tomato, Aoi Hirai, groovisions, Toru Shimizu, Senya Nemoto, Masashi Tomura, Hiroya Kaji
SYSTEM DESIGNER: Yusuke Okamura

PRINCIPALS: Tadashi Shimada,
Norie Kadokura, Junko Shimada
FOUNDED: 1991
NUMBER OF EMPLOYEES: 3

2-17-8-302 Ebisu-nishi
Shibuya-ku, Tokyo 150-0021
TEL (81) 3-5489-8763
FAX (81) 3-5489-8795

BANANA STUDIO

Many young Tokyo-based designers, in the early years of their careers, especially if they are working on a freelance basis or in small, start-up studios, find themselves cutting their professional teeth on pop-product assignments; these are the products that feed Japan's insatiable appetite for pop culture of both the homegrown and imported varieties, and the unique amalgam of the two that manifests itself in such phenomena as robot-schoolgirl, action-figure characters, or a rock band called Violent Onsen Geisha. Tadashi Shimada's

work for Banana Studio has spanned a gamut of pop-product applications, from photo-filled promotional booklets for many teen-idol singing acts (called a *tarento* in Japanese, from the English word talent), to beautifully printed, lavishly illustrated computer-game manuals and deluxe packaging for multi-CD soundtrack sets linked to animated-cartoon series. The detail-minded thoroughness that is evident in Shimada's work and is complemented by the high-quality printing that is so typical in Japan is an attractive hallmark of much Japanese graphic design in general, whoever its creators or end users may be.

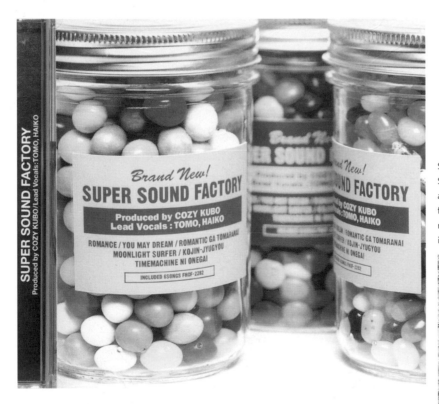

Shimada's self-conscious design for Super Sound Factory's CD pokes fun at the nature of familiar packaging forms and hints at the spirit of the music the album contains with an image of bright candies in jars.

FRONT MISSION 2
フロントミッション セカンド ™

In 2012 A.D. Alordesh soldiers, in their small republic of O.C.U. deploring their motherland crisis, made resistance to their leaders. They named themselves "Revolutionaries", and declared their independence...

"FRONT MISSION 2" Guide Book

SQUARESOFT

Shimada's lavishly illustrated, full-color manuals for adventure-themed computer games, some inspired by Japanese martial arts, pack considerable amounts of information and a multitude of cross-cultural references into each spread. Note the cover of the PlayStation guide with no illustration and only Japanese *kanji* and phonetic writing on what appears to be an affixed, black-and-white label. In fact, this element is not actually glued to the cover, as it normally would be on a book of this traditional, Sino-Japanese format. Instead, like the string binding visible on the left edge of this volume, the title label is part of this paperbound book's flat, smooth, printed cover.

These booklets, with their boldly colored cover images, are promotional items for concerts and recordings by the, for English speakers, improbably or unfortunately named teen duo known as Kinki Kids.

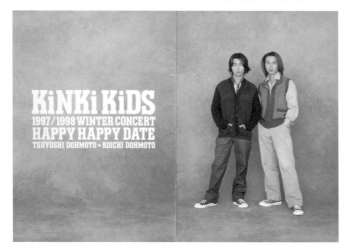

KiNKi KiDS
1997/1998 WINTER CONCERT
HAPPY HAPPY DATE
TSUYOSHI DOHMOTO + KOICHI DOHMOTO

KiNKi KiDS
1997/1998 WINTER CONCERT
HAPPY HAPPY DATE
TSUYOSHI DOHMOTO + KOICHI DOHMOTO

This wrapper for a promotional music CD exudes a sense of minimalist cool with its white-on-silver foil printing.

Re-Debut Album 9·23 Release

KIYOMI SUZUKI · VOICE

Say · VOICE(Album Version)/NICE GUY/MOTHER MOON
Onna ga Otoko o Aisuru toki/Knock on my heart
Time Goes By~Toki no nagare o shinji-tai
ETERNALLY/Downtown Story(Shita-machi no futari)
A Place in the Sun/Utsuri kawaru Mono no naka de
CD·TOCT-6540/Cassette:TOTT-6540

A deluxe, slipcased-and-boxed set of compact discs containing the soundtrack music to an animated cartoon series gives Banana Studio an opportunity to interpret a familiar packaging format. Like many multi-disc CD boxed sets, the dimensions of this one's container are those of a conventional LP record sleeve.

Bright, playful cover motifs belie the complexity of the information that Shimada's layouts must package and convey in manuals for Nintendo computer games featuring the popular Mario cartoon character.

PRINCIPALS: Yasushi Fujimoto, Masahiko
Nomura, Kazuyoshi Komatsu, Youichi
Iwamoto, Tomoko Kumagai, Kyoko Kato,
Kahori Matsushita
FOUNDED: 1982
NUMBER OF EMPLOYEES: 20

Tokyo Soir Harajuku Bldg., B1F
4-3-4 Jingumae
Shibuya-ku, Tokyo 150-0001
TEL (81) 3-3408-5190
FAX (81) 3-3408-5195

CAP

Magazines do as much to help shape attitudes, opinions, styles, and tastes as they do to document those of a particular place and time. In Japan, as in the United States and Europe, thousands of local, regional, and national periodicals of all kinds are produced each year. While the average consumer may throw away an issue just as soon as it has been read, or at least looked at, those who give these information-and-entertainment products concrete visual form unabashedly regard the images and graphic elements they handle, and the covers and pages they create, as art. Cap's Yasushi Fujimoto is one of Tokyo's best-known magazine art directors. He has given provocative looks to such style sheets as *Studio Voice* and *Brutus* that reflect the moods and meanings of various forms of cultural expression—movies, fashion, music, design—and that record them, too. In his layouts for in-depth feature articles on pop topics that are a hallmark of Japanese style magazines, Fujimoto has brought a visible sense of organization and understanding to his varied themes. Magazines in Japan present subject matter from foreign sources, too, which means that designers like Fujimoto must first intellectually and aesthetically assimilate it—then find novel ways to present it to local audiences already overwhelmed by a constant outpouring of mass-media, visual material.

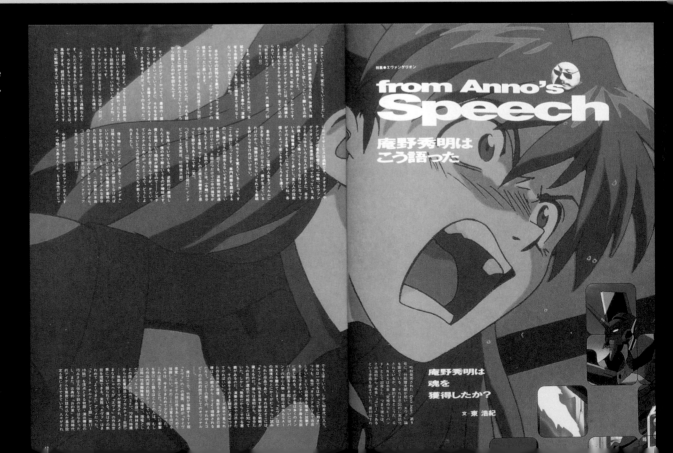

Inset pictures framed in rounded-corner rectangles, vaguely reminiscent of TV screens, and dropped-out white or colored type set against blown-up illustrations, pull readers into these *Studio Voice* layouts for a feature about the Japanese comic-book hero Evangelion.
ART DIRECTOR: Yasushi Fujimoto
or Fujimoto & Cap
DESIGNER, PAGE LAYOUTS:
Tomoko Kumagai

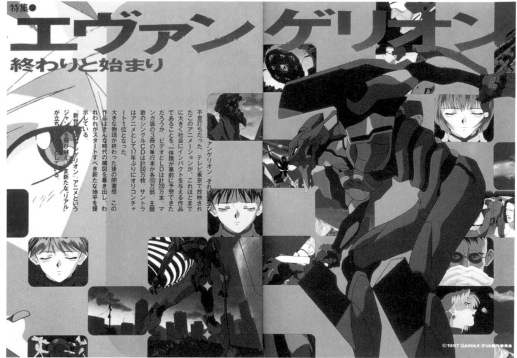

特集●
エヴァンゲリオン
終わりと始まり

©1997 GAINAX/EVA製作委員会

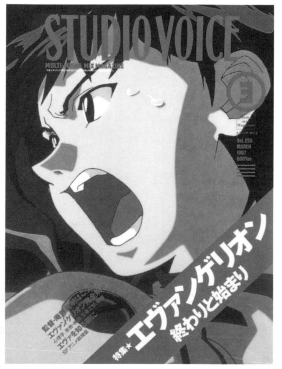

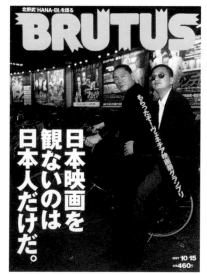

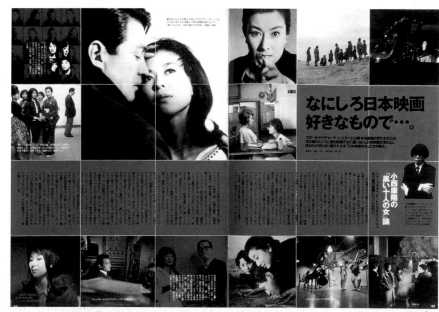

Kanji and kana (phonetic-alphabet forms), written in the counterpart to a Western language's bold, sans-serif typeface, loudly announce titles and appear in many Japanese book, magazine, and newspaper headlines, as on this *Brutus* cover. Inside, Fujimoto uses a simple grid of squares and bright pink, contrasting with black-and-white film stills, in a feature about the history of Japanese cinema.

ART DIRECTOR: Yasushi Fujimoto or Fujimoto & Cap

DESIGNER, PAGE LAYOUTS: Makiko Kimura

PHOTOGRAPHY, COVER AND CINEMA STORY: Kishin Shinoyama

Haven't U Heard?
エリノ エリノ エリノ

Fujimoto helped formulate the aesthetic vision for this small-format promotional magazine for Laforet, Tokyo's youth-oriented emporium of style and fashion. The use of type is sparse, contrasting with pronounced snapshot-like photos, in each issue. Here, minimalist design works hard in a series of trend-evoking mood pieces.

ART DIRECTORS: Yasushi Fujimoto, Youichi Iwamoto, Tomoko Kumagai and Ayako Yabe, *vol. 4,* girl in boots; Fujimoto, Youichi Iwamoto, and Tomoko Kumagai, *vol. 9*

DESIGNERS: Iwamoto, *vol. 4;* Kumagai, *vol. 9*

PHOTOGRAPHY: Munehisa Sakurada, *vol. 4;* Jun Kanno, *vol. 9*

Laforet's EYE
Vol.09 "Love" issue

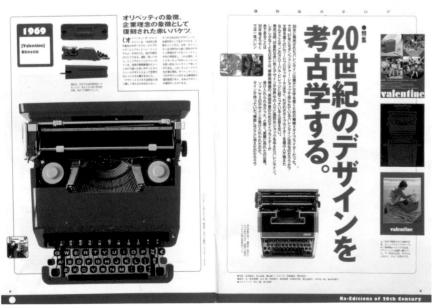

Fujimoto uses a luscious, eye-popping red as his main organizing color in layouts of this special issue of *Brutus* filled with a visual history of modern design.

ART DIRECTOR: Yasushi Fujimoto or Fujimoto & Cap

DESIGNER, PAGE LAYOUTS: Makiko Kimura

Japan's *Brutus* magazine offers trendy servings of pop music, fashion, movies, cars, and endless consumer goods for the young male readers at whom it is aimed. In his art direction for its covers and inside layouts, Yasushi Fujimoto packages pop culture subjects, often from foreign sources, not only to grab readers' attention, but also, importantly, to effectively help *explain* them and make them intelligible to the magazine's audience. Here, for example, he uses a custom-made icon, inspired by a movie-maker's clapboard, to anchor a long feature on a movie about the 1980s painter Jean-Michel Basquiat.

ART DIRECTOR: Yasushi Fujimoto or Fujimoto & Cap

DESIGNER, PAGE LAYOUTS: Kazuyoshi Komatsu

PHOTOGRAPHY: Michael Halsband, Eiko Aoshima-Botashi Group/Imperial Press

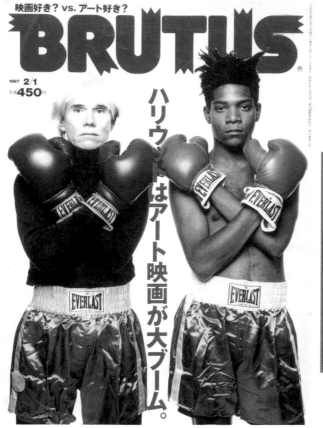

映画好き? vs. アート好き?

BRUTUS

1997 2/1 定価450円

ハリウッドはアート映画が大ブーム。

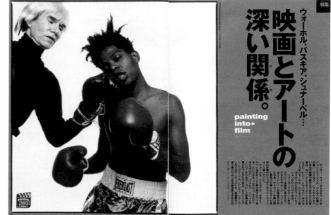

特集

ウォーホル、バスキア、シュナーベル…

映画とアートの深い関係。

painting into★film

This yellow page is an example of the kind of shopping-guide layouts that are typical of Japanese consumer magazines. Note the use of silhouetted photo images, another common convention.

ART DIRECTOR: Yasushi Fujimoto or Fujimoto & Cap

DESIGNER: Makiko Kimura

Bold and solid, or tinted color simultaneously compliments and pops out in contrast to crisp black-and-white photos in this *Studio Voice* feature about cultural gathering places.

ART DIRECTOR: Yasushi Fujimoto

DESIGNER, PAGE LAYOUTS: Tomoko Kumagai

The presentation of considerably large amounts of well-organized information on topics explored in depth is a hallmark of many Japanese popular magazines.

ART DIRECTOR: Yasushi Fujimoto or Fujimoto & Cap

DESIGNERS: Tomoko Kumagai and Kenji Oguro

ILLUSTRATION: Kenji Oguro

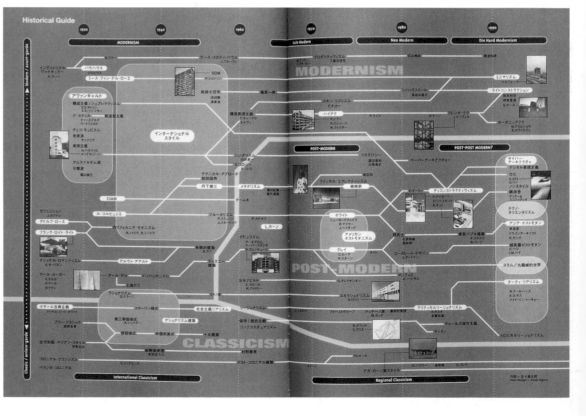

STUDIO VOICE

MULTI-MEDIA MIX MAGAZINE

①

Media
mix
Magazine

スタジオ・ボイス

Vol.247
JULY
1996
600Yen

★特集

Girlquake!

秘められた
少女たちの暴力性

Black type set against a pink
polka-dot pattern gives this
Studio Voice cover a sense of
vibrancy and energy.
ART DIRECTOR: Yasushi Fujimoto

A special issue of *Studio Voice*
focusing on Britain's Northern Soul
pop-music trend includes visually
coordinated feature stories, as well
as supplementary, information-
packed articles about particular
aspects of this alluring scene.
ART DIRECTOR: Yasushi Fujimoto
or Fujimoto & Cap
DESIGNERS: Youichi Iwamoto

PRINCIPALS: John Tymkiw,
Takako Sakata
FOUNDED: 1993
NUMBER OF EMPLOYEES: 2

308 Château Hatsudai
1-37-11 Hatsudai
Shibuya-ku, Tokyo 151-0061
TEL (81) 3-5351-5268
FAX (81) 3-5351-5263

CHEREPAKHA

John Tymkiw, an American of Ukrainian background, and Takako Sakata first met when both young designers worked for Katsumi Asaba, a well-established Tokyo art director. Sakata went out on her own in 1992; Tymkiw left the office a year later. Sakata had been concentrating on music CD packages and doing editorial design, and Tymkiw was creating logotypes when they brought their talents and interests together to form a new studio. They named it after the Ukrainian word for turtle. "We like what the turtle can symbolize," Tymkiw says, "like a sense of the long-lasting, the wise, the independent." And a sense of the unpretentious, too, he adds, for Cherepakha eschews adherence to style doctrines or to what its partners call Tokyo's general, inescapable tide of "pop design"—"as in 'pop music,'" Tymkiw notes—which is, in effect, a large segment of the Japanese mass media's contemporary visual vernacular. Only the individual viewer can decide how much Cherepakha has managed to avoid—or, perhaps inevitably, how much it may have been influenced by—this potent force. "We try to be ourselves," says Tymkiw of his and Sakata's young firm. "Trusting in our gut feelings makes for honest and unique solutions."

Imprinted stones identify a pop act's greatest hits collection in a design with a hint of calm irreverence.
ART DIRECTOR: Takako Sakata
PHOTOGRAPHY: Takashi Honma

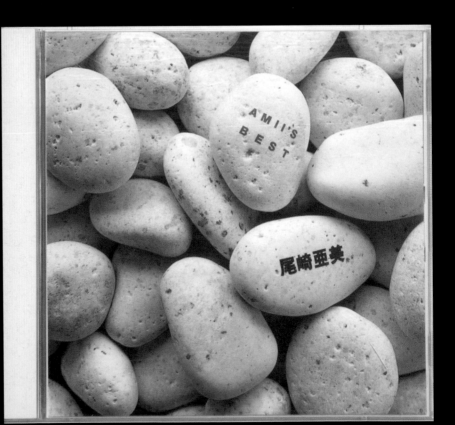

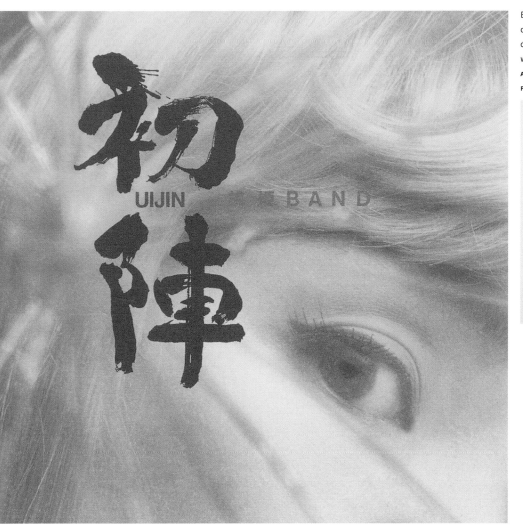
UIJIN BAND

Brush-written, black *kanji* forms complement the cool, enigmatic cover photo of this pop CD with a bold, dramatic touch.

ART DIRECTOR: Takako Sakata
PHOTOGRAPHY: Yoshihiko Miyazawa

In this logo for a computer game made by Nintendo, strokes of each letterform alternate in color, green or orange, for a bright, sporty look. (Note that, technically, the two colors are of exactly the same value, a common detail of many logos that gains strength here from the thick, black shadow outline.)

ART DIRECTOR: John Tymkiw

タモリの ピクロス PICROSS

A thick, energetic line and complex curlicue, incorporating a cursive letter *B*, make this logo for a record label an attention-grabber.
ART DIRECTOR: John Tymkiw

These worm-like, gesticulating letterforms spell out the name of a magazine published by a well-known, corporate-sponsored cultural center in Tokyo whose building, designed by the noted Japanese postmodern architect Fumihiko Maki, is popularly known as the Spiral Building.
ART DIRECTOR: John Tymkiw
CREATIVE DIRECTOR: Tetsu Hamasaki

CHEREPAKHA
308 CHATEAU HATSUDAI
1-37-11 HATSUDAI
SHIBUYA KU TOKYO 151
TEL 5351-5268
FAX 5351-5263
EMAIL kame@gol.com

有限会社 チェレパハ 〒151 東京都渋谷区初台 1-37-11 シャトー初台308 TEL 5351-5268 FAX 5351-5263 E-MAIL kame@gol.com

post card

The choppy, chunky black lines on the back side of this postcard carry on the intentionally offbeat, slightly aberrant look of the typeface that appears on the front side. The piece is a New Year's greeting card promoting the Cherepakha studio. In Japan, traditionally, friends and relatives send each other, and businesses send their clients, greetings for the new year in the form of postcards. The custom affords graphic designers ample opportunities to create promotional materials in postcard and related formats for themselves and for their clients.

ART DIRECTOR/PHOTOGRAPHY:
John Tymkiw

PRINCIPAL: Hideyuki Tanaka
FOUNDED: 1992
NUMBER OF EMPLOYEES: 5

1-38-3, No. 2302 Tomigaya
Shibuya-ku, Tokyo 151-0063
TEL (81) 3-3485-6643
FAX (81) 3-3485-6640

FRAME GRAPHICS CO., LTD.

Hideyuki Tanaka's work reflects two interesting strains of artistic-emotional expression that are evident in contemporary Japan's culture and visual language. Frequently, in advertising, graphic design, and product design, they converge. First, there is a fondness for anything *kawaii* (cute or adorable), often demonstrated when teenage girls squeal with glee over cuddly stuffed animals, little dolls, teen-idol posters, or any merchandise—keychains, pens, notebooks, tote bags—adorned with brightly colored cartoon characters. Second, there is Japan's long, rich tradition of cartooning and animation, which has its roots in centuries-old brush paintings of ghosts and monsters. Young Tanaka, through his Frame Graphics studio, fuses this popular penchant for the cute with an exceptional talent for conjuring up memorable cartoon characters. The computer-graphics programs that he uses allow for dramatic modeling and shading of his bikini-clad, space gun-wielding fetish girls in their knee-high boots, or his goofy-delightful bugs, dogs, and panda bears. Tanaka has an instinctive understanding of the fun-fueled, feel-good, optimistic color and line of classic space age and sixties pop-art styles; his work has been used in advertising and packaging for snowboards, computer games, and other youth-oriented goods. His designs are also marketed through his studio's own line of merchandise, from inflatable beach toys and sweat-shirts to fuzzy slippers and condoms.

Frame Graphics Co., Ltd. is best known for its goofy-delightful, sometimes outrageous cartoon characters that turn up in advertisements for youth-oriented products or brands, such as Fila. Designer-illustrator Hideyuki Tanaka gives his futuristic fetish girls names like the Sexyrangers, and uses comic-book-inspired typography in a work like "Cheers to Extraterrestrials!" which appeared in the Japanese graphic-design magazine *Idea*.

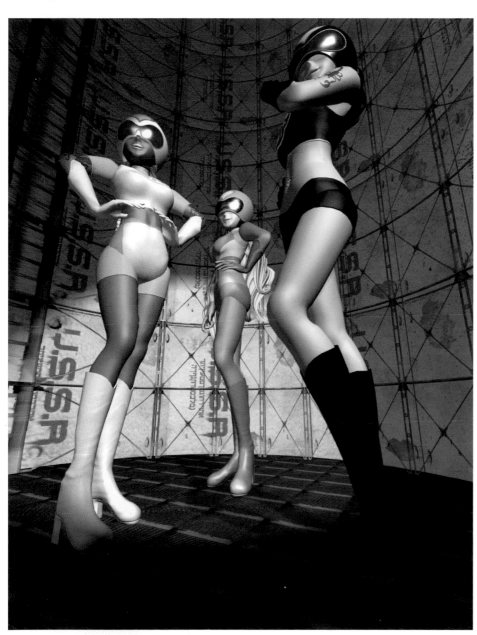

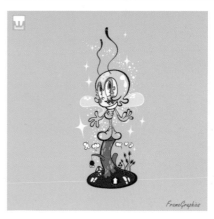

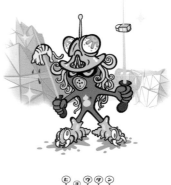

Tanaka's illustration style and design aesthetic come together and perfectly serve to shape the Groove Jigoku V computer game for Sony's PlayStation published by Ki/oon Sony Records in Japan. The game's package and related promotional poster evoke the exuberant, even optimistic, futuristic-psychedelic style of the late sixties. Screens from the game show how readily Tanaka's cartoon creations and design sensibility lend themselves to this particular kind of application.

ART DIRECTOR: Hideyuki Tanaka
CREATIVE DIRECTOR: Denki Groove

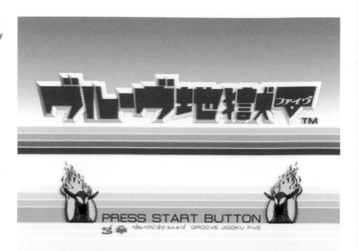

PRINCIPAL: Osamu Fukushima
FOUNDED: 1995

2-4-15-101 Nishi-Kasai
Edogawa-ku, Tokyo 134-0088
TEL (81) 3-5658-2590
FAX (81) 3-5658-2590

OSAMU FUKUSHIMA

The touch and sensibility of both the poet and the fine artist are never far from view in the work of Osamu Fukushima, an award-winning young graphic designer who is a native of the southern Japanese city of Hiroshima. In his posters, Fukushima displays a thoughtful, sophisticated understanding and assimilation of the themes and technical concerns that have motivated postmodern artists of the eighties and nineties, including the body, memory, spirituality, and, most surprisingly in the context and for the purposes of mass-media advertising, even death. In the tradition of one common strain of Japanese television and print advertising, Fukushima's posters are often spare, mood-suggesting conveyors of a feeling or ambiance. Theirs is the poetically persuasive message of the soft sell—never the hard—in compositions in which seemingly unrelated elements assume mind-tickling, eye-catching affinities. The unlikely monumentality of his Lego-block lovers or docking spaceships in his Valentine's Day posters for Godiva chocolates, for example, show Fukushima working at his best, with a definite edge and a sense of cleverness that resonate long after a viewer gets his visual jokes.

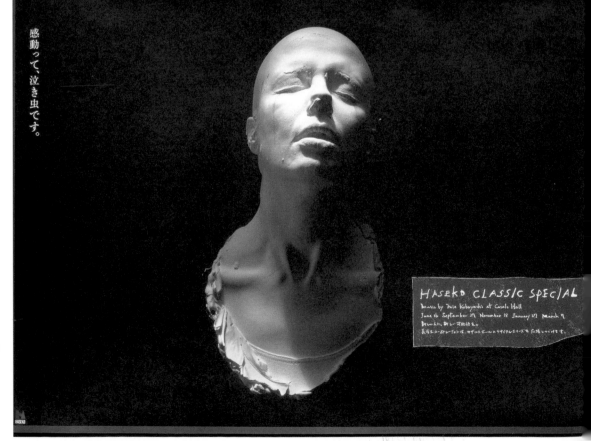

A dramatically illuminated plaster cast lends an unusual, theatrical air to this poster for a series of concerts at Casals Hall.
ART DIRECTOR: Osamu Fukushima
CREATIVE DIRECTOR: Bob Ward
PHOTOGRAPHY: Kazuyasu Hagane

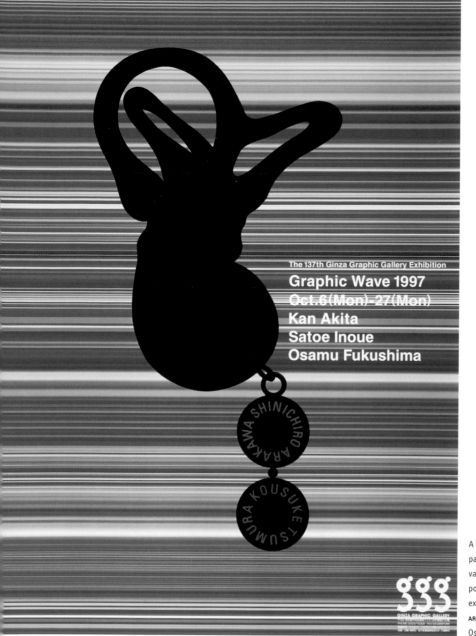

The 137th Ginza Graphic Gallery Exhibition
Graphic Wave 1997
Oct.6(Mon)–27(Mon)
Kan Akita
Satoe Inoue
Osamu Fukushima

A simple random, background
pattern of horizontal lines of
varying widths energizes this
poster for a graphic-design
exhibition in Tokyo.
ART DIRECTOR/ILLUSTRATOR:
Osamu Fukushima

The eerie stillness of a taxidermy
workshop in this poster image
contrasts markedly with the loud
sounds of rock music that it pro-
motes. The poster advertises a
concert by the Japanese rock
group Bow Wow.
ART DIRECTOR: Osamu Fukushima
PHOTOGRAPHY: Kazuyasu Hagane

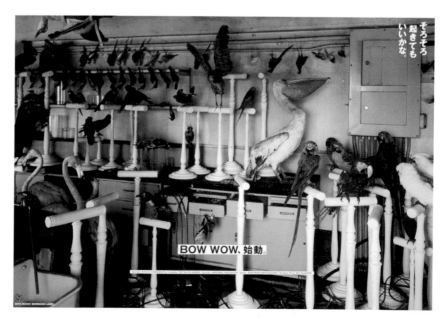

そろそろ
起きても
いいかな。

BOW WOW, 始動。

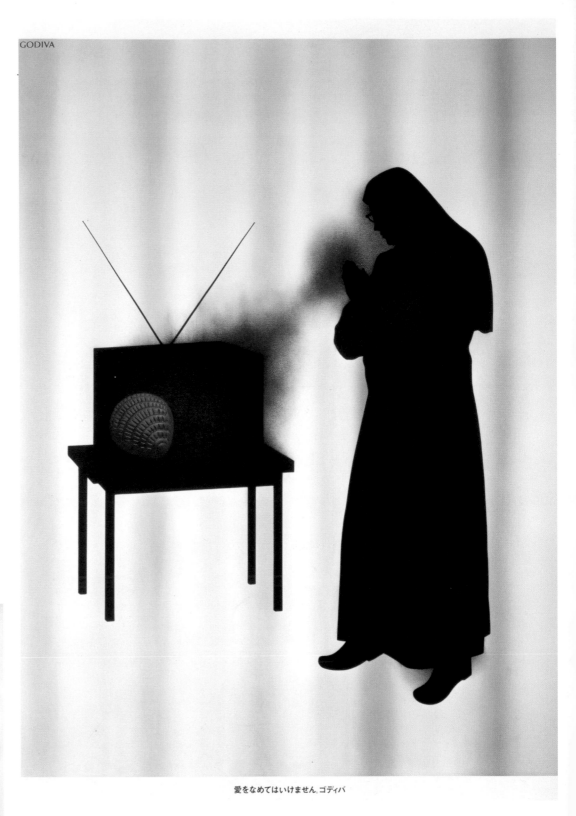

GODIVA

愛をなめてはいけません。ゴディバ

下心なんか、あります。ゴディバ

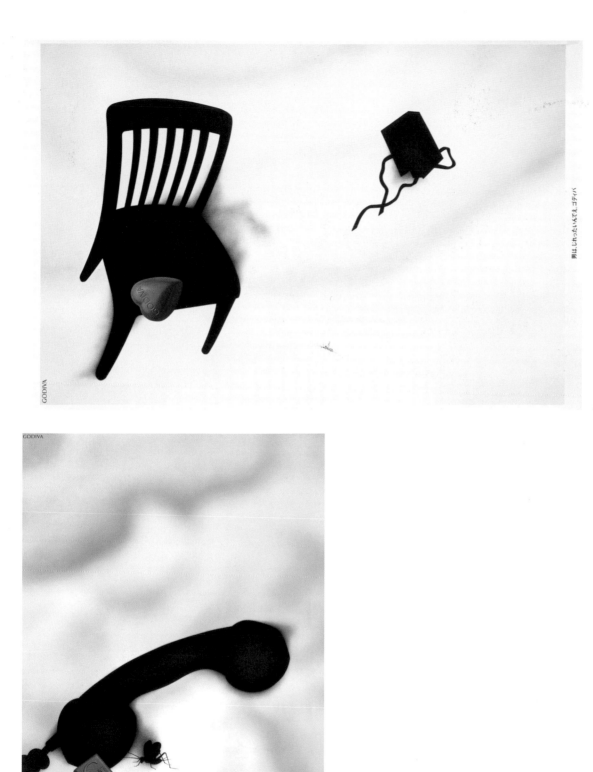

GODIVA

男は、しけったいんてえ。ゴディバ

GODIVA

去年の人にはあげなかった。ゴディバ

Godiva chocolates enter the realm of the metaphysical in this series of dreamy, mood-conjuring posters, which Fukushima himself illustrated.

ART DIRECTOR: Osamu Fukushima

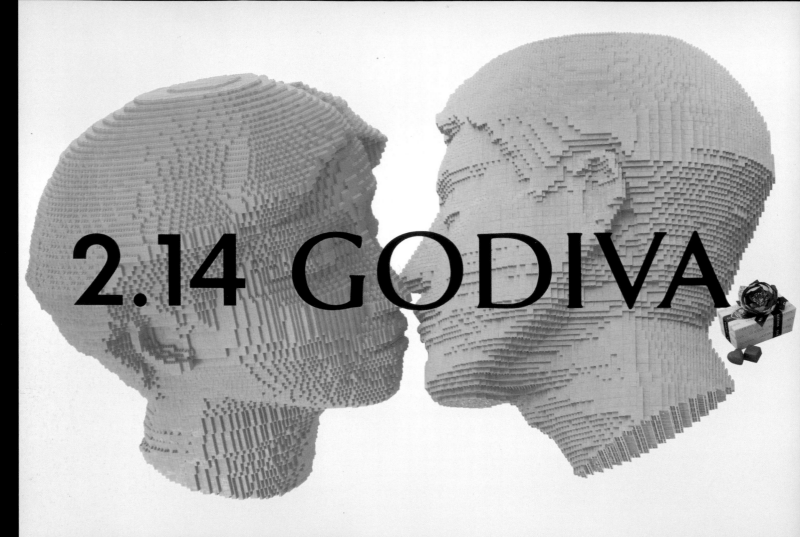

2.14 GODIVA

Appropriated from the West, in Japan, Valentine's Day is more of a retailer's excuse for special sales than a genuinely popular holiday. In these Valentine's Day posters for Godiva chocolates, Fukushima uses Lego-block sculpted forms to create gently romantic images in which the advertised product appears as something of an afterthought quietly punctuating boldly depicted but subtly expressed messages.

ART DIRECTOR: Osamu Fukushima
PHOTOGRAPHY: Toshio Nakajima

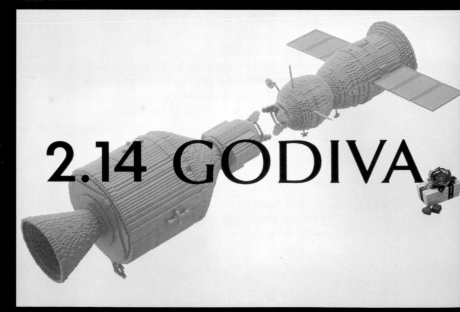

2.14 GODIVA

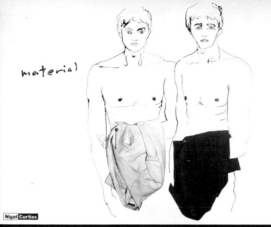

material

Fukushima combines photography
and surprisingly unaffected,
straightforward figure drawing in
these unusual advertising posters
for the Nigel Curtiss fashion label.
ART DIRECTOR: Osamu Fukushima
CREATIVE DIRECTOR: Bob Ward
ILLUSTRATION: Masaaki Okino

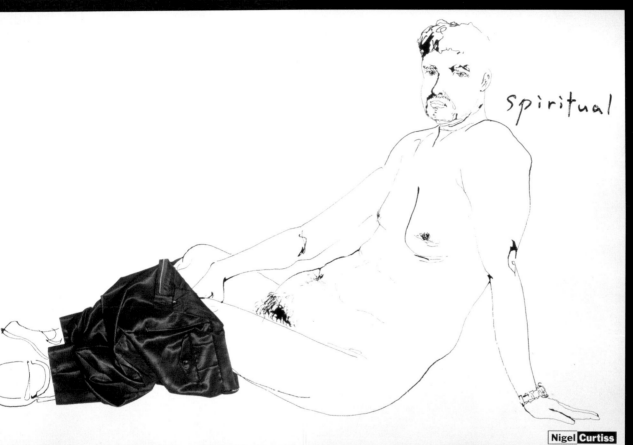

spiritual

In postmodernist terms,
Fukushima appropriates the
familiar organizational chart
ordinarily associated with the
graphic representation of a
family tree or a modern
corporate bureaucracy to
comment on the far-reaching
impact of AIDS.
ART DIRECTOR: Osamu Fukushima

PRINCIPAL: Yasutaka Kato
FOUNDED: 1994
NUMBER OF EMPLOYEES: 1

5-17-5 Yutaka-cho
Shinagawa-ku, Tokyo 142-0042
TEL (81) 3-3788-4563
FAX (81) 3-3788-0635

GHOST RANCH STUDIO

In a self-promotional pamphlet, Yasutaka Kato bills himself as an art director/surrealist. Even so, that label only begins to describe his multifaceted, prolific talent. For Kato's CD covers and packages may strike a viewer as somehow inadequate mirrors of the voracious curiosity and effusive imagination that propel this artist who is as much a one-man energy force as he is a well-known design-studio manager. Kato credits his all-consuming passion for design to his discovery, at the age of ten, of the posters and cover art for the Beatles' *Sgt. Pepper's Lonely Hearts Club Band* record album. "I experienced a violent, intense aesthetic shock," Kato says of his reactions to Michael Cooper and Peter Blake's now-classic, pop-psychedelic concoctions. Kato was also moved by the dazzling work of Japan's own pop-era poster master, Tadanori Yokoo. Kato studied commercial design and worked at the Nippon Design Center

before becoming a record-company art director. He held this post for twelve years at Sony Records, where he master-minded the in-house studio—dubbed the Creative Room—that provided cover art and promotional materials for the media giant's labels. Kato went solo in 1994 and now manages both Ghost Ranch Studio and the Above Us Only Sky Studio. His work is often dense with collage-like effects and rich in visual texture, mixing handwriting, silhouetted photos, ornate patterning, and computer-generated, image-altering effects.

If Kato's designs for covers of albums by the Japanese band Earthshaker recall those of the Grateful Dead, it may be no accident; in pop culture's self-cannibalizing tradition, everything is grist for the mill.

ART DIRECTOR: Yasutaka Kato
ILLUSTRATION: Keiichi Koike

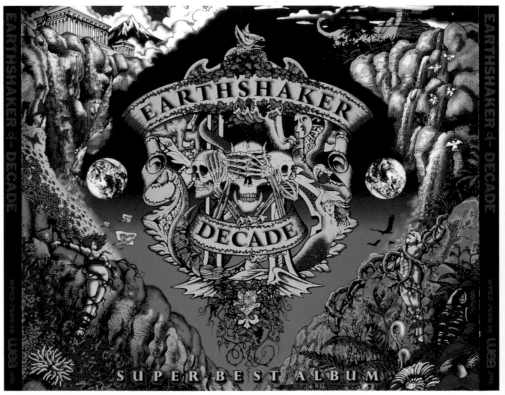

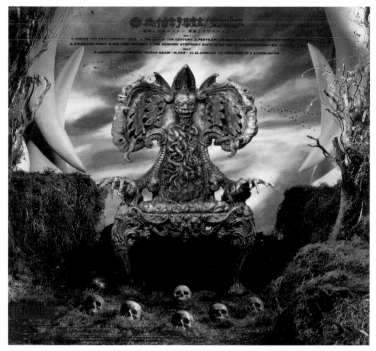

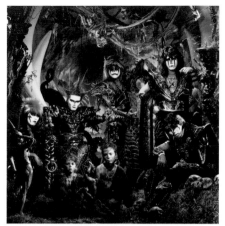

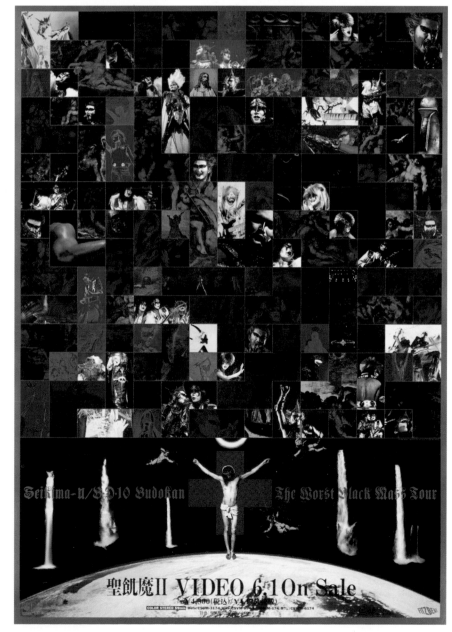

The Japanese band Seikimatsu's amalgam of heavy metal, glam-rock, punk, grade-B horror movies, Arthurian legend, and Satan worship has produced a style that only Kato, with his equally fecund and unpredictable imagination, could match in images. Note the Christian crucifixion, set against a patterned red cross, in the band's concert-video poster.

ART DIRECTOR: Yasutaka Kato

ILLUSTRATION: Shiro Nishiguchi

PHOTOGRAPHY: Peter Ashworth, Haruhi Fujii

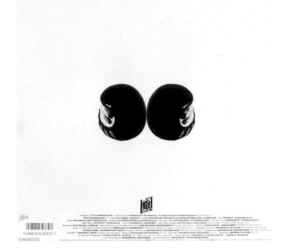

Kato uses a traditional Japanese *daruma* doll (from the Buddhist term dharma) in this stark but clever record-album cover for the band Ryudogumi. In Japan, the gift of a papier-mâché *daruma* doll, with one eye painted in, is offered as a token of good luck; later, the recipient paints in the other eye. Here, Kato's topsy-turvy, painted *daruma* faces express a range of emotion against a minimalist white background.

ART DIRECTOR: Yasutaka Kato
ILLUSTRATION: Hideki Igawa
PHOTOGRAPHY: Shigeru Bando

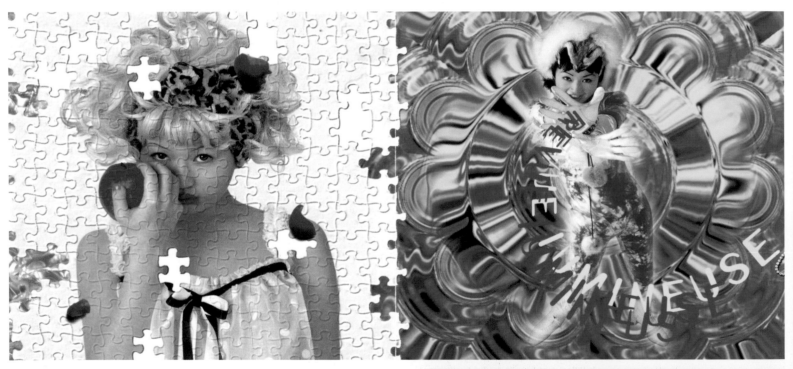

Computer-manipulated photos, doodles, handwritten song lyrics, and endless reworkings of posed, teen-idol publicity shots—Kato throws it all into the design hopper in his CD booklet and promotional flyer for a Mami Yamase album.

ART DIRECTOR: Yasutaka Kato
PHOTOGRAPHY: Koh Hosokawa

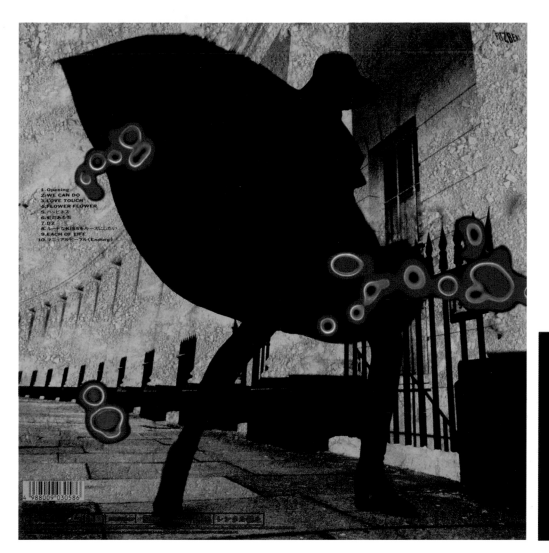

1. Opening
2. WE CAN DO
3. LOVE TOUCH
4. FLOWER FLOWER
5. ハッピネス
6. 虹のある街
7. DZ
8. ルートとKISSをルーズにしたい
9. EACH OF LIFE
10. センチメンタルピープル（Ending）

4 988009 030586

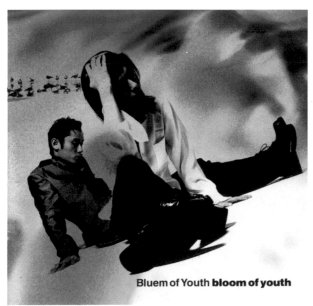

Bluem of Youth **bloom of youth**

Kato's goal in designing record or CD covers and related materials, he says, is a harmonious fusion of music and graphics so that each perfectly complements the other. Here, his cover and booklet design for this CD blends billowing washes of color with crisp black-and-white photos in what, for Kato, is a more restrained, spare visual mode.

ART DIRECTOR: Yasutaka Kato
PHOTOGRAPHY: Koh Hosokawa

Superimposed photos and color layers on the front side, and globs of drippy color floating on the surface of the image of a dramatically silhouetted human form on the back side, give this laser-disc sleeve a spooky-romantic, psychedelic air.

ART DIRECTOR: Yasutaka Kato
ILLUSTRATION: Betty Tompkins
PHOTOGRAPHY: Zigen

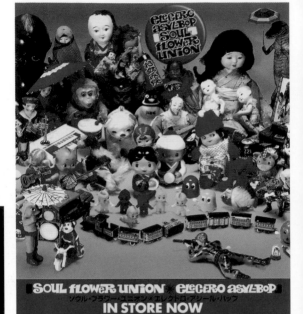

A convocation of plastic dolls and figurines, and other examples of what the Japanese call *kawaii mono* (cute things) come together in an unwitting homage to the Beatles' landmark *Sgt. Pepper's Lonely Hearts Club Band* record-album cover of 1967. With their logo in the form of what used to be called a protest button, this CD cover and promotional materials for an album by a Japanese pop band honor—and inadvertently send up—the hippy-innocent mood and style of the "swinging sixties."

ART DIRECTOR: Yasutaka Kato

PHOTOGRAPHY: Taro Naiki

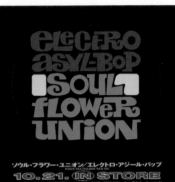

Kato's combined sense of the fantastic, the opulent, the theatrical, and the magical, all of which are evoked and expressed through graphic design, infuses his CD covers and promotional materials for Hidehiko Urayama and Yoko Kumagai's recording and film projects.

ART DIRECTOR: Yasutaka Kato

PHOTOGRAPHY: Haruhi Fujii

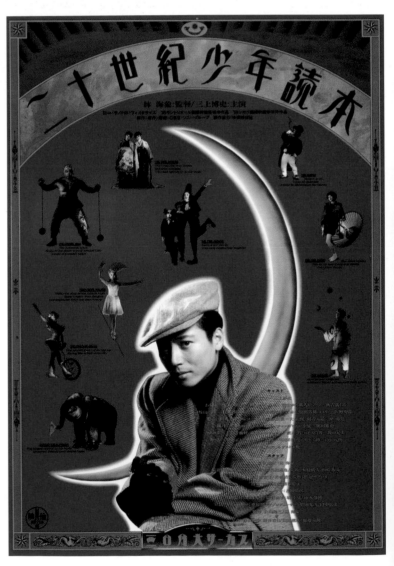

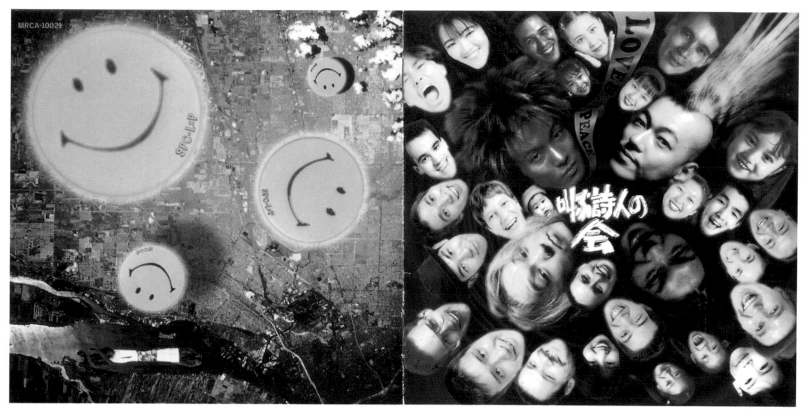

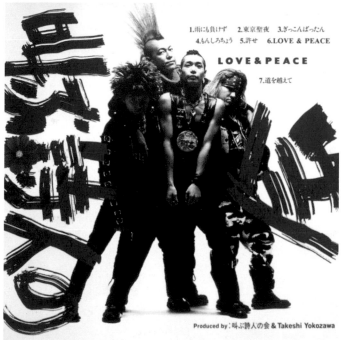

Hippy-happy pop meets urban-guerrilla style by way of spiked-hair punk; that's the sensibility Kato interprets in these cover designs and booklet for a CD by the Japanese band Screaming Poets Com'. Note the use of a wide felt-tip marker in the album's handwritten, graffiti-like title logo.

ART DIRECTOR: Yasutaka Kato

PHOTOGRAPHY: Masato Yokoyama

PRINCIPALS: Hiroshi Ito,
Kazuhiro Saito, Kenji
Sumioka, Toru Hara,
Hideyuki Yamano
FOUNDED: 1993
NUMBER OF EMPLOYEES: 5

No. 201 Kandaya Building
2-4-6 Kamimeguro
Meguro-ku, Tokyo 153-0051
TEL (81) 3-5723-6558
FAX (81) 3-5723-6356

groovisions

In a city with a voracious appetite for pop culture and its celebrity- and brand-associated artifacts, from teen-idol compact discs and posters to hairstyles, clothes, and pencils imprinted with cartoon characters, the anonymous members of the studio known as groovisions, whose designers never take credit for their efforts by name and are never photographed (they might publish illustrations of themselves in their house style instead) occupy a special place among graphic designers. For they are simultaneously keen observers of the rhythms and attitudes that propel Japan's youth-pop scene, with its crisscrossing tributaries in fashion, music, art, advertising, and mass media, and knowing, fruitful contributors to its constant efflorescence. The studio's signature style is marked by the frequent use of illustrations of flatly rendered, youthful figures set against generous fields of white or lightly colored space, and a minimal, bold use of Helvetica type. Most groovisions creations are crisp, cool, clever, and inescapably chic; the studio's flyers, brochures, and posters for rock bands, young furniture makers, and nightclubs link its recognizable sensibility to—and superimpose its finely tuned, high-design-retro, style-conscious vision on—other conjurer-purveyors of the culture of *now*.

This die-cut piece with a rotating text-and-images wheel inside, serves as the catalog for an exhibition of groovisions' own creations.

groovisions taps into the youth-pop scene with flyers like this one announcing music and video events at a Kyoto nightclub.

pedantic 96

djs and vjs

**le hammond inferno [from berlin]
yasuharu konishi [pizzicato five]
sound impossible
groovisions by groove quest**

96

**19951206WED. pm9:00start
at metro,kyoto**

keihan marutamachi station exit no.2
phone:0757524765

supported by TU-Ka station kitayama and spinns

admission 2500yen[with one drink] Readymade Inc. GRV0049

FL07&12

||||| ▤
FL07 "PORTRAIT" CHAIR
W445D465H650/SH380
¥65000

▦
FL12 "PORTRAIT" MINI TABLE
W350D290H360
(top 300sq.)
¥48000

High-tech meets retro-pop in this promotional booklet for the Flastic line of tables, chairs, and shelves sold by the E&Y furniture company.

groovisions' flatly rendered, signature portrait illustrations turn up on the outer box and accompanying booklet cover of this CD by the Tokyo Ska Paradise Orchestra on Epic/Sony Records.

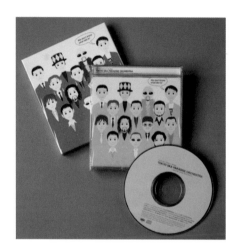

groovisions' applies this same pared-down, Helvetica-driven styling to companion sleeves and labels for back-to-back 45-r.p.m. discs by Pizzicato Five and April March. Released by Nippon Columbia Co., Ltd.

groovisions brings the right touch of self-consciously sophisticated, pop-minimalist chic to its deluxe-box packaging for *Great White Wonder: Rare Masters 1990-1996,* a CD by Pizzicato Five. This Japanese duo, which looks back to sixties-era lounge music and Europop for inspiration, has a large U.S. cult following. The performers pitch themselves as jet-setting pop icons in the disc's accompanying flip books. Released by Nippon Columbia Co., Ltd.

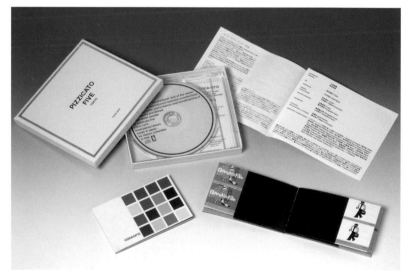

19961025
19961026
19961027

This postcard uses an illustration of colored building blocks to announce a furniture designer's show at a high-end store in Kyoto.

les pizzicato five boutique
ready to wear-ready to hear

30 septembre
15 octobre

shibuya parco part 3

The design motif for one of the flip books inside Pizzicato Five's *Great White Wonder: Rare Masters 1990-1996* CD box is echoed in this postcard announcing the band's boutique in the Parco department store.

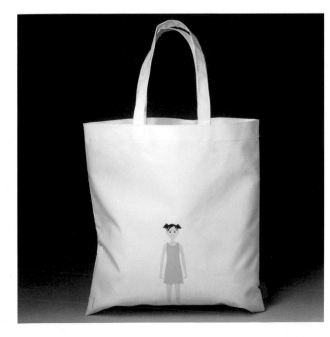

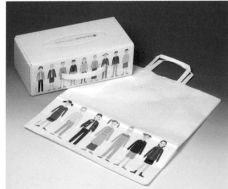

This glossy, hard-cardboard tissue-box holder bears the logo of the well-known department store Takashimaya on its top, punch-out hole section, and is decorated with groovisions' signature illustrations of generic, wide-eyed, style-minded young people. Similar figures appear on a vinyl tote bag and paper shopping bag. The designers created the pieces for the store's Young World department.

A simple pattern of fat, overlapping, colored rings forms a striking motif for a brochure announcing the Juggernaut Polo Furniture Collection sold by E&Y in Japan.

juggernaut
polo furniture collection

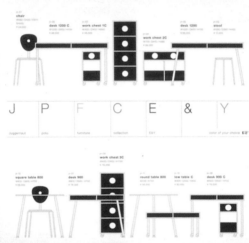

This flyer announces a musical performance at a club specializing in French-themed events.

la soirée de salvador
**salvador,
OUI!
gainsbourg,
NON!**
la réception donée pour fêter
la formation du comité salvador
971101 at six factory

présentée par **six/delfonics/smith**

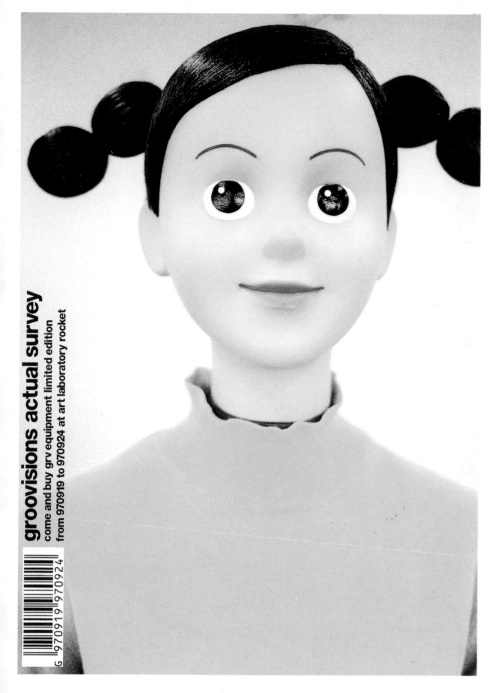

groovisions actual survey
come and buy grv equipment limited edition
from 970919 to 970924 at art laboratory rocket

Cards announcing shows and sales of groovisions' design works bear the design team's familiar wide-eyed figures.

An unusual flyer announcing groovisions' own work on view at a club in Kyoto is printed in purple and black on 35 mm film strips that are inserted into a typical vinyl protector sheet. The piece perfectly captures the design team's media-savvy spirit.

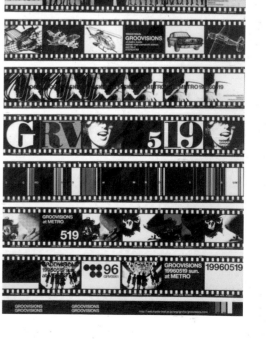

PRINCIPAL: Ichiro Higashiizumi
FOUNDED: 1994
NUMBER OF EMPLOYEES: 3

Villa Gaien 7D
3-38-16 Jingumae
Shibuya-ku, Tokyo 150-0001
TEL (81) 3-5411-0872
FAX (81) 3-5411-0873

HIGRAPH TOKYO

Ichiro Higashiizumi's work exudes an instinctive sense of the cool at the same time that it comes across with real entertainment value and unaffected warmth. This may be because his interests straddle several disciplines; years ago, this well-known young designer quit his studies in the science and technology section of Tokyo's prestigious Waseda University to transfer to the equally renowned Tama Fine Arts University, the breeding ground of many of Japan's most notable, influential modern artists. Higashiizumi went to work for *Ryuko Tsushin* magazine after one of his art-and-design heroes and major influences, Japan's legendary, pop-era master Tadanori Yokoo, had stepped down as its art director. Higashiizumi did editorial and poster design there, then spent time at an independent design studio before launching his own in 1994. Like other Tokyo designers with a fondness for a retro-pop aesthetic that taps into sixties-seventies psychedelia, space age looks, anonymous commercial art and what, to Western eyes, can only be described as goofy kitsch, Higashiizumi has fashioned his own distinctive visual style from these sources. He does not shy away from color and seems to favor a line-drawing style that recalls industrial or mechanical drawings; this also turns up in large-scale works that he presents in galleries.

Higashiizumi's take on pop-psychedelia is sophisticated, lyrical, and full of energy in these posters for Les 5-4-3-2-1, a pop act that records for the Nippon Columbia label.
PHOTOGRAPHY: Kaoru Ijima

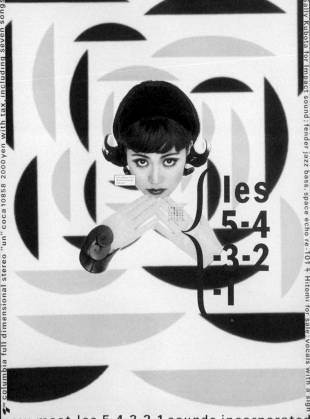

Higashiizumi slides easily from a swinging, groovy style in his promotional stickers for the Japanese edition of *Wired* magazine to souped-up retro-kitsch, featuring some colorful, imaginative *kanji* forms, in a series of CD covers.

Higashiizumi's cover for an annual publication surveying advertising design features the line drawing style that has become his signature. It recalls a draftsman's mechanical drawings.

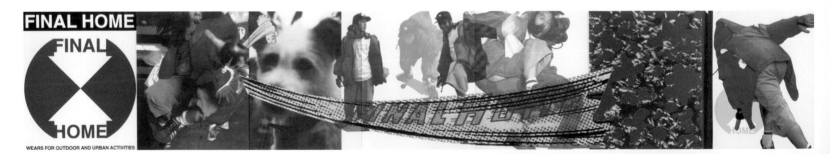

American-born hip-hop style meets Japanese merchandising in this accordion-fold brochure for Final Home, a young people's fashion line designed by Kosuke Tsumura—who is also a well-known, accomplished sculptor—for Issey Miyake, Inc.
CREATIVE DIRECTOR: Kosuke Tsumura
PHOTOGRAPHY: Mitsuru Mizutani

In this promotional piece for a video game, with its collage-like sequence of photos, Higashiizumi perfectly captures the spirit of high-charged fun that is the kids-oriented product's main selling point.

ILLUSTRATION, COMPUTER-GRAPHICS
CHARACTERS: Shinya Takemura
PHOTOGRAPHY: Hiroshi Nomura

The retro aesthetic is evident in full force in this design for a poster and flyer advertising an outlet for old records at a Nagoya store. Note the line drawings reminiscent of clip art from catalogs or appliance instruction manuals of yesteryear.

カタログ東泉　Ichiro Higashiizumi

構成・文：伊藤ガビン

Tokyo Editorial 1994

Ichiro Higashiizumi created these
pages for a special issue of Japan's
Designer's Workshop magazine
featuring editorial layouts by
prominent graphic designers.

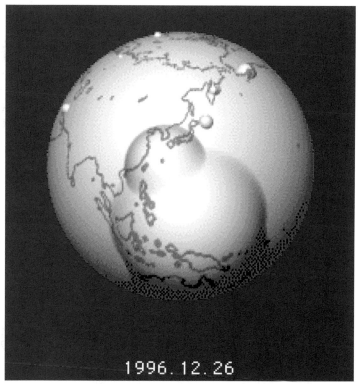

1996.12.26

Sensorium, at www.sensorium.org,
is a collaborative, conceptual-
scientific-artistic Web site with
which designer Ichiro Higashiizumi
is deeply involved. The site invites
visitors to monitor the Earth's
rhythms, poetically speaking, from
a variety of vantage points, and
to become aware of the collective
consciousness, so to speak,
of the planet's inhabitants, and
of the Internet itself as a
kind of living, breathing organism.

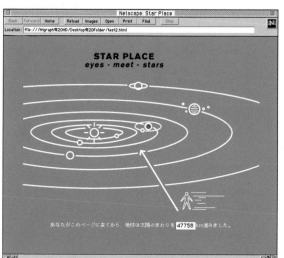

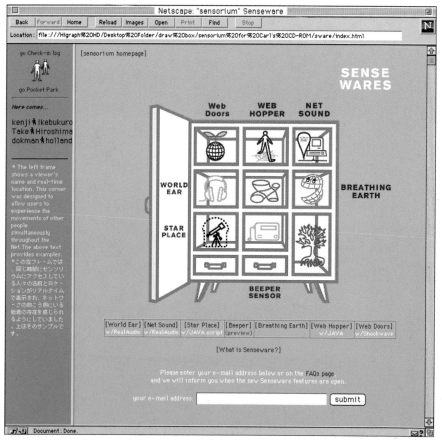

PRINCIPALS: Masaaki
Hiromura, Nobuhiko Aizawa,
Yoshifumi Mizuno
FOUNDED: 1988
NUMBER OF EMPLOYEES: 8

Aoyama Sakairi Building,
Room 401
2-2-18 Shibuya
Shibuya-ku, Tokyo 150-0002
TEL (81) 3-3409-5546
FAX (81) 3-3409-5572

HIROMURA DESIGN OFFICE

Masaaki Hiromura brings the designer's art of harmonious composition and the power to set a tone of scintillating, quiet but inescapable energy to his posters for retailers, sporting goods, exhibitions, and other clients or purposes. Often sparse-feeling, always clean and never cluttered, Hiromura's design is a kind of lush minimalism in which blown-up photo details of his subject matter, from snack-food chips to bicycle spokes, nevertheless give his layouts interesting and rich visual textures. His works can be as effective up close as they are when viewed from a distance. Sometimes they percolate with color, and with visual rhythm generated by random pattern, as in his poster for the Internet 1996 World Exposition and, in a similar vein, those that he created for the Takeo Co., Ltd. Hiromura's series for Mujirushi Ryohin, Japan's popular no-brand-name retailer of no-frills, back-to-basics products, makes such otherwise plain items as a set of stacking, corrugated-cardboard drawer units look positively elegant. Likewise, his catalog-on-a-poster of this same company's illustrated roster of sale items, with its splash of burgundy in a field of fine black lines against a creamy-white background, hints at the luxury of simple comfort that the purchase of well-made, well-designed, inexpensive goods can buy.

In various posters for Mujirushi Ryohin, Japan's no-brand-name retailer, Masaaki Hiromura gives a touch of sumptuous minimalism to no-frills merchandising.
ILLUSTRATION: Norihisa Toujinbara
PHOTOGRAPHY: Takashi Ohyama, Noritoyo Nakamoto

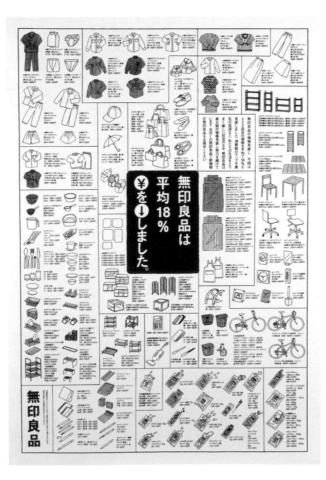

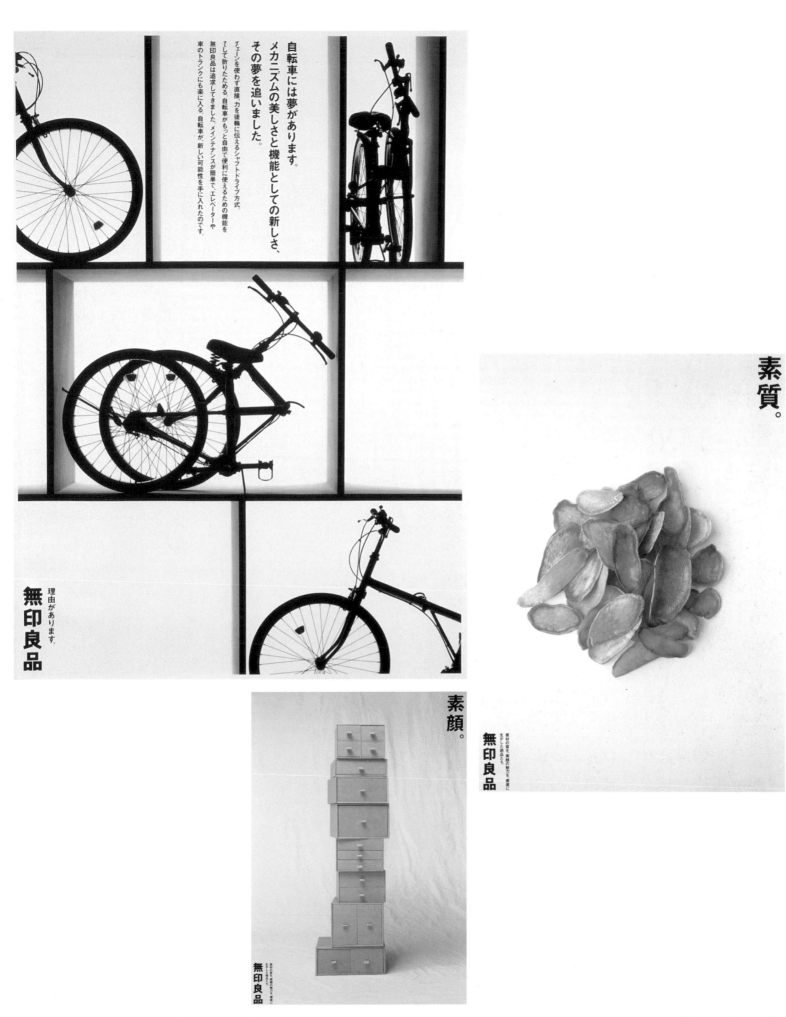

自転車には夢があります。
メカニズムの美しさと機能としての新しさ、
その夢を追いました。

チェーンを使わず直接、力を後輪に伝えるシャフトドライブ方式。
そして折りたためる、自転車がもっと自由で便利に使えるための機能を
無印良品は追求してきました。メインテナンスが簡単で、エレベーターや
車のトランクにも楽に入る、自転車が、新しい可能性を手に入れたのです。

理由があります。

無印良品

素質。

素材の質と、素肌の魅力を、素直に
生かした商品たち。

無印良品

素顔。

無印良品

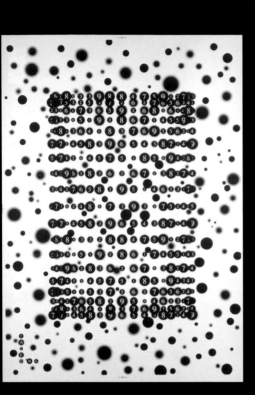

インターネット1996ワールドエキスポジション
'96.1.1〜12.31 http://park.org/

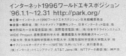

The announcement of the Internet
1996 World Exposition emerges
out of a thick visual soup of color
blobs and blurry letterforms in this
abstractly composed poster. Hiromura
used a similar treatment in a series
of posters promoting paper for the
Takeo Co., Ltd.

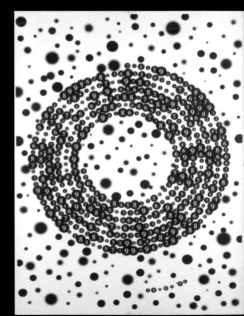

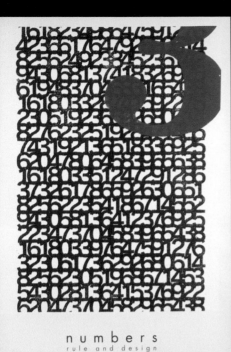

n u m b e r s
rule and design

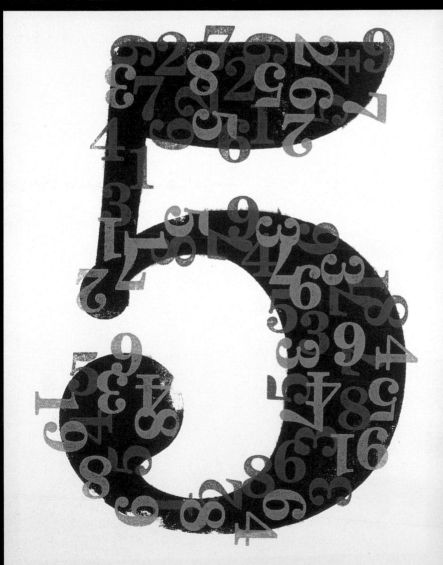

n u m b e r s
rule and design

Hiromura used dense, multi-layered designs based on the repeated forms of numerals in a series of posters displayed in a private exhibition of his studio's work.

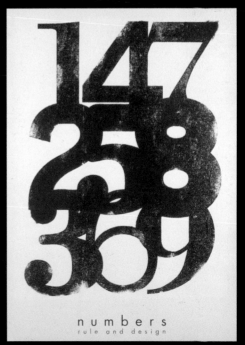

n u m b e r s
rule and design

n u m b e r s
rule and design

PRINCIPAL: Issen Okamoto
FOUNDED: 1979
NUMBER OF EMPLOYEES: 13

No. 1307 Tatsumura
Aoyama Mansion
5-4-35 Minami-Aoyama
Minato-ku, Tokyo 107-0062
TEL (81) 3-5485-7555
FAX (81) 3-3400-4924

ISSEN OKAMOTO GRAPHIC DESIGN CO., LTD

Issen Okamoto is one of the more senior and experienced talents on Tokyo's contemporary graphic-design scene. A graduate, like a considerable number of Japan's leading visual artists and designers, of Musashino Fine Arts University, Okamoto over the years has produced his fair share of compact-disc packages, book covers, and book designs, as well as other kinds of publications. His magazine work is especially prolific and well-known, and it is in this area that his ideas have continued to find vivid, attractive form. Okamoto has served as art director for dozens of consumer magazines and for special-purpose periodicals issued as public relations vehicles for various corporations. Whatever their marketing or entertainment purposes, and whatever their audiences, Okamoto has brought a bold, eye-catching style to his covers and layouts, in which big images and headlines never fail to pull a reader into an article and its subject. His work displays a keen interest in and remarkable versatility with typography; whether he is toying with Japanese or Western letterforms, this architect of the printed page seems to have as much fun exploring the emotional-communicative power of text-and-image compositions as he does in invisibly guiding a reader's eyes through each new layout's multiple—and, in their own ways, hard-working—points of interest.

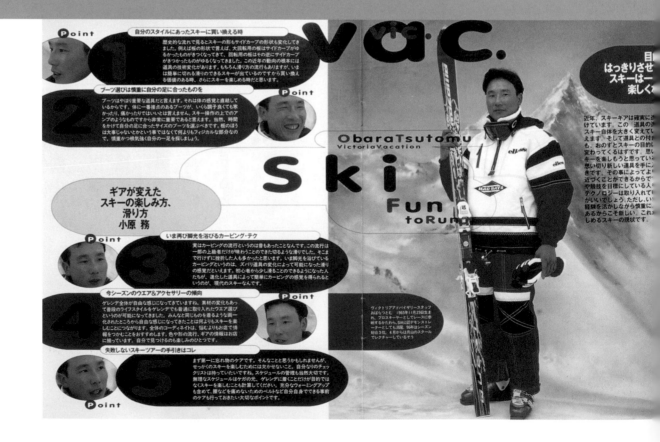

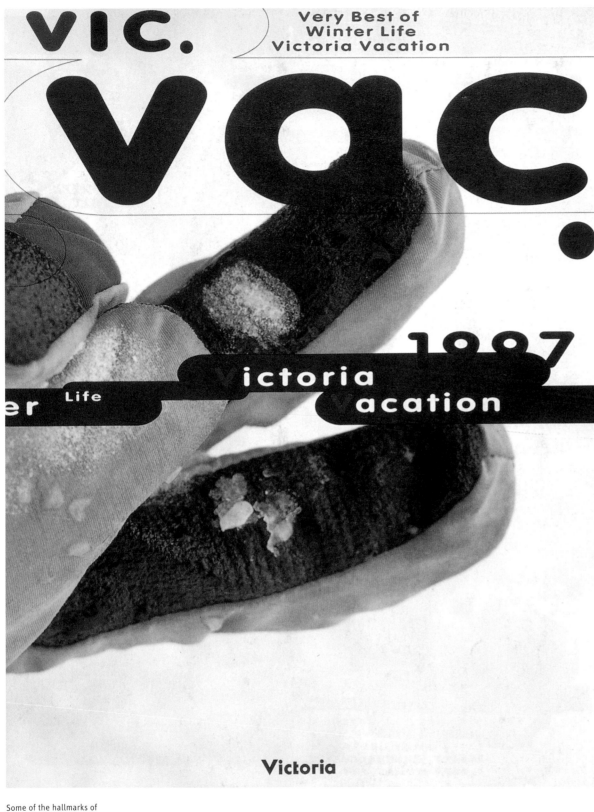

VIC.

Very Best of
Winter Life
Victoria Vacation

vac.

1997

Life

victoria
vacation

Victoria

Some of the hallmarks of
late-nineties techno design,
like free-floating hairlines and
bubble-shaped text blocks, pop
up in this pamphlet for Victoria
Travel's winter-vacation packages.
ART DIRECTOR: Issen Okamoto

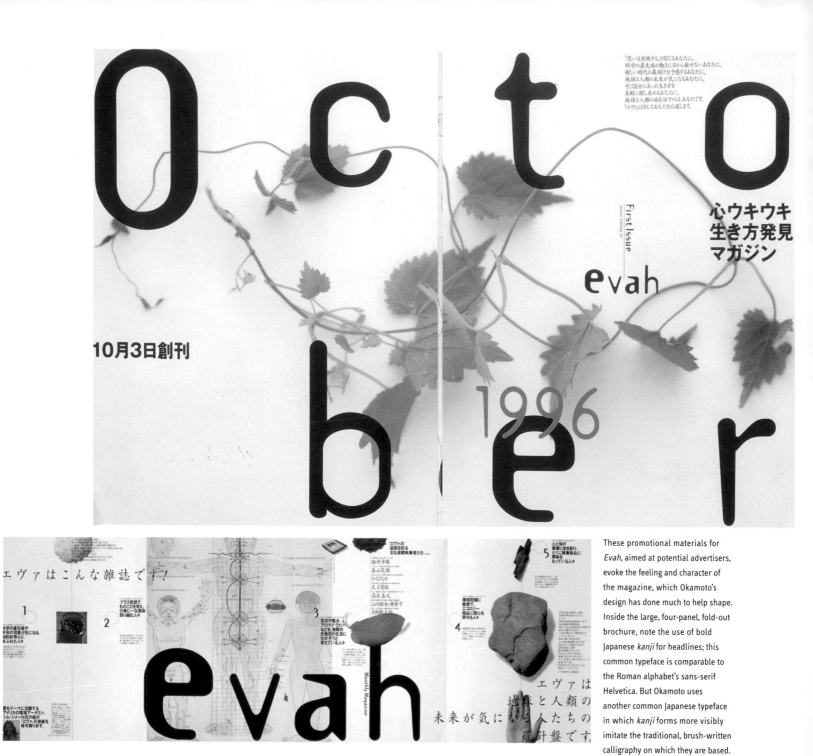

October 1996

evah

「思いは実現する」と信じるあなたに。
科学の最先端の動きに目が離せないあなたに。
新しい時代の幕開けを予感するあなたに。
地球と人類の未来が気になるあなたに。
そして自分にあった生き方を
真剣に探し求めるあなたに。
地球と人類の病を治すのは、あなたです。
「エヴァ」はそんなあなたを応援します。

心ウキウキ
生き方発見
マガジン

First Issue

10月3日創刊

エヴァはこんな雑誌です！

evah

These promotional materials for *Evah*, aimed at potential advertisers, evoke the feeling and character of the magazine, which Okamoto's design has done much to help shape. Inside the large, four-panel, fold-out brochure, note the use of bold Japanese *kanji* for headlines; this common typeface is comparable to the Roman alphabet's sans-serif Helvetica. But Okamoto uses another common Japanese typeface in which *kanji* forms more visibly imitate the traditional, brush-written calligraphy on which they are based. The use of the two kinds of typefaces in a layout like this one adds to its visual texture.

ART DIRECTOR: Issen Okamoto

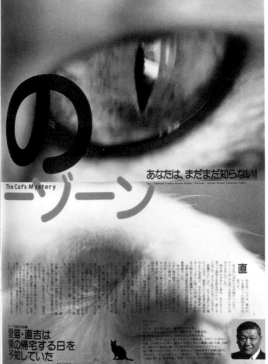

今から5000年も前、
古代エジプト時代から
人類の友として身近にいる猫。
でも、本当のところ、猫がどんな
生態なのかは、飼い主たちでさえ
よくわからないという。
また、それで魅力だという人も多い。
知られざる名猫の、不思議なお話を
たくさん集めました。

The Cat's Mystery

あなたは、まだまだ知らない！

猫の
ミステリーゾーン

愛猫・直吉は
僕の帰宅する日を
予知していた

Bold headlines and superb
photography, including many
detail-revealing close-ups,
pull readers into the pages
of *Evah*, a magazine about
health and healing. A two-page
spread from an article about the
varieties of Japanese green tea,
below, is typical of the clarity and
attractiveness that Okamoto's
touch brings to even a data-
packed, consumer-service piece.
ART DIRECTOR: Issen Okamoto

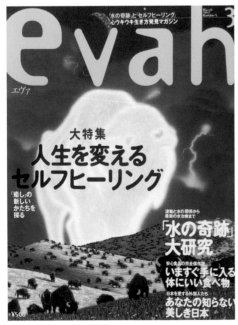

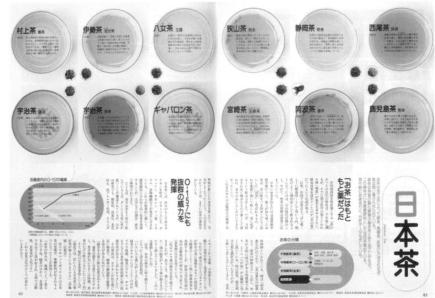

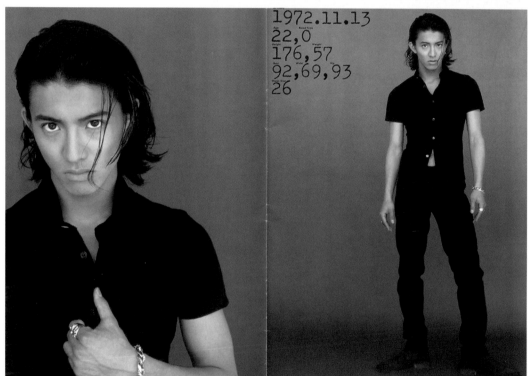

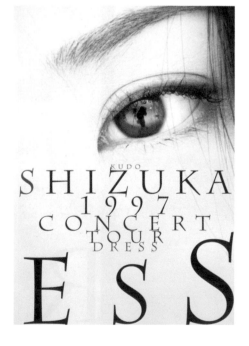

Okamoto has designed numerous concert-program booklets, like this large-format piece for singer Kudo Shizuka, and fanzines of various sizes, like *SMAP*, which celebrates, in pictures, Japan's so-called *tarento* teen-idol performers.

ART DIRECTOR: Issen Okamoto

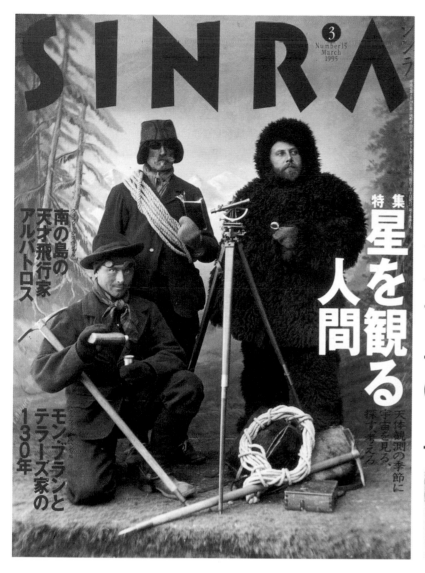

Sinra is a Japanese magazine about animals, nature, and the environment. Working with excellent photography from around the world, in its pages Okamoto creates layouts that set the tone for and capture the connoisseur-explorer's spirit of its long feature articles.

ART DIRECTOR: Issen Okamoto

Okamoto's layouts for *Spiritus*, a magazine about fine food and drink published by Suntory Ltd., Japan's beer and spirits giant, may cause readers to salivate—and to dream of the faraway places depicted and described in its alluring pages.

ART DIRECTOR: Issen Okamoto

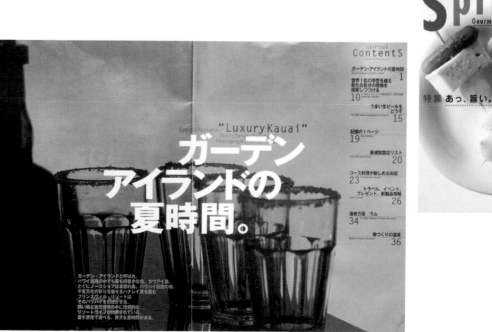

PRINCIPALS: Tomohiro Itami,
Yukio Abe, Shiho Notake,
Yukiko Nakai
FOUNDED: 1984
NUMBER OF EMPLOYEES: 3

204 Patio Harajuku
3-15-22 Jingumae
Shibuya-ku, Tokyo 150-0001
TEL (81) 3-3408-5753
FAX (81) 3-3408-7773

IT IS DESIGN CO.

Graphic designers in many places—or, more precisely, in many different marketplaces—often find themselves facing the challenge and the need of taking on a wide variety of assignments. Their subject matter may be diverse, as may be the purposes for which their skills and talents are applied. Like other designers in Tokyo, the undisputed capital of Japan's mass-media industries, It Is Design Co.'s Tomohiro Itami has turned his attention to the design of books and their jackets, posters for exhibitions and pop-music recordings, compact-disc packages, and much more. If no single signature style or look dominates his output, an accomplished versatility does: Itami conjures up conceptual art's meditative-aspirational moods in a poster for a Richard Long museum show as capably as he evokes a sense of snappy, outrageous fun in a bright CD cover for the Japanese pop band Ulfuls. In part, a generalist's broad perspective may be its own reward; for designers like Itami, each new project seems to offer fresh opportunities not to become creatively pinned down.

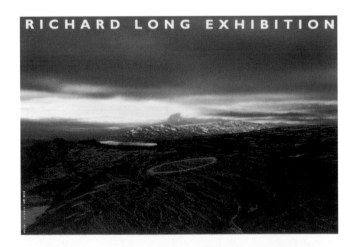

As graphic-design elements, little arrows set against a generous white background, and that empty space itself, help evoke the minimalist-conceptual mood of the wind-themed exhibition that this poster advertises for one of Tokyo's biggest contemporary-art museums.
ART DIRECTOR: Tomohiro Itami
PHOTOGRAPHY: Richard Long

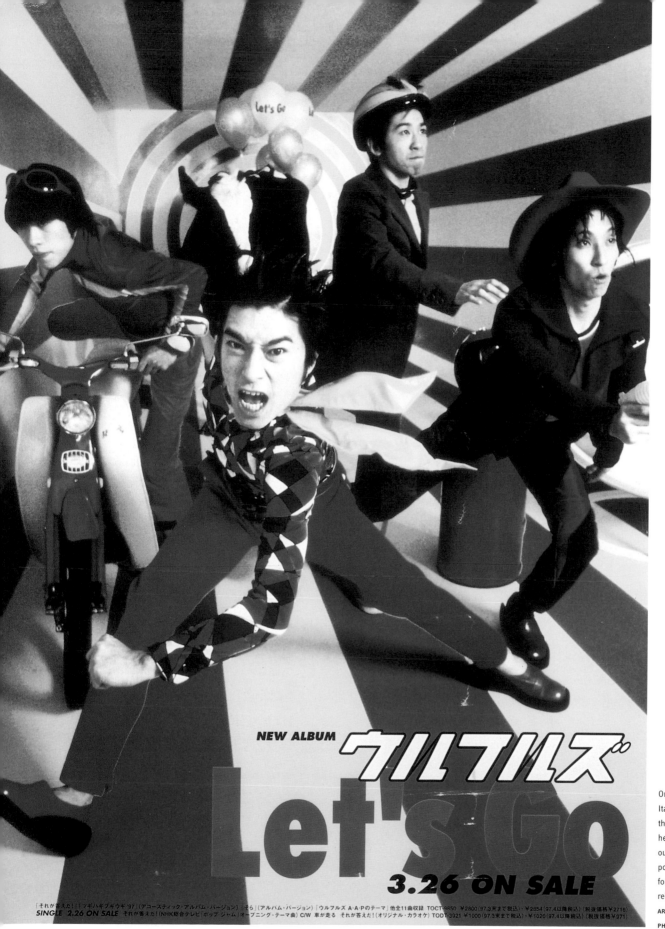

NEW ALBUM ウルフルズ
Let's Go
3.26 ON SALE

「それが答えた！」「ツギハギブギウギ'97」（アコースティック・アルバム・バージョン）「そら」（アルバム・バージョン）「ウルフルズ A・A・P のテーマ」他全11曲収録　TOCT-9850　¥2800（97.3末まで税込）・¥2854（97.4以降税込）（税抜価格¥2718）
SINGLE 2.26 ON SALE それが答えた！（NHK総合テレビ「ポップ ジャム」オープニング・テーマ曲）C/W 車が走る　それが答えた！（オリジナル・カラオケ）TODT-3921　¥1000（97.3末まで税込）・¥1020（97.4以降税込）（税抜価格¥971）

One dimension of Tomohiro Itami's work finds expression in the punchy, colorful styling that he employed to capture the outrageous fun of the Japanese pop band Ulfuls, as in this cover for one of its CD albums and a related promotional poster.
ART DIRECTOR: Tomohiro Itami
PHOTOGRAPHY: Takeo Ogiso

In this poster for an exhibition of ancient sculptures from a famous temple, with great subtlety, an overlapping and repeated main headline alludes to the sense of transcendent spiritual movement that Buddhist seekers, like the holy figures depicted in the mandala art shown, may strive for.

ART DIRECTOR: Tomohiro Itami

DE-GENDERISM

détruire dit-elle/il

LAND OF PARADOX
ランド・オブ・パラドックス

Yuji Saiga Naoya Hatakeyama Norio Kobayashi Toshio Yamane

Itami's book-cover design ranges
in scope from the understated glitz
of the embossed-foil dust jacket
of a collection of images by the
photographer Hiroshi Nonami
to the bright pink of a catalog for
an exhibition of postmodern
art, with its trademark-emulating
headline typography.

ART DIRECTOR: Tomohiro Itami

CHAOS
HIROSHI NONAMI

PRINCIPAL: Sachiko Kikuchi
FOUNDED: 1996
NUMBER OF EMPLOYEES: 2

1-42-16-2F Wada
Suginami-ku, Tokyo 166-0012
TEL (81) 3-3383-9732
FAX (81) 3-3383-9732

KAPUALANI GRAPHICS TOKYO

Relatively new Japan watchers may not be aware of just how close Japanese ties with Hawaii have become. A century-and-a-half ago, the first sponsored immigrants from Tokyo and Yokohama made their way to the cluster of islands Americans now call their Aloha State to work on sugar plantations. Today, people of Japanese ancestry and aspects of their heritage are well-integrated into Hawaiian society's ethnically diverse, multicultural mix. In more late-modern times, the Japan-Hawaii axis has served as a conduit of aesthetic ideas and style trends that have found expression in Tokyo as much as in Honolulu in fashion, music, and other areas of the pop-culture scene. The young designer Sachiko Kikuchi's Hawaiian-named Kapualani Graphics Tokyo studio taps into this rich cross-cultural vein in its work for record and book-publishing companies. With a simplicity at once reminiscent of travel posters and the feel-good vibe of early, unaffected, pop-music graphics, Kikuchi has created compact-disc covers and related promotional materials that celebrate the free-wheeling, Hawaiian paradise, escapist fantasy that plays so well among young, hard-working consumers in Japan's congested cities.

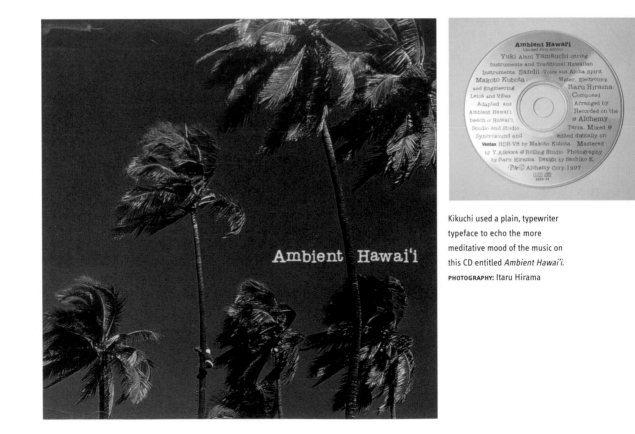

Kikuchi used a plain, typewriter typeface to echo the more meditative mood of the music on this CD entitled *Ambient Hawai'i*.
PHOTOGRAPHY: Itaru Hirama

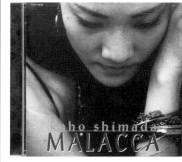

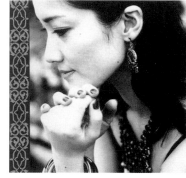

東芝ＥＭＩ移籍第一弾。アジア、ブラジル、地中海の風をたっぷりと。20世紀最後のディーヴァ誕生。プロデュース◆久保田麻琴

11 12 IN STORE
(TOCT-9979) ￥3,059(税込)

kaho shimada
MALACCA

TBS系「はなまるマーケット」エンディングテーマ曲"今日もいい天気"収録
CDシングル「今日もいい天気」(TODT-5098) **12・10発売**
TOSHIBA-EMI LIMITED

With its use of indigenous patterns, Kikuchi's CD-package design and related promotional materials evoke the exoticism of faraway places that is part of this recording's appeal.
PHOTOGRAPHY: Peter Lau

Ambient
Hawai'i
iteru hirana exhibition
平間至写真展

1997・6・12[木]−7・6[日] 会期中無休
10:00am−8:30pm（入場は8:00pmまで）
料金：一般500円　学生400円（中学生以下無料）
主催：パルコ　特別協賛：TOY'S FACTORY
協賛：TOWER RECORDS

会場：パルコギャラリー（渋谷パルコ パート1・8F）
会場デザイン：阪田信一（GAGA）　会場構成：JCT
サウンドプロデュース：久保田麻琴　協力：サンティー、山内雄喜
音響器材協力：Vestax　お問い合わせ：03-3477-5873

An opening reception for the artist will be held as follows.
We hope you will be able to attend.

Date:June 12th(thu) 6:30pm-8:30pm
Place:Parco Gallery(Shibuya Parco part1-8F)

※This card permits the entry of two during the exhibition of AMBIENT HAWAI'I

Ambient Hawai'i
平間至写真展

レセプション・パーティのご案内

展覧会のオープンを記念して作家を囲みレセプションを開催いたします。
皆様のご出席をお待ち申し上げております。

日時：6月12日（木）6:30pm−8:30pm
会場：パルコギャラリー（渋谷パルコ　パート1・8F）

＊会期中本状にて2枚様までご入場いただけます。

Parco, a popular department-store chain in Japan, is a major purveyor of style in fashion and, through its advertising and promotion, in design. Its branches also sponsor exhibitions, like this one of photographs of Hawaii by Itaru Hirama, for which Kikuchi created posters and invitations.

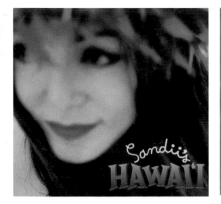
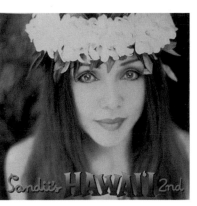
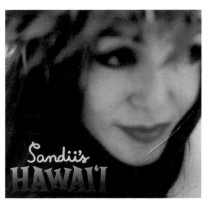

A type treatment that exudes a sense of the laid-back and casual carries the workload in these CD covers for a set called *Sandii's Hawai'i*.
PHOTOGRAPHY: Itaru Hirama.

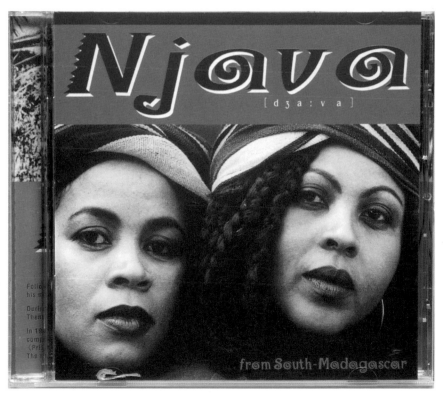

Through color and typography, Kikuchi continues to explore an ethnic-looking sensibility in this CD package for a group of musicians from Madagascar.
PHOTOGRAPHY: Paul Verstrecken

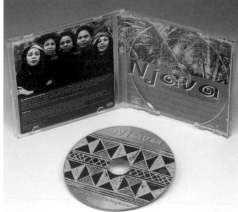

PRINCIPAL: Kenzo Izutani,
Aki Hirai
FOUNDED: 1987
NUMBER OF EMPLOYEES: 2

1-24-19 Fukasawa
Setagaya-ku, Tokyo 158-0081
TEL (81) 3-3701-7535
FAX (81) 3-3701-7536

KENZO IZUTANI OFFICE CORP.

For graphic designers, the poster's flat, two-dimensional, usually rectangular format presents its own familiar opportunities for—and challenges to—expression; its borders have long delimited an arena in which a designer's artistry has combined with sophisticated mass-communications techniques to deliver specific messages of persuasion or seduction. In Japan, despite the presence of huge billboards and advertising of all shapes and sizes, the poster still occupies a proud place in the visual environment and in many a graphic designer's portfolio. A range of expression can be seen in Kenzo Izutani's work for a wide variety of clients, from corporate giants like AT&T to the Japan Graphic Designers Association, for which he produced a series on an anti-war theme. Izutani's posters often feature a main, central element that anchors a composition. As in many Japanese advertising posters, type is used sparingly, which, in conjunction with a generous use of white or uncluttered background space, helps to evoke a reflective mood. Such works represent the antithesis of the hard sell, or of contemporary American, look-at-me-I'm-clever irony in advertising. Nevertheless, such works have tremendous impact on Japanese audiences, for whom the power of a single, gentle word or image to imply or suggest can be more forceful than a barrage of screaming, boldfaced headlines.

Izutani produced this series for the Peace and Environment Poster Exhibition of the Japan Graphic Designers Association (JAGDA) in 1995 on the occasion of the fiftieth anniversary of the atomic bombings at Hiroshima and Nagasaki.
ART DIRECTOR: Kenzo Izutani
DESIGNER: Aki Hirai
ILLUSTRATION: Kenzo Izutani
PHOTOGRAPHY:
Yasuyuki Amazutsumi

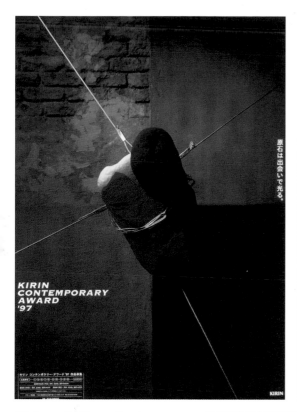

These posters were made for a JAGDA show on the theme of preserving the world's cultural patrimony.

ART DIRECTOR: Kenzo Izutani

DESIGNER: Aki Hirai

ILLUSTRATION: Kenzo Izutani

PHOTOGRAPHY:

Yasuyuki Amazutsumi

Kirin Brewery Co., Ltd., one of Japan's leading manufacturers of beers and spirits, sponsored a contemporary art award competition that these posters announced.

ART DIRECTOR: Kenzo Izutani

DESIGNER: Aki Hirai

OBJECTS: Jet's

PHOTOGRAPHY:

Yasuyuki Amazutsumi

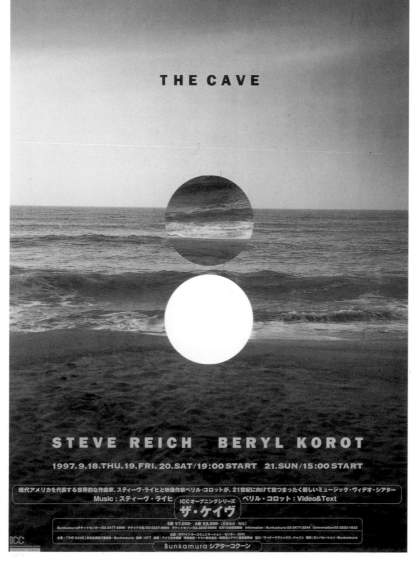

This poster for a concert by the composers-performers Steve Reich and Beryl Korot reflects their music's minimalist character.

ART DIRECTOR: Kenzo Izutani

DESIGNER: Aki Hirai

PHOTOGRAPHY:

Yasuyuki Amazutsumi

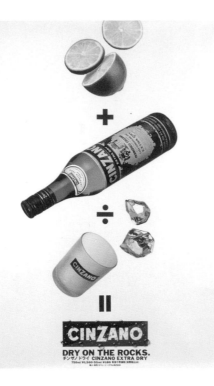

Izutani perfectly picks up the beat of classic European spirits advertising, complete with a clever visual pun, in this poster for Italian-made Cinzano.
ART DIRECTOR: Kenzo Izutani
DESIGNER: Aki Hirai
PHOTOGRAPHY:
Yasuyuki Amazutsumi

Exquisitely produced, with type printed in brilliant gold, these posters advertise a dramatic series on Japanese television.
ART DIRECTOR: Kenzo Izutani
DESIGNER: Aki Hirai
PHOTOGRAPHY: Toru Katoh

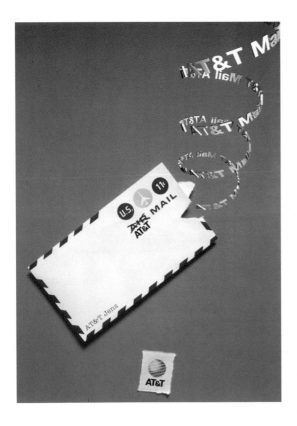

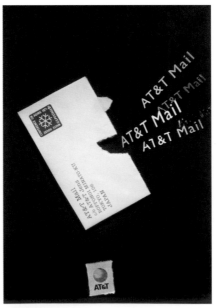

A main central element—a stamped envelope—anchors each of these compositions in a series of posters for an AT&T electronic-mail service. The swirling, curling messages flowing out of the torn-open envelopes are something of a visual pun, too.
ART DIRECTOR: Kenzo Izutani
DESIGNER: Aki Hirai
ILLUSTRATION: Kenzo Izutani
PHOTOGRAPHY:
Yasuyuki Amazutsumi

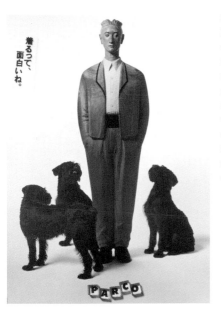

着るって、面白いね。

Izutani uses a wooden statue by the well-known Japanese contemporary sculptor Katsura Funakoshi in this convivial mood piece of an advertising poster for a sale on men's clothes at Parco, the hip fashion department store.

ART DIRECTOR: Kenzo Izutani
DESIGNER: Aki Hirai
PHOTOGRAPHY: Yasuyuki Amazutsumi, dogs; Takahito Ochiai, statue.

This poster for IBM computer systems in Japan features an unusually sad image. That's because it announces that "a lost file is very vexing," and proposes IBM products as a solution to the practical—and emotional—hardship that lost data can cause.

ART DIRECTOR: Kenzo Izutani
DESIGNER: Aki Hirai
ILLUSTRATION: Tadasu Nishii

PRINCIPALS: Toshiaki Uchikoshi,
Shinnoichi Yoshida, Yasushi
Yamaguchi, Ryo Asada,
Maiko Yoshino
FOUNDED: 1994
NUMBER OF EMPLOYEES: 4

1003, 15-1 Nanpeidai-cho
Shibuya-ku, Tokyo 150-0036
TEL (81) 3-5456-4044
FAX (81) 3-3770-9334

KING CAY LAB

The ornateness of certain forms and patterns in traditional Japanese and Chinese art; rock 'n' roll's attitudes and graphic-design styles; ancient Eastern brush painting; and the eye-popping psychedelia of the late sixties and early seventies—these are some of the influences that have motivated designer Toshiaki Uchikoshi. His portfolio is a smorgasbord of cleverly assimilated pop-design conventions with a uniquely Japanese gloss. Uchikoshi is as wild about rock music as his work is unsinkably vivacious; born in 1969, he did two years of business-management studies in England (he jokingly calls that experience his "first mistake") before returning to Japan to work in the music business (his self-confessed second). Abruptly, though, he quit and became a graphic designer's unpaid assistant, but was soon fired. That "third mistake" led the renegade Uchikoshi to set up his own King Cay Lab studio and dive headfirst into designing packaging and related materials for the music industry. He has created covers for countless record albums and compact discs, and is interested in typography. He has used his original display typeface called Uchifont, with its hook-like serifs, in his designs, and through his prolific, energetic output in the music and fashion fields, with its varied fine touches—sometimes techno-cool, sometimes calligraphic, sometimes new Asian psychedelic with dragons—Uchikoshi has concocted something of an East-West, techno-baroque signature style.

Contemporary graphic design in the pop-music field hungrily eats up and regurgitates its own recent past. Here, Uchikoshi expertly packages the mood and manners of the Japanese punk band Kuroyume (its name means black dream) in a now-familiar, punk-rock graphics style worthy of Iggy Pop, the Sex Pistols, or X-ray Spex.
ART DIRECTOR: Toshiaki Uchikoshi
PHOTOGRAPHY: Takeo Ogiso

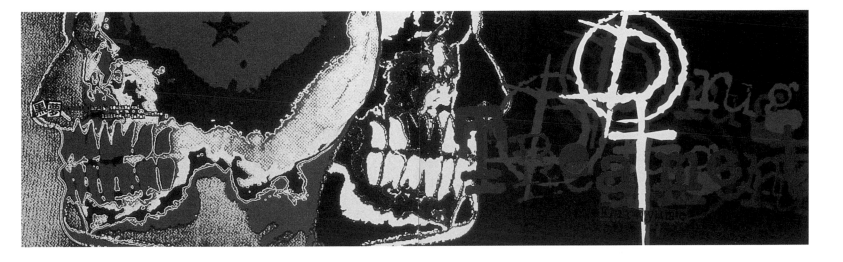

Uchikoshi taps into the ornate
elegance of traditional
Eastern art and iconography
in the graphics for this CD by
a Japanese hard-rock band.
ART DIRECTOR: Toshiaki Uchikoshi
PHOTOGRAPHY: Sumio Fukushima

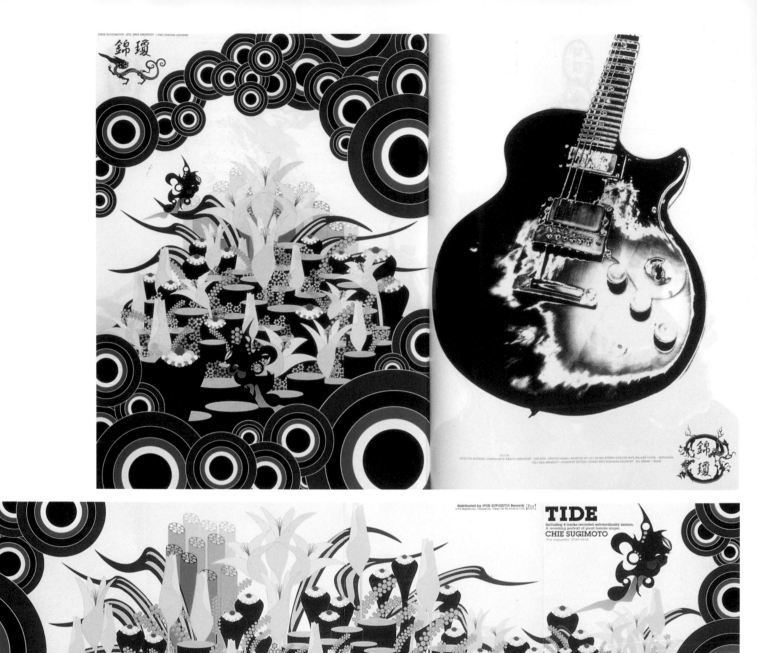

King Cay Lab's fold-out CD insert for an album by Chie Sugimoto bursts forth in a pop-psychedelic mode; Uchikoshi revisited this motif for a series of specially commissioned layouts highlighting his work in an issue of *Switch*, Japan's hip magazine of art and culture.

ART DIRECTOR: Toshiaki Uchikoshi

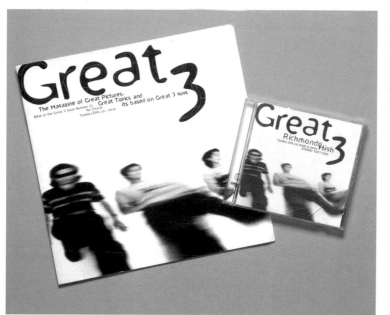

Uchikoshi created his own display type for use in the compact-disc artwork and related promotional booklet for the Japanese band Great 3's *Richmondo High* album.

ART DIRECTOR: Toshiaki Uchikoshi

PHOTOGRAPHY: Nicci Keller

The designer used his own Uchifont display typeface to spell out the band's name on this cover of a CD single by the band Great 3.

ART DIRECTOR: Toshiaki Uchikoshi

PHOTOGRAPHY: Nicci Keller

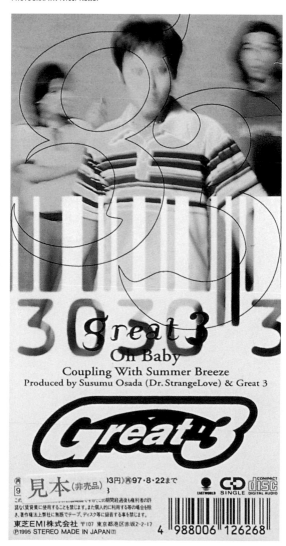

Uchikoshi brings his own inflections to the contemporary rock-music design vernacular, such as a hint of the baroque to his treatment of this Yukie CD-single cover, and a touch of pop whimsy for one by Great 3.

ART DIRECTOR: Toshiaki Uchikoshi

PHOTOGRAPHY: Kwaku Alston, *Yukie* CD; Nicci Keller, *Great 3* CD

Uchikoshi's knowing assimilation of vintage sixties and seventies graphic-design stylings offers both a send-up of and a certain reverence for its source material in these CD-single covers for various Japanese pop acts.

ART DIRECTOR: Toshiaki Uchikoshi

PHOTOGRAPHY: Nicci Keller

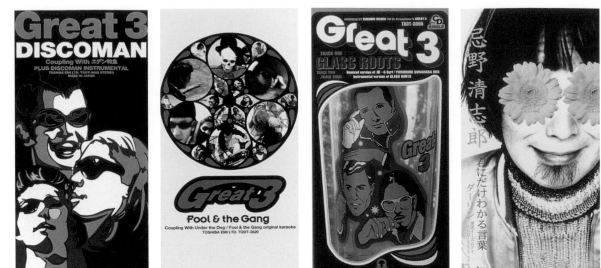

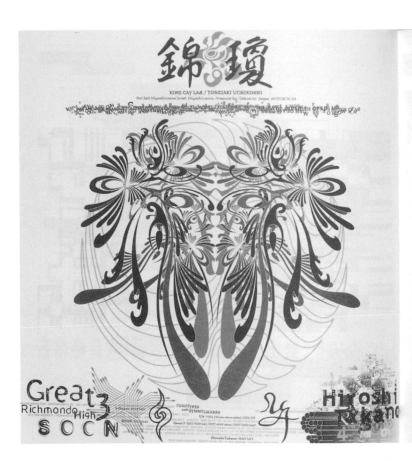

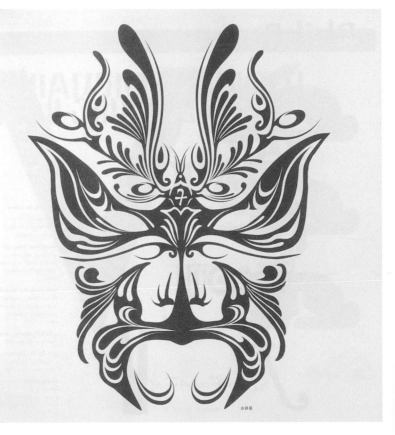

This design motif by Uchikoshi sums up what might be called King Cay Lab's signature style.

ART DIRECTOR: Toshiaki Uchikoshi

The Chang
ESCB1600 Epic / Sony Records
DAY OFF

(P)(C)1995 Sony Music Entertainment (Japan) Inc. Manufactured by Sony Music Entertainment (Japan) Inc. / ● is A Trademark of Sony Music Entertainment Inc. (xx)
WARNING: All Rights Reserved. Unauthorized duplication is a violation of applicable laws.

The spare cover design of this CD
by the Japanese band called The
Chang, with its high-contrast,
black-and-white photo, belies the
simple lushness of its insert
booklet, which also features loose,
card-like pages with song lyrics
and pictures of the musicians.

ART DIRECTOR: Toshiaki Uchikoshi

PHOTOGRAPHY: Nicci Keller

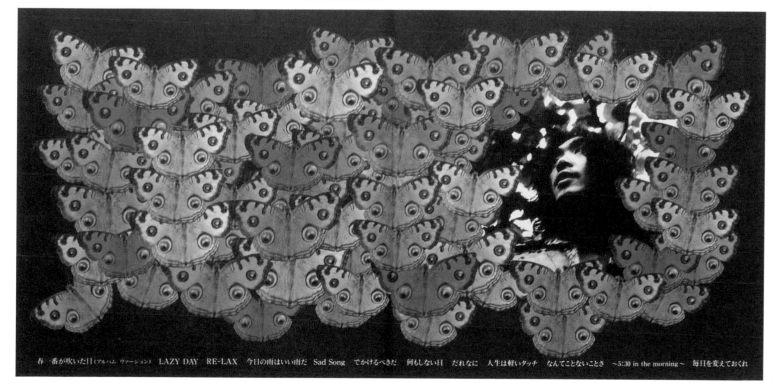

春 一番が吹いた日 (アルバム ヴァージョン)　LAZY DAY　RE-LAX　今日の雨はいい雨だ　Sad Song　でかけるべきだ　何もしない日　だれなに　人生は軽いタッチ　なんてことないことさ　〜5:30 in the morning〜　毎日を変えておくれ

The Chang
ESCB1600 Epic / Sony Records
DAY OFF

FOUNDED: 1956
NUMBER OF EMPLOYEES: 1,200

Asatsu, Inc.
16-12 Ginza 7-Chome
Chuo-ku, Tokyo 104-0061
TEL (81) 3-3547-2338
FAX (81) 3-3547-2392

YOICHI KOMATSU

To Western eyes unaccustomed to the diversity and conventions associated with the contemporary Japanese poster, some examples of the form may appear to contain elements whose purposes or usage may seem incongruous at best. In them, evoking a mood can be more important than making a direct pitch; illustration and even photography can be used abstractly. Sometimes an apparent incongruity may actually be a case of intended irony or irreverence, just as in much of the youth-oriented advertising of the late 1980s and the 1990s in America and Europe. (Think Benetton, MTV, and Guess! Jeans.) Yoichi Komatsu easily works in either mode, and sometimes in both at the same time, often by transforming the ordinary into something special. His series of posters for Cool Wool features lyrical, poetic, simple compositions that incorporate visual puns (Cool Wool logos become flowers or tree leaves). His full-page, color newspaper ads for Toshiba emphasize visual texture that emerges from imaginatively photographed, simple subjects, like a swarm of ants or a broken sheet of glass.

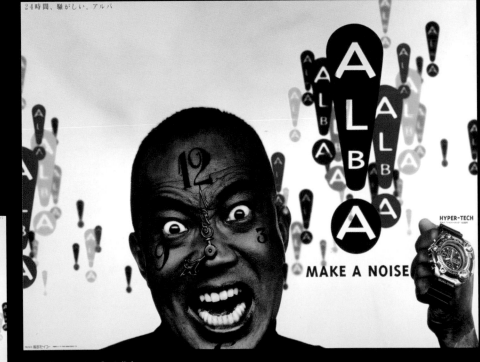

These vibrant posters for Seiko's Alba wristwatches explode with color and energy. Even the model's dark face, which becomes a clock in these images, set against crisp

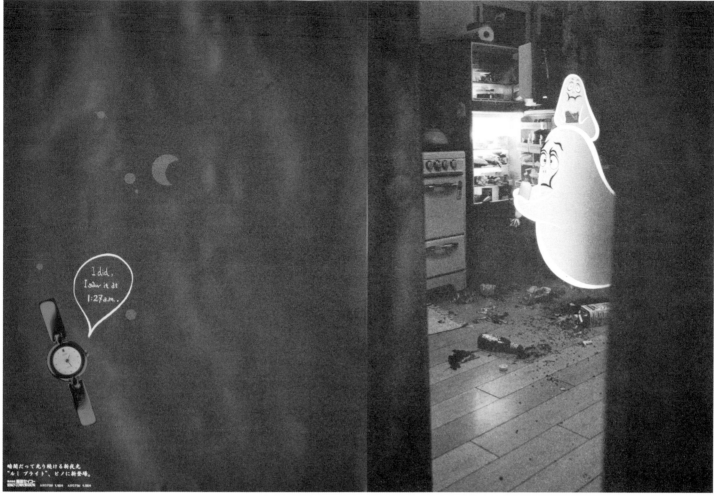

Komatsu's poster compositions often present quick, snapshot scenes from narratives, like these for Seiko Lumi-Brite glow-in-the-dark watches. Here, the timepieces witness mischievous ghosts at play in the wee hours of the morning.

ART DIRECTOR/DESIGNER: Yoichi Komatsu

CREATIVE DIRECTOR: Satoru Yokokawa

PHOTOGRAPHY: Yukihiko Uda

ILLUSTRATION: Yoichi Komatsu

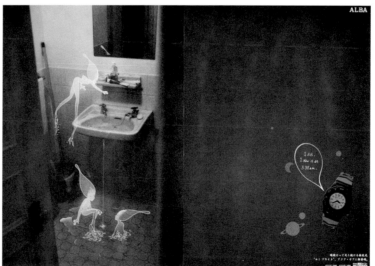

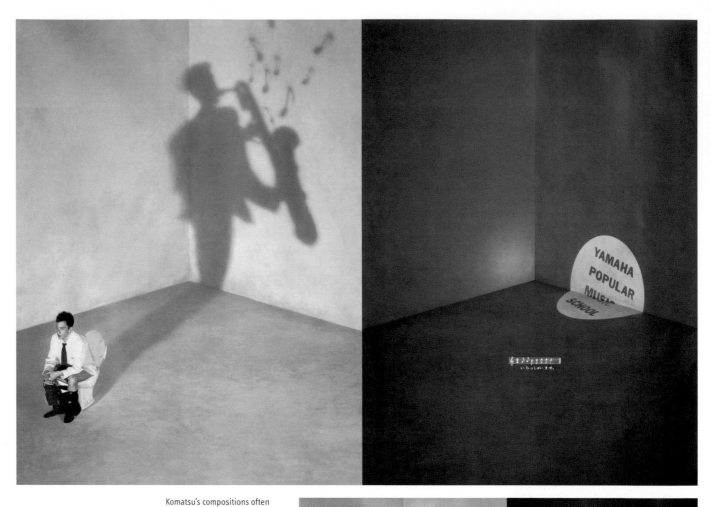

Komatsu's compositions often transform the ordinary into something special and visually arresting, as in these sensitive, imaginative posters for the Yamaha Popular Music School.

ART DIRECTOR/DESIGNER:
Yoichi Komatsu

CREATIVE DIRECTOR: Keiichi Murai

PHOTOGRAPHY: Akihito Kubota

These newspaper ads for Toshiba emphasize visual texture that emerges from imaginatively photographed, simple subjects, like a swarm of ants or a broken sheet of glass.

ART DIRECTOR/DESIGNER:
Yoichi Komatsu

CREATIVE DIRECTOR: Yasuo Fukuda

PHOTOGRAPHY: Yukihiko Uda,
Hiroki Shirakawa

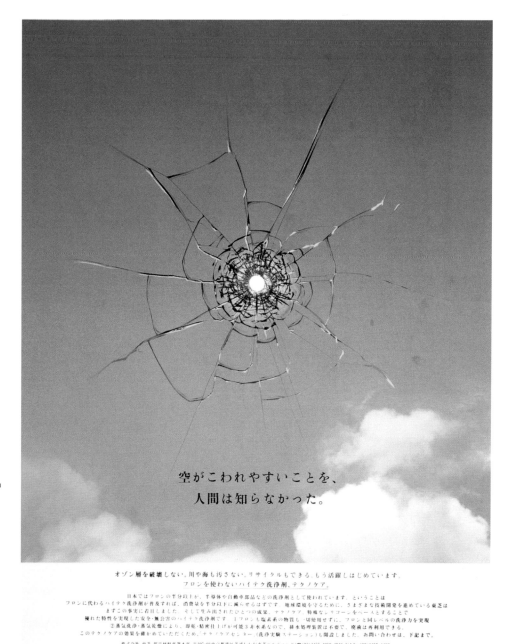

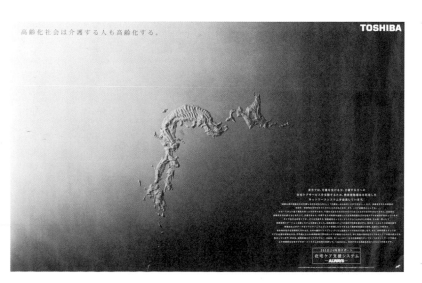

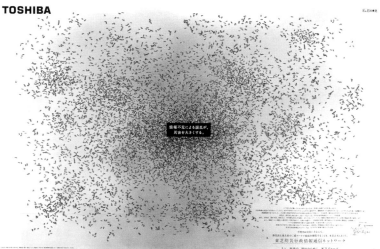

クールウールで、ずーっとウール。

COOL WOOL
NEW WOOL 100%

Komatsu's posters for Cool Wool feature lyrical, poetic, simple compositions that incorporate visual puns in which Cool Wool logos become flowers or tree leaves.

ART DIRECTOR/DESIGNER:
Yoichi Komatsu

CREATIVE DIRECTOR:
Nobukata Sasaki.

ILLUSTRATION: Keiko Hirano.

COOL WOOL

"We are Spoon Ager," these posters for Seiko's youth-targeted Spoon wristwatches declare in Japanese English.

ART DIRECTOR: Yoichi Komatsu

CREATIVE DIRECTOR: Satoru Yokokawa

DESIGNERS: Yoichi Komatsu, Tamon Saito

PHOTOGRAPHY: Takashi Honma, Robert Rosenheck

OBJECTS: Yoichi Komatsu, Jun Watanabe

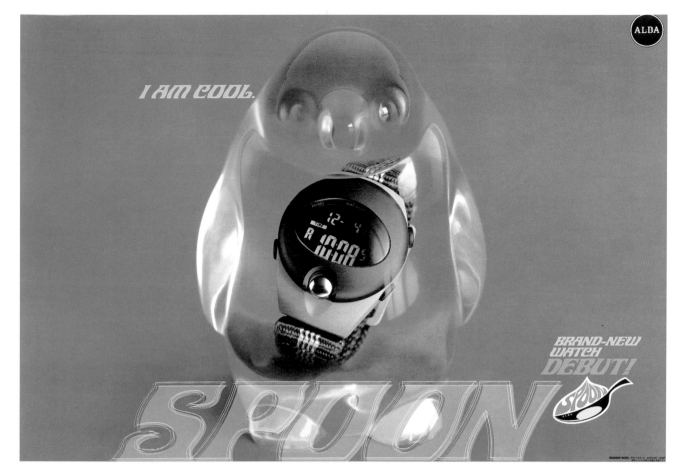

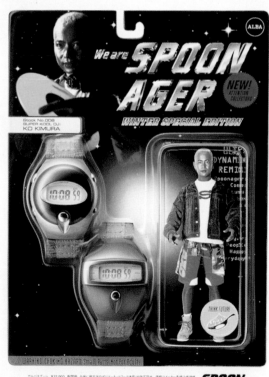

PRINCIPAL: Madoka Iwabuchi
FOUNDED: 1996
NUMBER OF EMPLOYEES: 2

Jinnan R 5F
1-3-10 Jinnan
Shibuya-ku, Tokyo 150-0042
TEL (81) 3-3462-4672
FAX (81) 3-3462-4673

MADOKA IWABUCHI

Madoka Iwabuchi, a young designer from northern Japan, graduated from Tokyo Zokei University in 1989 and soon thereafter firmly established herself in the world of magazine art direction. She designed for *Marie Claire Japon*, the Japanese edition of the French fashion monthly, but made her mark creating distinctive layouts for such hip, music-and-style magazines as *Studio Voice*, *SiFT*, *Skool of Edge*, and *Switch*. There, her work has blended a classically modern approach to the page as a staging area in which graphic elements are harmoniously arranged, and in which white space figures prominently, with a clever, postmodern point of view, in which the designed page self-consciously regards itself. Thus, some Iwabuchi layouts include clearly visible color bars and crop marks; others are, in effect, "pictures" of kinds of pages, such as those from notebooks or vaguely official-looking dossiers. Iwabuchi describes her generation of graphic designers as caught between Fabian Baron's "perfectionism" and David Carson's "intentionally immature" style. Her own sensibility is at once inquisitive, inventive, and neat. Her designs are well-poised—with an edge.

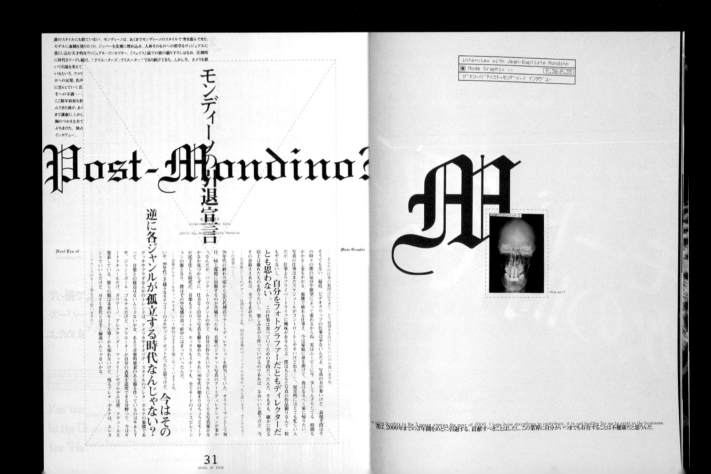

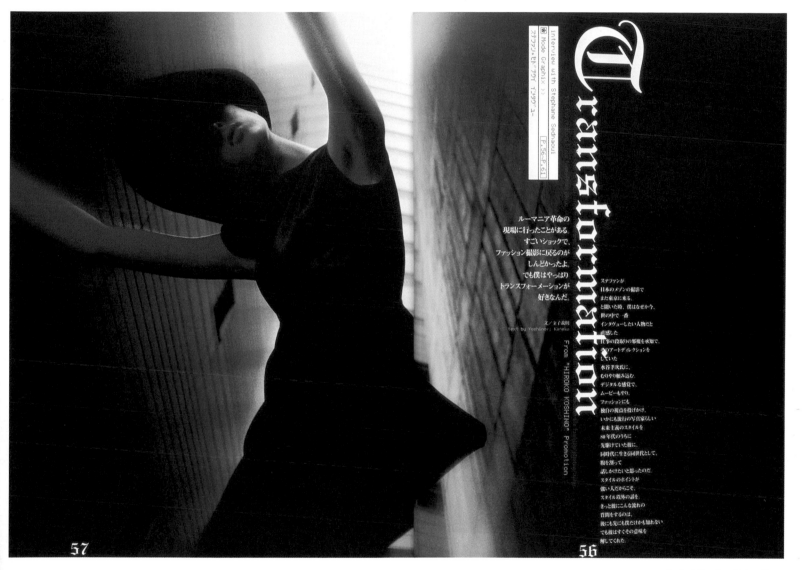

Iwabuchi has found interesting ways to give antique typography new allure in unusual fashion layouts for *Skool of Edge*, a companion magazine to the Tokyo-oriented *Studio Voice*. Here, she mixes dramatic Gothic, conventional Japanese and dot-matrix computer characters.

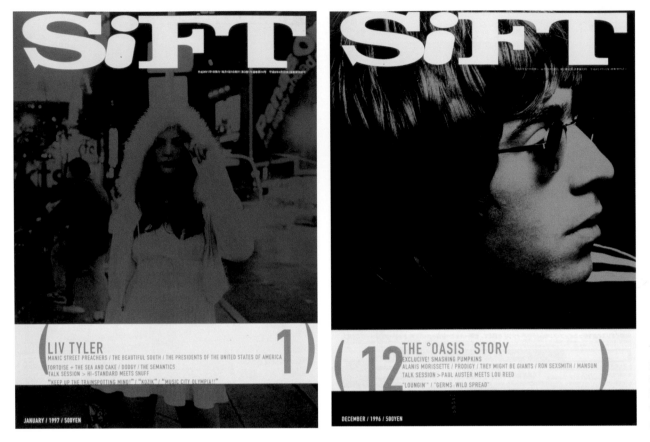

SiFT

(LIV TYLER
MANIC STREET PREACHERS / THE BEAUTIFUL SOUTH / THE PRESIDENTS OF THE UNITED STATES OF AMERICA
TORTOISE + THE SEA AND CAKE / DODGY / THE SEMANTICS
TALK SESSION > HI-STANDARD MEETS SNUFF
"KEEP UP THE TRAINSPOTTING MIND!" / "KOZIK" / "MUSIC CITY OLYMPIA!!"
1)

JANUARY / 1997 / 500YEN

SiFT

(12 THE °OASIS STORY
EXCLUCIVE! SMASHING PUMPKINS
ALANIS MORISSETTE / PRODIGY / THEY MIGHT BE GIANTS / RON SEXSMITH / MANSUN
TALK SESSION > PAUL AUSTER MEETS LOU REED
"LOUNGIN" / "GERMS : WILD SPREAD"
)

DECEMBER / 1996 / 500YEN

Tinted, monochromatic photo portraits and a memo-like contents listing are the key ingredients of Iwabuchi's covers for *SiFT*, a pop-music monthly published by Rittor Music, Inc.

MANIC STREET PREACHERS'
USA SECOND VISIT! マニック・ストリート・プリーチャーズ

NY TOUR JOURNAL
文＝撮影／伊藤和史　TEXT ＆ PICTURE : KAZY ITON

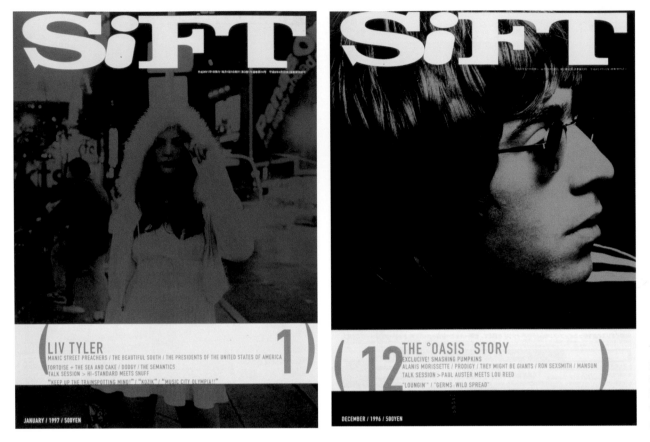

In a layout for *Big Magazine*, an article title's, "Big in Tokyo," is repeated within the forms of the dot-matrix, computer-printed *kanji*, or characters, that spell the city name Tokyo.

PHOTOGRAPHY: Hiromix

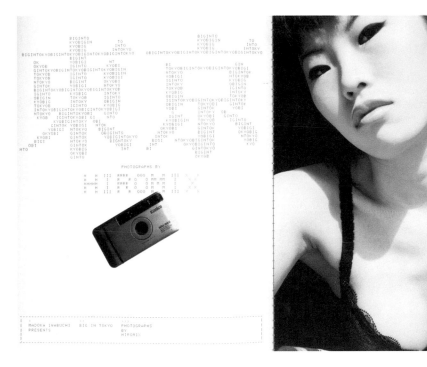

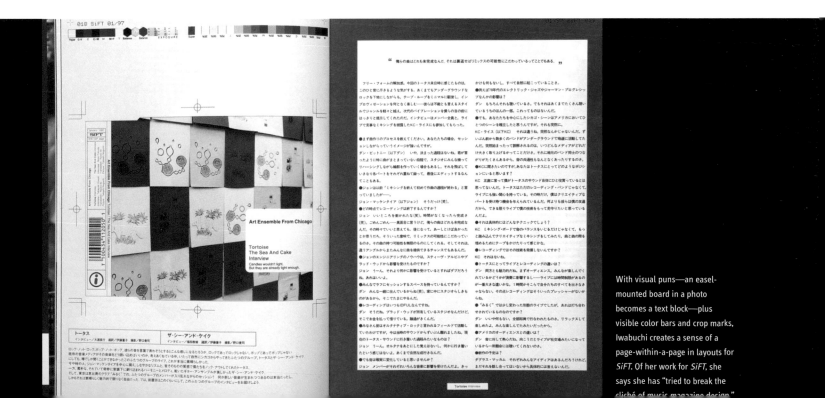

With visual puns—an easel-mounted board in a photo becomes a text block—plus visible color bars and crop marks, Iwabuchi creates a sense of a page-within-a-page in layouts for *SiFT*. Of her work for *SiFT*, she says she has "tried to break the cliché of music magazine design."

In a spread in *Switch* highlighting guitars, capacious white space surrounding silhouetted photos of the instruments helps reinforce their value as rock 'n' roll icons.

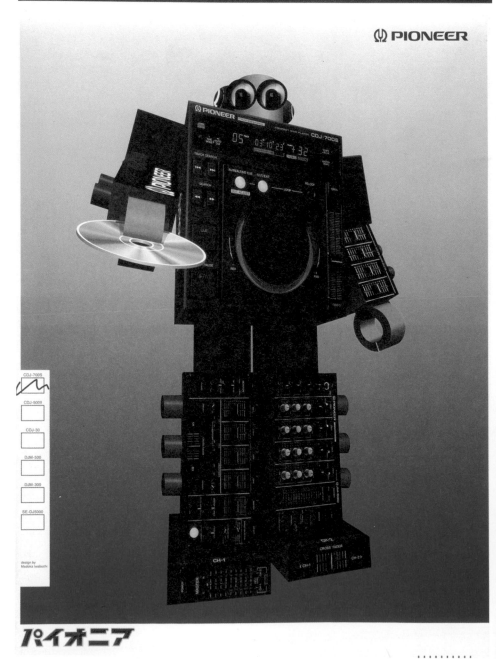

Created with Daisuke Hirotaki, this advertisement for Pioneer's *Visual Dictionary* delivers its message with high-tech whimsy.

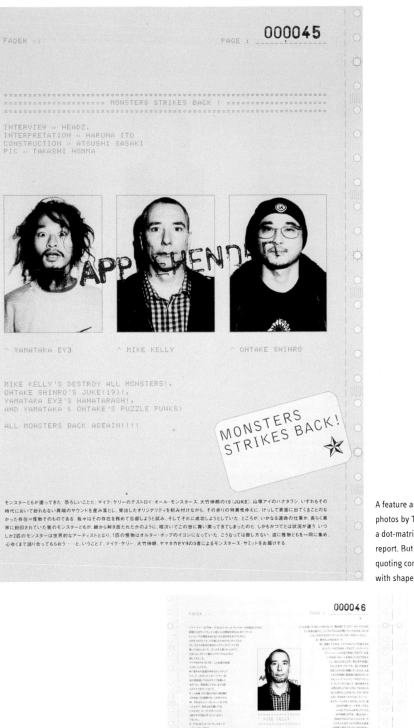

A feature article in *Fader*, with photos by Takashi Homma, resembles a dot-matrix, computer-printed police report. But even within this format-quoting context, the designer has fun with shaped, wrap-around text.

PRINCIPAL: Makoto Orisaki
FOUNDED: 1991
NUMBER OF EMPLOYEES: 1

2-6-18 Jingumae 3F
Shibuya-ku, Tokyo 150-0001
TEL (81) 3-3470-0246
FAX (81) 3-3470-0246

MAKOTO ORISAKI DESIGN

Makoto Orisaki believes that designers and their creations should take and express what he calls a "responsible position towards society." For Orisaki, in practice, this means finding ways to design economically with and for materials that are by-products or cast-offs of manufacturing processes, or to find ways to design that effectively help recycle these same, otherwise overlooked resources. In his own work for E&Y, a Japanese retailer of high-end, designer-label furniture, Orisaki has created promotional pieces to announce special sales and new merchandise—posters, cards, direct-mail items—that have been printed on such unconventional materials as rough, unbleached cardboard, or on a paper coated on one side by a thin layer of blue-colored foam. Orisaki's sensitivity to industrial techniques may be rooted in his high school and college focus, before turning to design, on electronics. After studying at the Kuwazawa Institute of Design, he worked with Yukimasa Okumura at the Studio Tokyo Japan, then went out on his own in 1991. Orisaki has worked in the fields of graphic, packaging, industrial, and interior design; he has also expressed his ideas through the fine arts, where his concept-exploring creations have investigated both the nature of perception and human responses to the designed environment.

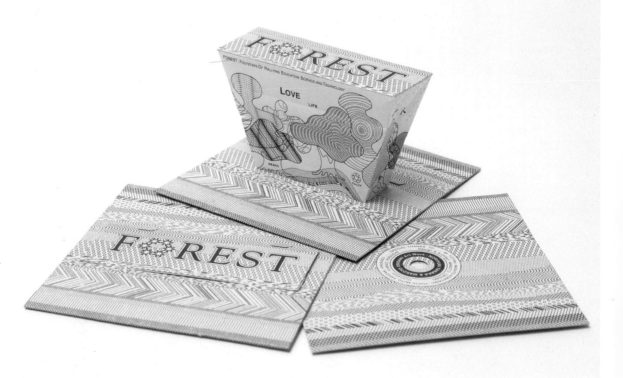

This unusual pop-up card-sculpture, with an environment-friendly message, was created for Tokyo's Science Museum. It is inflated when a user blows into the hole on its back side.
ART DIRECTOR: Makoto Orisaki
CREATIVE DIRECTOR, LOGO DESIGN: Noriyuki Tanaka
ILLUSTRATION: Yumiko Noguchi

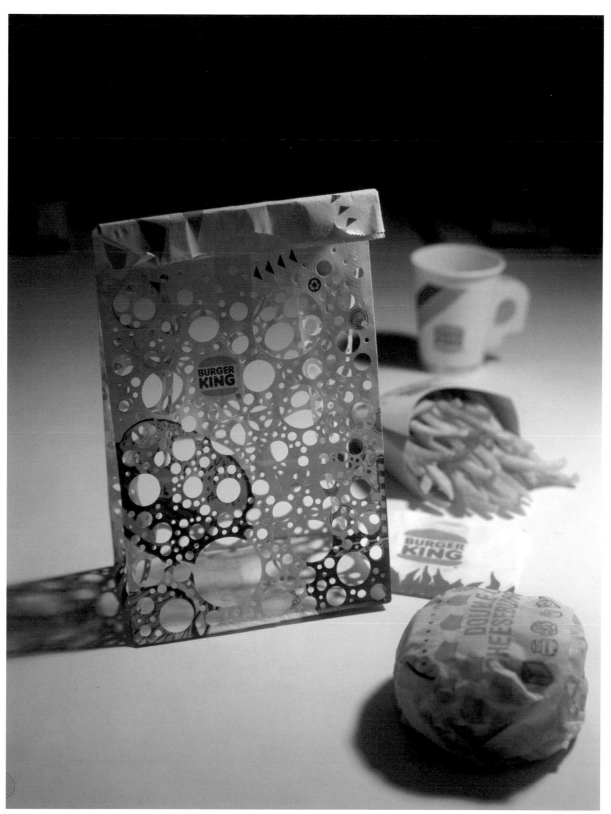

"Holes represent the light, a device that reveals the essentials," Orisaki says. In what serious postmodernists might call an illuminating deconstructionist exercise, but which the young designer pursues much less self-consciously in his fine-arts mode, he has literally punched holes in the packaging designs of fast-food giants McDonald's and Burger King as a way of calling attention to their relative, comparative aesthetic merits—or faults. Orisaki calls the McDonald's color scheme "rough" and says that it may have a "bad effect" on children; Burger King's, he notes, makes "people feel something with good design." A consideration of how popular fast food is presented, the artist-designer suggests, has ramifications that "involve the food culture as a whole."

ART DIRECTOR: Makoto Orisaki

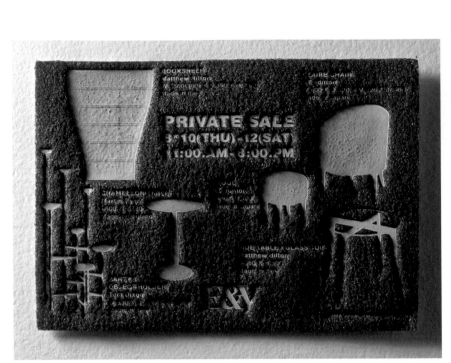

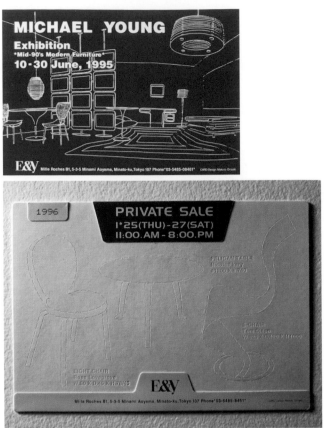

"I covertly put my message into the world," Orisaki says of his designs made using recycled materials, such as rough cardboard or a foam-coated stock, as in these sales-promotion postcards for Japan's E&Y furniture store.

ART DIRECTOR: Makoto Orisaki

ILLUSTRATION, MICHAEL YOUNG CARD: Michael Young

For E&Y, a Japanese retailer of designer-label furniture, Orisaki created a direct-mail piece that unfolds to become a poster. With its many images of different kinds of furnishings, the poster serves as a catalog of the Italian-made Cappellini line that E&Y represents. Orisaki intentionally chose a rough-grade paper on which to print, and also incorporated into the design a detachable invitation to the gallery-store's opening of its Cappellini show printed on rough cardboard. Attached to the poster, a hole-punched tab allows the folded piece to be neatly stored in standard binders for later reference.

ART DIRECTOR: Makoto Orisaki

PHOTOGRAPHY ASSISTANT/ COLLABORATOR: Kuni Shinohara

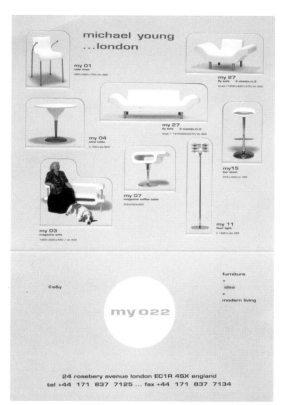

For a one-piece catalog of a new
collection of the English furniture
designer Michael Young's work,
Orisaki, in conjunction with E&Y's
Yoichi Nakamuta, devised this
folding card with pop-outs. One
side of the card shows photos
of Young's furniture designs.
The other is imprinted with a
line drawing of a typical,
traditional, high-ceilinged
European salon. When folded,
with the photo-miniatures of
the furnishings popped out, the
piece gives a prospective
customer a doll's-house
impression of how the sofas,
tables, and lamps might look
in an actual room.

ART DIRECTOR: Makoto Orisaki
CREATIVE DIRECTOR:
Yoichi Nakamuta
ILLUSTRATION: Philip Hooper

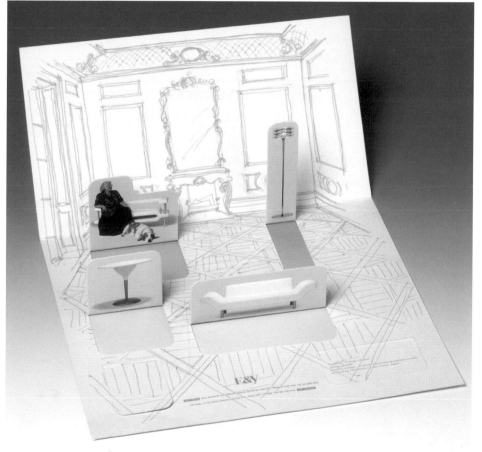

PRINCIPALS: Junichi Tsunoda,
Junko Tanaka, Keita Ishiguro
FOUNDED: 1991
NUMBER OF EMPLOYEES: 3

A-907 Megurodai Mansion
1-1-16 Meguro
Meguro-ku, Tokyo 153-0063
TEL (81) 3-5496-7415
FAX (81) 3-5436-6055

MANAS, INC.

Over the years, the sounds, attitudes, fashions, and supporting visual vocabulary of rock 'n' roll-fueled youth culture have solidified their unshakable grip on much of the advertising, entertainment products, and other outpourings of the world's imagefactories. So, too, have those forces powerfully influenced the design techniques and approaches that have given those media creations their familiar, meaningful, and distinctive—or not-so-distinctive, even repetitive—looks. In much of his work, Junichi Tsunoda of Manas, Inc. demonstrates with relative ease and dexterity an understanding of and fluency in the now-reigning international pop vernacular of graphics for music, fashion, and entertainment products and services. His cover for a book of photographs by Richard Prince aptly employs this visual language in a way that captures the wildcat spirit of this provocative, sometimes cheeky artist. His CD covers for albums of experimental or rock-instrumental or ambient-dance, trip-hop music make use of the graphic-design conventions that have become associated with these genres, such as fractured or elaborated typefaces, graffiti-like tags, and band-name logos. Tsunoda's covers and related advertising posters for a pop magazine called *Barfout!* feature a logo or icon element in the upper right-hand corner of each issue.

Like many young Japanese designers who feel at home working in the now global visual vernacular associated with pop music, fashion, and entertainment products, Junichi Tsunoda makes use of graphic-design conventions that have become associated with such contemporary, urban musical genres as ambient-dance and trip-hop.

ART DIRECTOR/DESIGNER:
Junichi Tsunoda
CO-DESIGNER, *NATURAL SONIC 2* AND
JUNGLIST: Junko Tanaka
TITLE LOGO DESIGN, *JUNGLIST*:
Tomoo Gokita
PHOTOGRAPHY, *CHEROKEE'S LOUNGE*:
Kyoji Takahashi

Printed cardboard replaces the usual plastic jewel box as a package for this compact disc by a Japanese singer, Kiyoshiro Imawano. In looks, proportion, and feel, if not exactly in scale, it both evokes and emulates fold-out, rock-music LP covers of yesteryear. The full-color label printed on the compact disc itself reprises motifs from the brushy front-cover artwork by Tomoo Gokita.

ART DIRECTOR/DESIGNER: Junichi Tsunoda

CO-DESIGNER: Junko Tanaka

PHOTOGRAPHY: Katsumi Omori

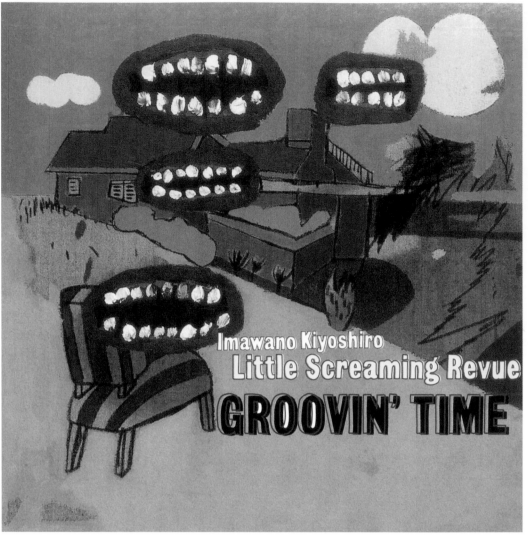

Tsunoda's front and back covers of a book by Richard Prince capture the wildcat spirit of the photographs inside it and of the provocative artist who made them.

ART DIRECTOR/DESIGNER: Junichi Tsunoda

PHOTOGRAPHY: Richard Prince

Tsunoda's advertising sheets for a pop magazine called *Barfout!* feature poster-size blow-ups of each issue's front cover, which he designs. A logo or icon element appears in the upper right-hand corner of each issue's cover.

ART DIRECTOR/DESIGNER:
Junichi Tsunoda

PAINTING: Tomoo Gokita

PHOTOGRAPHY: Yoshiko Seino

Magazine for Cool Resistants of The World APRIL 1998 VOL.032

In this poster, a boxed-in, centrally placed headline acts something like a big logo. It counterbalances the strong vertical thrust of the figure in the photograph in this large-format piece for the Monsieur Nicole line of men's clothes.

ART DIRECTOR/DESIGNER:
Junichi Tsunoda

PHOTOGRAPHY: Shingo Wakagi

MONSIEUR NICOLE by YUKIO KOBAYASHI
FALL&WINTER 1997

PRINCIPALS: Gento Matsumoto,
Kei Kasai, Kaname Sakuma,
Masaaki Uchino, Taro Enomoto
FOUNDED: 1990
NUMBER OF EMPLOYEES: 6

Saru Brunei Co., Ltd.
2-21-3 Shoto
Shibuya-ku, Tokyo 150-0046
TEL (81) 3-5790-5312
FAX (81) 3-5790-0012

GENTO MATSUMOTO

For poststructuralists reared on the "pleasures of the text," everything the mass media and popular culture produce—TV shows, pop songs, commercials and advertising posters, fashion, and slang—can be considered "texts" loaded with multi-layered meanings. All of it is grist for the critical mill, and for the analytically inclined, Japan's highly visual, form-conscious (in every sense) environment provides a constant supply of fascinating material. But foreign viewers, beware: In this cacophonous visual culture, where design finds so many different forms of expression, looks can be deceiving. Designer Gento Matsumoto's Turbine-brand bags for Sanyo Shokai, for example, are decorated with obscurely iconographic images; in fact, they're meant to be filled with

trash. For Tokyo's Saru Brunei Co., Ltd., Matsumoto has created posters and packaging. A sense of exploring established forms or visual vocabularies is evident in his work, as in his photo-adorned, self-consciously rectangular Kleenex box, or in his poster that revisits the now-classic movie *2001: A Space Odyssey* (1968). Here, the use of a space-age retro, starry background, despite the inclusion of an image of a spaceship from the film, effectively helps resituate this ground-breaking motion picture in the broader, more ordinary genre of sci-fi space fantasies. Matsumoto's work is notably varied; in each piece, he seems to search for something new.

Matsumoto's poster for a re-release of *2001: A Space Odyssey* gives this forward-looking science-fiction classic a retro feeling.
ART DIRECTOR/DESIGNER:
Gento Matsumoto
PRODUCER: Masayuki Kawakatsu

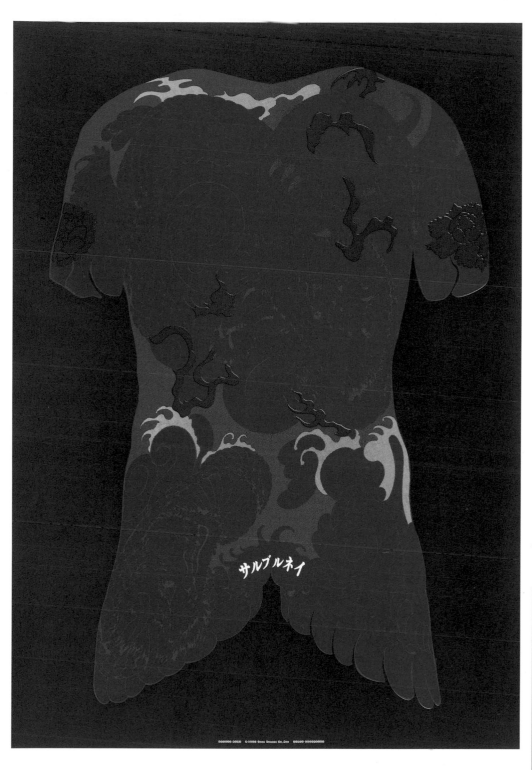

Posters for Japan's artist entries
at the 1995 São Paulo Biennial
feature updated traditional carp
and dragon motifs.
ART DIRECTOR/DESIGNER: Gento
Matsumoto
PRODUCER: Takako Terunuma

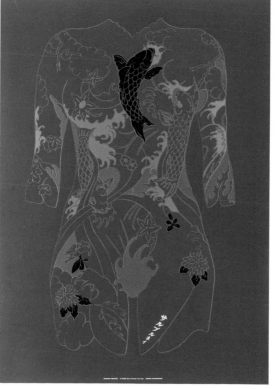

The graphics for a poster
promoting *M.O.P.*, a magazine
that Matsumoto oversees and
designs, are inspired by the
form of a pinball machine.
ART DIRECTOR: Gento Matsumoto
DESIGNERS: Gento Matsumoto,
Hikaru Koike
CONCEPT: Yoshiki Sumikura,
Masato Samata

A package for a CD-ROM whose
screenplay Matsumoto wrote
and whose character design he
created, uses an orientation
map in its cover art.
ART DIRECTORS: Gento Matsumoto,
Hikaru Koike
PRODUCER: Naomi Enami

Matsumoto designed a playful package for this CD-ROM that he wrote and created in collaboration with other artists. Note the package's outer wrapper, an element that often appears on books and similar materials published and marketed in Japan.

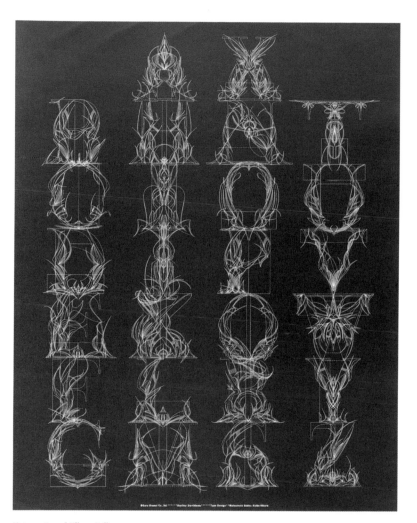

Matsumoto and Hikaru Koike created this poster to promote Harley Davidson, a typeface they designed that was inspired by the legendary motorcycles of the same name.

Matsumoto's photo-adorned Kleenex box calls clever attention to the otherwise mundane, rectangular shape of the package itself.

ART DIRECTOR/DESIGNER: Gento Matsumoto
PHOTOGRAPHY: Youichi Inoue

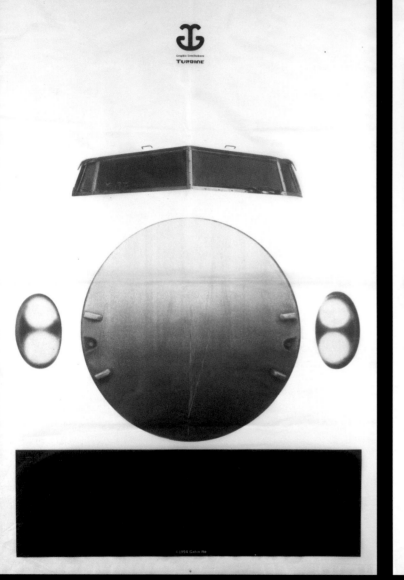

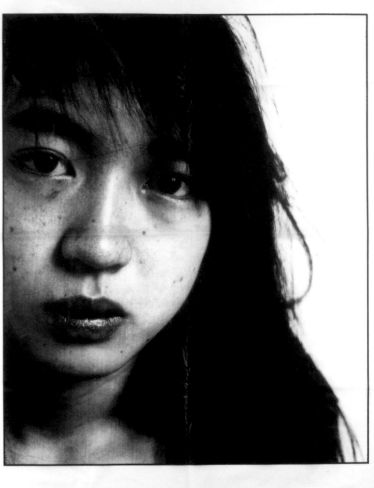

Intriguing, somewhat obscurely
iconographic images decorate
these Turbine-brand bags,
which are actually meant to
be filled with garbage.

Graphic Gemütlichere
TURBINE

PRINCIPALS: Michimasa Itaya
(Mic*Itaya), Noriyuki Yokota,
Satomi Kume
FOUNDED: 1988
NUMBER OF EMPLOYEES: 7

Power of Beauty Co., Ltd.
4-41-18 Kamimeguro
Meguro-ku, Tokyo 153-0051
TEL (81) 3-3712-8521
FAX (81) 3-3712-8523

MIC*ITAYA

Never underestimate the resonant impact of the human touch, even in—perhaps especially in—the field of cutting-edge contemporary graphic design, where the evermore influential and ubiquitous computer, the designer's most powerful tool, now does just about everything short of negotiating with clients over fees. In Japan today, as this book amply demonstrates, many a designer is inescapably connected, both electronically and culturally, to a worldwide pop sensibility that in some ways may inform his or her creative approach and vision. Nevertheless, in this environment there is still accommodating room for a visual poet like Michimasa Itaya—who goes by the moniker Mic*Itaya—and his charming, lyrical, sophisticated style. To find its affinities, think of the classic modern line drawings of Picasso, Matisse, and Jean Cocteau, and of Alexander Calder's playful, high-spirited wire sculptures. Suns, moons, stars, angels, flowers, and bodies—ever-present variations of the human form—are the stuff of Mic*Itaya's recognizable visual vocabulary. In *Star Castle*, a handsome, hardbound volume in the modern Japanese tradition of the published artist's or designer's notebook, he gathers a rich collection of drawings and collages that bears witness to a lively imagination; its freshness and vitality have found expression in posters, book covers, typefaces, and product designs, such as wall clocks with bright, decorated faces.

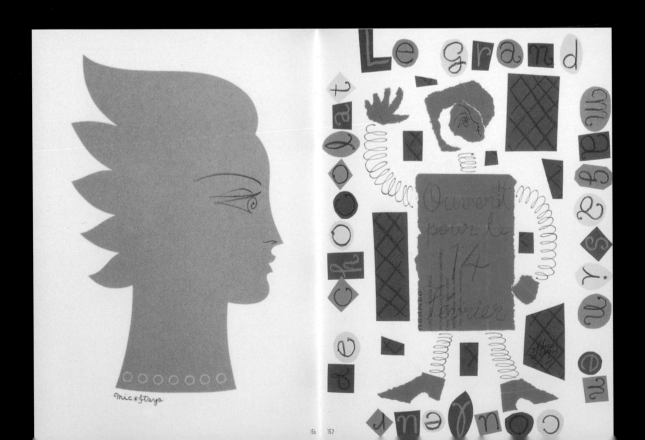

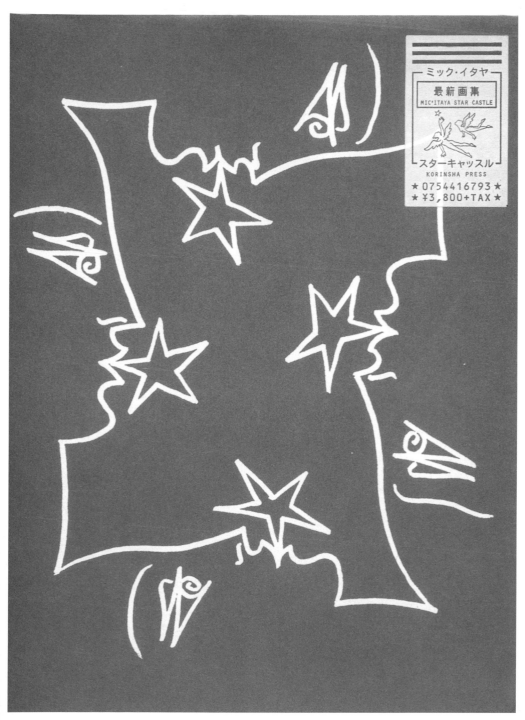

ミック・イタヤ
最新画集
MIC*ITAYA STAR CASTLE

スターキャッスル
KORINSHA PRESS
★ 0754416793 ★
★ ¥3,800+TAX ★

Star Castle, a handsome,
hardbound volume, assembles
a colorful collection of Mic*Itaya's
drawings and collages. It
displays the freshness and
vitality that have helped make
his work popular and respected
among other artist-designers.
ART DIRECTOR: Mic*Itaya

ABCDEFGHIJKLMN
OPQRSTUVWXYZ
ABCDEFGHIJKLMN
OPQRSTUVWXYZ
$1234567890=+-*
.,:;!?_#@

Michimasa Itaya, who uses the moniker Mic*Itaya, has created his own typefaces, whose wiry forms complement the serpentine lines of the drawings that are the main components of his designs. The typeface that appears in this poster for an exhibition in Kyoto of his work is called Bureamic.

ART DIRECTOR: Mic*Itaya
DESIGN ASSISTANT, TYPEFACE PROJECT:
Sanemasa Mushakoji

Mic*Itaya's brightly colored Miclock wall clocks offer style mavens an opportunity to own a practical, functioning example of the designer's art.

ART DIRECTOR: Mic*Itaya
PHOTOGRAPHY: Takeo Ogiso

It's not uncommon for Japanese graphic designers to develop and market their own merchandise based on cartoon characters or other elements that appear in their work. Mic*Itaya created a silk-screened rag doll in conjunction with an exhibition of his work in Kyoto; the poster for that show shares the doll's same color scheme. **ART DIRECTOR:** Mic*Itaya

Mic*Itaya uses his Pim typeface in posters, books, and many other designs, often in conjunction with his line drawings.
ART DIRECTOR: Mic*Itaya
DESIGN ASSISTANT: Sanemasa Mushakoji

Mic*Itaya and his associates created this package for a Japanese pop-music album by Yukinojo Mori on the theme of angels. The abstract cover image of an angel, like the unusual Japanese *kanji* on the package's blue outer wrapper, is sharply angular and highly stylized.
ART DIRECTOR: Mic*Itaya
GRAPHIC DESIGN: Bou Ishimatsu, Sanemasa Mushakoji
ILLUSTRATION: Mic*Itaya
PHOTOGRAPHY: Kyoji Takahashi, Mic*Itaya

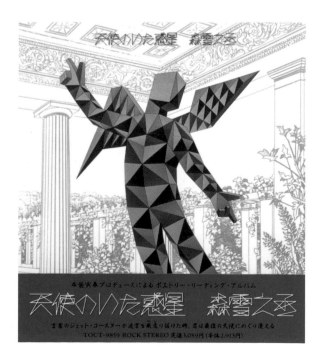

An abstract form that emerges
from a pattern of repeating face
profiles becomes a motif on these
posters for an exhibition of
Mic*Itaya's work at a Tokyo gallery.
ART DIRECTOR: Mic*Itaya

With few colors or other graphic
elements, but with a sense of
minimalist lushness, Mic*Itaya
sometimes creates CD covers that
depart from his usual illustration-
centered style, as in this
album called *Yukinojo Mori
Presents Tokyo Poets, Volume 1.*
ART DIRECTOR: Mic*Itaya
GRAPHIC DESIGN: Noriyuki Yokota

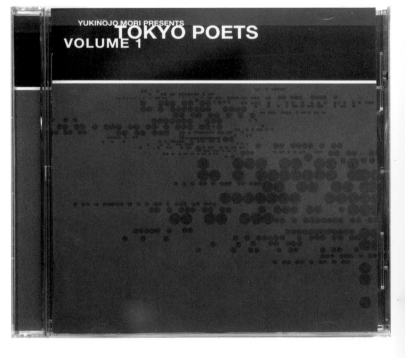

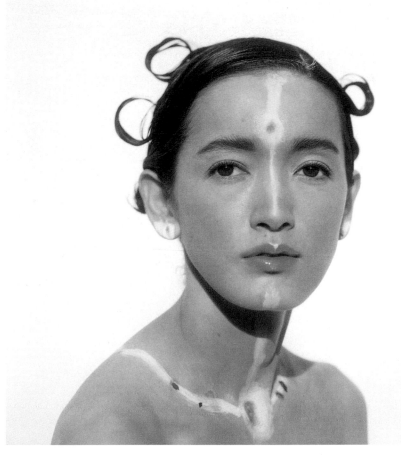

Generous white space, plain
type, and dramatic lighting and
make-up come together to help
set the thoughtful, meditative
mood for a Japanese pop
singer's album on star-gazing,
spiritual themes. The package
contains both a compact
disc and a computer diskette.

ART DIRECTOR: Mic*Itaya
GRAPHIC DESIGN: Noriyuki Yokota,
Bou Ishimatsu
HAIR AND MAKE-UP: Saburo
Watanabe for Sashu
PHOTOGRAPHY: Yoshihiko Ueda

PRINCIPAL: Hitoshi Nagasawa
Founded in 1982
NUMBER OF EMPLOYEES: 2

Papier Collé, S.A.
203 Gunji Building
3-42-11 Jingumae,
Shibuya-ku, Tokyo 150-0001
TEL (81) 3-3470-4975
FAX (81) 3-3470-1031

HITOSHI NAGASAWA

Hitoshi Nagasawa was born in Saitama prefecture, north of Tokyo, and graduated from the Musashino Fine Arts University in 1979. He established his studio in 1982, naming it Papier Collé after the French term for glued paper, as in collage. In his work for consumer magazines and culture-oriented periodicals, Nagasawa has shown interest in collage-like arrangements of various aesthetic ideas. He has published a journal (also called *Papier Collé*) that examines such themes. Nagasawa has also served as an art director for institutions such as the Kawasaki City Museum, for which he has created exhibition catalogs and other publications. Among them is a book, documenting the museum's colloquium on Bauhaus-era photography. Typically, Nagasawa gave this historically inspired project a shot of contemporary, computer-graphics-flavored momentum. In his recent dense, multi-textured layouts, Nagasawa has assimilated the roguish, rollicking energy of grid-busting, type-mixing, late-nineties graphics.

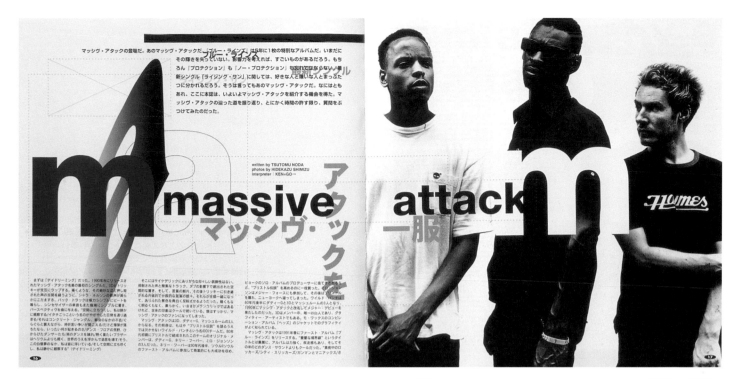

マッシヴ・アタックの登場だ。あのマッシヴ・アタックだ。『ブルー・ラインズ』は5年に1枚の特別なアルバムだ。いまだにその輝きを失っていない。影響力を考えれば、すごいものがあるだろう。もちろん『プロテクション』も『ノー・プロテクション』も忘れてはならない。最新シングル『ライジング・サン』に関しては、好きな人と嫌いな人とまっぷたつに分かれるだろう。そうは言ってもあのマッシヴ・アタックだ。なにはともあれ、ここに本誌は、いよいよマッシヴ・アタックを紹介する機会を得た。マッシヴ・アタックの辿った道を振り返り、とにかく時間の許す限り、質問をぶつけてみたのだった。

written by TSUTOMU NODA
photos by HIDEKAZU SHIMIZU
interpreter : KEN=GO→

m massive attack m
マッシヴ・アタック
一服

まずは『デイドリーミング』だった。1990年秋にリリースされたマッシヴ・アタック名義の最初のシングル、3Dがリリックが交互にラップする。軽くささやくほどの声、続くほどの初めなほど押し殺された声の圧倒感に、シャラ・ネルソンの歌声が肩のようにパック。バック・トラックはシンプルにピートを鳴らし。シンセサイザーの単音もまた幾層にもシンプルに響き。パースペクティヴを感じさせる"空間に立ちつくし。私は静かに観察する"イクチごっこという心がかがけがたい日常を通り過ぎる。それはコンクリート・ジャングル、夢なのか不安のくらくらと震えながら、時折買い迷いが聞こえるだけで震撼が響きたらない。いったい何が起きるのかダンス・フロアの荒野、フロアからびがダンサーたち。街のダンスを離れない重さというブラザーハーリウムよりも続く、世界のうえを浮かんで遊び出そう。この白昼夢のなか、私は深に浮いている。そして空間に立ちつくし、私は静かに観察する"(デイドリーミング)

そこにはサイケデリックにありがちな甘々しい表面性はない。即制された声と整然としたトラック、ダブの影響下で創造された空間的な響き。そして、言葉の刻印、その深いリリックに引き込まれるみの内部ので抒情的な叙事の都市、それらが全体一緒になってありふれた前色を見れた反射させるようだった。暗くもなく明るくもなく、黒もなく、いまさがメランコリックであるそのなのだった。3Dメンバーの、唯一の白人であり、グラフティ・アーティストでもある。モ・ワックスのコンピレーション・アーティスト、モ・ワックスのコンピレーション・アーティスト『ヘッズ』のジャケットのグラフィティがよく知られている。

ビョークのソロ・アルバムのプロデューサーに抜てきされるなど、『ブリストル伝説』を高めるのに一役買った。ゼロレコンゾンはメジャー・フォースにも参加して、その後はブリストルを離れ、ニューヨークに渡ってしまった。ワイルド・バンチは80年代後半にデイヴィーGと3Dとマッシュルームの3人となり、1990年にマッシヴ・アタックと改名してメジャー・デビューを果たしたのだった。3Dメンバーは、唯一の白人であり、グラフィティ・アーティストでもある、モ・ワックスのコンピレーション・アーティスト『ヘッズ』のジャケットのグラフィティがよく知られている。

マッシヴ・アタックは1991年春にファースト・アルバム『ブルー・ラインズ』をリリースした。"衝撃な境界線"というタイトルは裏腹に、アルバムは力強く、疾走感もあり。そしてその年のどのダンス・サウンドよりもクールだった。"真夜中のロッカーズ/シティ・スリッカーズ/ガンマンとマニアックス/

the communication for the electronic tribe
eJe-king
october/november 15
1997 volume

COLDCUT & POST HIP-HOP

m massive attack HOlMES

荒木宏/中西俊夫/工藤昌之/μ-ZIQ/DJ KRUSH/フィッシュマンズ/
STEVE REICH/イギリスの音楽とユーモア/JAH SHAKA/
MOTORBASS/パリは溶岩で燃えている/CARL COX/JONAH SHARP/
SOUP/竹村延和/クボタタケシ/OXYGEN FUNK/and more to come.

the communication for the electronic tribe
eJe-king
february/march 1998 volume 17

kem ishii RONI SIZE

In Nagasawa's designs for the hip style-and-music magazine *ele-king*, seemingly arbitrary dotted lines; overlapped, differing typefaces; and computer-manipulated, multi-dimensional letterforms give pages a dynamic edge.
PHOTOGRAPHY: Hidekazu Shimizu and others

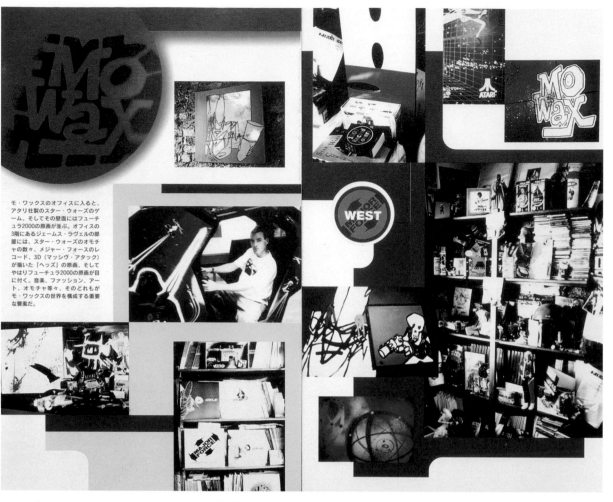

モ・ワックスのオフィスに入ると、
アタリ社製のスター・ウォーズのゲ
ーム、そしてその壁面にはフューチ
ュラ2000の原画が並ぶ。オフィスの
3階にあるジェームス・ラヴェルの部
屋には、スター・ウォーズのオモチ
ャの数々、メジャー・フォースのレ
コード、3D（マッシヴ・アタック）
が描いた『ヘッズ』の原画、そして
やはりフューチュラ2000の原画が目
に付く。音楽、ファッション、アー
ト、オモチャ等々、そのどれもが
モ・ワックスの世界を構成する重要
な要素だ。

Nagasawa's page designs for
Mo'Wax Japan, a press kit in
small-magazine format, explodes
with the multi-textured thickets
of jumbled type styles and
closely packed images that have
become the visual language
of the global pop-music and
youth-culture scenes.
PHOTOGRAPHY: Hitoshi Nagasawa,
Kumiko Nakata

mo'wax japan

featuring
ape vs mo'wax
sukia
attica blues

NIGO'S

**◉U.N.K.L.E. FEATURING NIGO AND SCRATCH PERVERT
/APE SHALL NEVER KILL APE**

NIGOとスクラッチ・パーバートをフィーチャーしたU.N.K.L.Eの新曲でアルバムははじまる。スクラッチ・パーバートはまだ無名ながらもアメリカのDJコンテスト「DMC」で優勝したという実力の持ち主。

**◉URBAN TRIBE/EASTWARD(ORIGINAL MIX)
◉URBAN TRIBE/EASTWARD(FORME MIX)**

カール・クレイグが見出したアーティスト、SHERARD INGRAMによるトラック。カール・クレイグは、デトロイト・テクノを代表するアーティストで、モ・ワックスからもインナー・ゾーン・オーケストラ名義でシングル「バグ・イン・ザ・ベースビン」をリリースしている。アーバン・トライブは、クレイグが現在主宰するレーベル「プラネットE」は前に拠点としていたレトロアクティヴからも作品を発表している。

**◉MONEY MARK
/GOT MY HAND IN YOUR HEAD**

ビースティー・ボーイズやベック、ジョン・スペンサー・ブルース・エクスプロージョンなどへの参加により、マーク西田(マニー・マーク)の名前は、ロック・ファンからヒップホップ・ファンにいたるまで広く浸透している。95年にファースト・アルバム「マーク・キーボード・リペア」をモ・ワックスよりリリース、ソロ・アーティストとしてのキャリアを歩み始めた。"ゴット・マイ・ハンド・イン・ユア・ヘッド" はファースト・アルバムに収録された曲。

**◉ATTICA BLUES/TENDER
(ORGANISED KONFUSION REMIX)**

モ・ワックスが誇るブリット・ヒップホップの秘蔵っ子。"テンダー" は彼らの通算3枚目のシングルになるが、ここに収録されたのはそのオーガナイズド・コンフュージョンによるリミックス・ヴァージョン。オーガナイズド・コンフュージョンは、故ファンクマスターが主宰していたハリウッド・ベーシックでの活動で知られるヒップホップ・グループ。

ファッション・ブランド「A BATHING APE」を主宰するNIGOは、モ・ワックスとも親交があつい。DJとしてロンドンでジェームス・ラヴェルと一緒にプレイしたり、先日青山の「BLUE」で開かれたモ・ワックスのパーティでもDJを披露してくれた。なお、NIGOは来年リリースが予定されているU.N.K.L.Eのファースト・アルバムにも参加している。

**◉DJ SHADOW/MIDNIGHT IN A PERFECT WORLD(ORIGINAL MIX)
◉THE GROOVE-ROBBERS/HARDCORE INSTRUMENTAL HIP HOP
◉THE GROOVE-ROBBERS/ 1/2 BONUS SCRATCHAPELLA**

ヒップホップの文脈から、旧来のそれを覆すようなサウンド・プロダクションにより、モ・ワックスはもとより90年代を代表するアーティストにまでなったDJシャドウについては、もはや手弁は要するまでもない。"ミッドナイト・イン・ア・パーフェクト・ワールド" は、「エンドトロデューシング」からのシングル・カット。"ハードコア・インストゥルメンタル・ヒップホップ" は、シャドウも関わっているサンフランシスコのソウルサイズからのリリースで、後にモ・ワックスのサブ・レーベル「エクスカーション」から再リリースされたもの。

**◉U.N.K.L.E./BERRY MEDITATION
(THE DARKER THE BERRY, THE SWEETER THE JUICE MIX)**

U.N.K.L.E.(アンクル)は、モ・ワックスのインターナショナルA&R担当のジェームス・ラヴェルと上條昌之のふたりからなる(オリジナル・メンバーのひとりティム・ゴールドワージィは97年に脱退している)。"ベリー・メディテーション" は1994年のファースト・シングル「タイム・ハズ・カム」に続き、97年にひさしぶりにリリースされた通算2枚目のシングルのタイトル曲。

◉SUKIA/THE DREAM MACHINE(SPACE ECHO MIX)

ダスト・ブラザーズの主宰するニッケル・バッグからデビューしたロサンゼルスの4人組スキアは、ヒップホップにモンドをミックスして、新たなポップの領域を目指している。96年にリリースされたファースト・アルバム「第三の性とのスペース・コンタクト」に、新たにリミックス・ヴァージョンを加えて、97年にモ・ワックスからもアルバムはリリースされている。"ドリーム・マシーン" は彼らの代表曲。

SUKIA

モ・ワックスの「精神的ヒップホップ・ジャンキー」ジェームス・ラヴェルが自らのレーベルの辺境さと変態さを極める為にスキアをゲットしたのは市場にストレートな状況判断だと思うし、ポルノという言葉を越えたエクスタシーをサウンド・トラック化してしまったこのコロンブスの卵みたいなスキアを極東の僕らが夜な夜なオカズとして愛撫するのもまったく自然なことである。そうなのだ。はっきりいって、ロス・ハリスがこのアイディアを思いつき実行をした瞬間に、スキアは「勝った」のである。しかし。ここが大事なのだが、このポルノ・ミュージックとでもいうべき音楽はおもいついてもなかなか実行に移せない手腕なのである。なぜならこの発想をポップ・ミュージックとして成立させるには目玉が飛び出すほど高度なセンスを要するからだ。下手にやると、それはミュージシャン、いやアーティストとしてももっとも恥ずかしい評価が下されるものなのではなかろうか。セクシュアルでありながらバイオレントでなければならない、人びとの倫理概念の中にある下心を上手く突いてウケをとりながらタブーを破壊せねばならない、一瞬目を背けたくなるほどグロなものでありながらもなにより古いオシャレでキッチュでなければならない、そして誰々の心にいつももっともシリアスな命題を突きつけなつてな大らかなユーモアのシーツでくるまねばならない。こんな難しい表現、誰が出来るというのだろう?

だが、スキアはやってのけた。これはブルースである。そしてロックである。もしかしたらもっとも繊細なアメリカのモンド・ミュージックかもしれないが、それよりも僕はこれをかつてなく高いレベルでの批評的なポップ・ミュージックとして受け止める。

「僕たちの世代に課された使命って、お決まりごとを破壊することだと思うんだ。実際には僕の世代などは何かにつけて慣習を保留したがってしまうんだけど、それはつまりすべてがお決まり事に甘えなんじゃないって理由から何かに自分の身を投じることが出来ない。世の中のほとんどが決まりごととして進んでいるとしか思えないから、人生を何かに捧げてしまうのが怖くてしょうがないんだ

よ。だからこそ僕はこの世界の全ての物事を一切合切投げ込んで、決して事として見えないように工夫してみることにしたんだ」

これはローリング・ストーン誌でベックが語ったコメントである。サンプリング世代としての真っ当な新しきロック・モダニズムを掲げるベックを敬愛する勇気あるコメントが、そんなベックがローリング・ストーン誌のマイ・アーム・チャートのトップにこのスキアのアルバムを持ってきたのは当然の事だと思う。このユーモア溢れるハイパーなフェロモン・サウンドは、あらゆる意味で僕らを騙す僕らのまったく新しいソウル・ミュージック、そのはじまりであるのだから……トップ・チューン "Feelin' Free" でジャック・ニコルソンのような声のロス・ハリスが「スパンク・ミー、スパンク・ミー、スパンク・ミー、スパンク、スパンク、スパンキング!!」と囁きだした時、耳たぶを赤くしながら僕はそう思ったのでした、それにしてもこの時代のバカげたサギ御3達の2ndアルバムは、いつ届くのだろう?今度は料理層喰の架空のサントラなんて聴いてみたいと思う。この人たちならば、食欲が性欲にも柔らめセクシャリティ溢れる欲求であることを、僕らに証明してくれると思う。そのときに再び、僕らとスキアはウットリするほど絡まるのだ。そう、合言葉は「スパンク・ミー 」

陽野 淳(ROCK'N ON/BUZZ) ライナーノーツより抜粋

SUKIA

In posters and a book for the
Kawasaki City Museum's programs
on the Bauhaus and Bauhaus
photographic style, Nagasawa
adds his own contemporary touch.

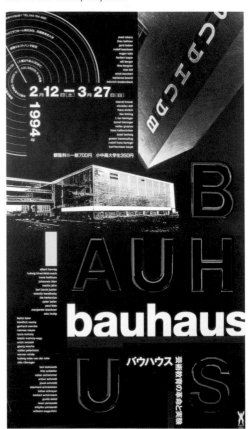

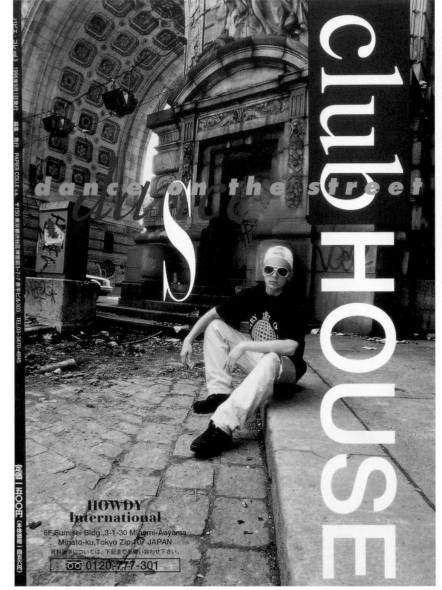

From its cover to its last page,
Nagasawa's pop journal of
aesthetics and culture, *Papier Collé*,
is full of dense layouts with busy,
type-jumbling designs.

january

sun	mon	tue	wed	thu	fri	sat
				1	2	3
4	5	6	7	8	9	10
11	12	13	14	15	16	17
18	19	20	21	22	23	24
25	26	27	28	29	30	31

The designer pays unabashed homage to some inspiring source material—vintage visions of the future—in a calendar created for the style-driven Parco department-store chain.

march

sun	mon	tue	wed	thu	fri	sat
	2	3	4	5	6	7
	9	10	11	12	13	14
	16	17	18	19	20	21
	23	24	25	26	27	28
	30	31				

FEATURING

THE STAR WATCHERS

An Interplanetary Novel by
ERIC FRANK RUSSELL

THE GAMBLERS

A Novelet by
M. REYNOLDS
AND F. BROWN

PRINCIPAL: Hideki Nakajima
FOUNDED: 1995
NUMBER OF EMPLOYEES: 4

Kaiho Building 4F
4-11 Uguisudani-cho,
Shibuya-ku, Tokyo 150-0032
TEL (81) 3-5489-1757
FAX (81) 3-5489-1758

HIDEKI NAKAJIMA

A driven, impulsive, admitted workaholic, Hideki Nakajima is motivated by a passion for design; he even has the word "design" tattooed on one arm. Known for his image-propelled layouts for hip style magazines, Nakajima was born in 1961 and is a member of a postwar generation seen as the first in Japan to put a priority on the individual's—not the group's or society's—desires and needs. Nakajima began making a name for himself in 1989 as an assistant to the advertising-design and art-direction master Masami Shimizu, who gave shape to *CUT* when that magazine was being launched. Later, Nakajima himself became its art director.

Meanwhile, he had been designing posters, CD packages, and book covers, too. In his work, Nakajima likes easy-to-read type set against powerful, straightforward pictures. In some of his *CUT* layouts, however, an inventive display-type treatment on one side of a two-page spread helps establish the mood of the article that follows and reflects the character of its well-known actor, artist, or performer subject. In his posters, minimal type elements seem to comment only marginally on the images they identify. Nakajima is interested in graphic design's capacity to make an impact. "Communicating through music is fastest," he says. "Visual communication is next fastest."

Nakajima used a modular, abstract sculpture of his own creation as a backdrop for dropped-out, white type in a two-page layout beginning a feature in issue no. 58 of *CUT*.
ART DIRECTOR: Hideki Nakajima
PHOTOGRAPHY: Yoshihiko Ueda

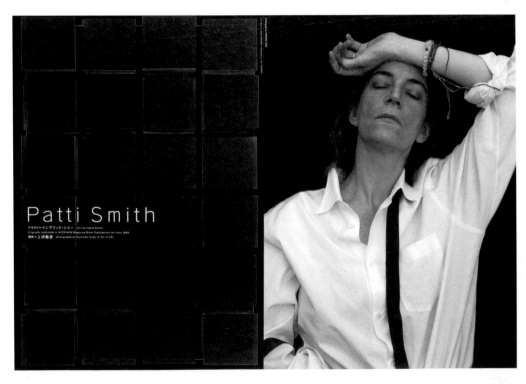

Patti Smith

A cover of the hip Japanese
style magazine *CUT*.
ART DIRECTOR: Hideki Nakajima
PHOTOGRAPHY: Terry O'Neil

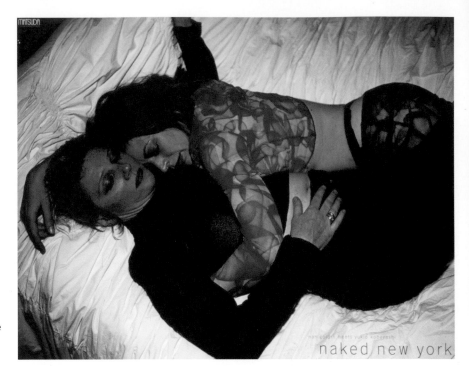

Nakajima used images produced by
the American photographer Nan
Goldin, a denizen of style's tattered
fringes, for a series of posters for the
Matsuda fashion label.
ART DIRECTOR: Hideki Nakajima

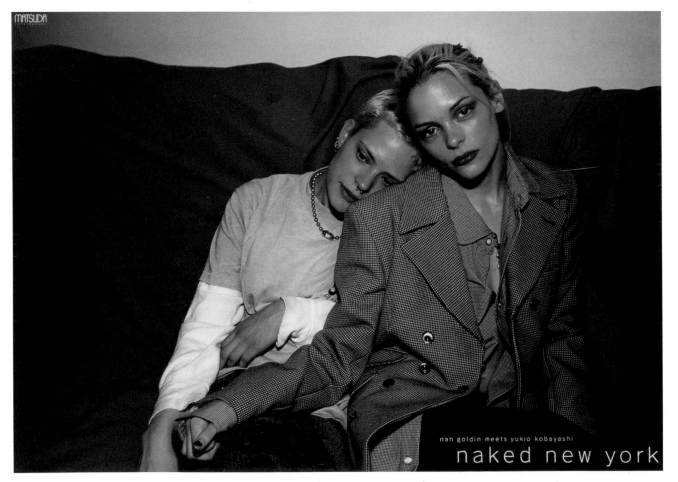

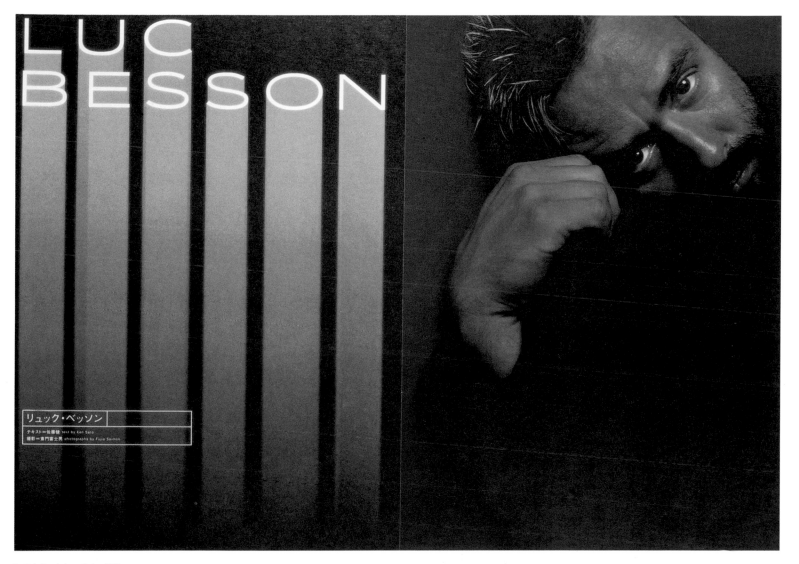

LUC BESSON

リュック・ベッソン

テキスト=佐藤健 text by Ken Sato
撮影=西門富士男 photographs by Fujio Saimon

In Nakajima's layouts for *CUT*, inventive display-type treatments on one side of a spread help establish the mood of the articles that follow and reflect the characters of their well-known actor, artist or performer subjects.
ART DIRECTOR: Hideki Nakajima
PHOTOGRAPHY: Fukio Saimon

An embossed, industrial-looking pattern gives record and laser-disc covers for releases by Ryuichi Sakamoto a hint of eye-grabbing, metallic elegance.
ART DIRECTOR: Hideki Nakajima
CREATIVE DIRECTOR: Norika Sky Sora

Lightweight, almost unobtrusive type is set against bold photo images that assume an ambiguous, looming presence in a series of posters for the book *N/Y* by musician-composer Ryuichi Sakamoto and photographer Kazunali Tajima.
ART DIRECTOR: Hideki Nakajima
CREATIVE DIRECTOR: Norika Sky Sora
EDITORIAL DIRECTOR: Shigeo Goto
PHOTOGRAPHY: Kazunali Tajima

PRINCIPAL: Norio Nakamura
FOUNDED: 1997
NUMBER OF EMPLOYEES: 1

1-12-7-602 Minami-Aoyama
Minato-ku, Tokyo 107-0062
TEL (81) 3-5468-2655
FAX (81) 3-5468-2662

NORIO NAKAMURA

Norio Nakamura's precisely rendered, architectonic concoctions are illustrations, graphic-design compositions, and two-dimensional depictions of sculpturally formulated thoughts all at once. Nakamura, who comes from Kawasaki, graduated in art from Nippon University in 1990 and went on to work for the CBS/Sony Group (now the Sony Music Entertainment Co., Ltd. in Japan). His signature style takes whatever messages a project must convey—whether he is preparing posters, direct-mail pieces, or other two-dimensional, printed items—and breaks them down into their logical components. In masterful forays into what the American expert in this field, Edward R. Tufte, calls the visual display of qualitative or quantitative information,

Nakamura then presents plain, instruction-manual-like drawings of exploding boxes that are, symbolically, units of data whose interrelationships are made visible and concrete. His postcard announcing a Sony-sponsored art exhibition is a consummate example of this simultaneous technique of illustration and information processing. "I like to understand; I do not enjoy what I do not understand," Nakamura has modestly observed. "I'd like to send out ideas that are basic and universal, aimed at people in general, instead of to a particular nation or culture." Nakamura has also designed CD packages and computer-game software.

C/W ●エーデルワイス（ツクバREMIX）　●エーデルワイス（オリジナル・カラオケ）

魁 さきがけ

明和電機

提供
明和電機

The designer's covers for CD albums or singles by the Japanese artists Meiwa Denki on Sony Music Entertainment (Japan), Inc. labels set stylized *kanji* against sterile, minimalist color fields or abstract backgrounds or vaguely scientific-looking maps.

Part instruction-manual allusion, part deconstructionist conceptual art (however unwittingly), Norio Nakamura's signature style of posters and cards breaks down hierarchies of related pieces of information and presents them in exploding box diagrams. This series of posters and cards announce events sponsored by Japan's CBS/Sony Group, including an invitational art exhibition.

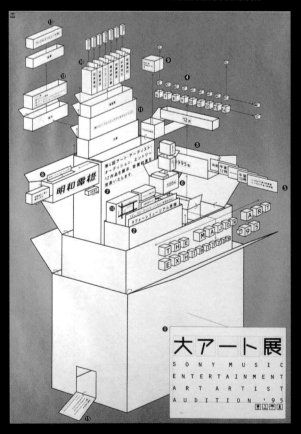

Nakamura applied his
visual-analytical approach to
this poster for an exhibition
at the 1995 São Paulo Biennial.
The show's theme: The Japanese
identity as seen through the
work of 23 Japanese artists.

Nakamura has also worked on computer games for Sony's popular PlayStation. In these images from Intelligent Qube, his designs are still rooted in three-dimensional, rectilinear geometry, but color, characters and more visual texture are introduced as well.

NOMADE, INC.

PRINCIPALS: Toshio Shiratani,
Yumi Morimoto
FOUNDED: 1985
NUMBER OF EMPLOYEES: 3

2-31-7, No. 204 Jingumae
Shibuya-ku, Tokyo 150-0001
TEL (81) 3-3497-5184
FAX (81) 3-3497-5324

The work of Toshio Shiratani's Nomade, Inc. studio instinctively assimilates and reflects many of the classic values of modern and late-modern design. But in projects like his Endless Summer promotional calendar for Dai Nippon Printing Co., Ltd., Shiratani extends his touch to embrace the more erratic, postmodernist aesthetic pioneered in the West, with its penchant for off-grid or closely leaded or overlapping type treatments. In his own way, Shiratani brings an instinctive sense of order to this now-familiar visual style. Some of his strongest work is also some of his simplest, such as his poster for the Tokyo Metropolitan Museum of Photography's *Rhapsody of Modern Tokyo* show. Here, Shiratani uses historic type styling for the main-headline, vertically placed *kanji* (the borrowed Chinese characters that are used, in part, to write Japanese words) that evoke the 1920s–1930s era of Japanese modern design. In these *kanji*, the traditional dot brushstroke literally is replaced by a round dot. Similarly, other horizontal and vertical strokes are abstracted and rendered with counter-balancing wide or narrow line widths. The artistry of a designer like Shiratani lies in his understanding and thoughtful use of elements like these, and in the simultaneous sense of harmony and energy that his design compositions convey.

Shiratani uses two typefaces with pronounced serifs in a carefully spaced interplay to give this fashion-label logo some character and spark.
PHOTOGRAPHY: Philippe Dixon

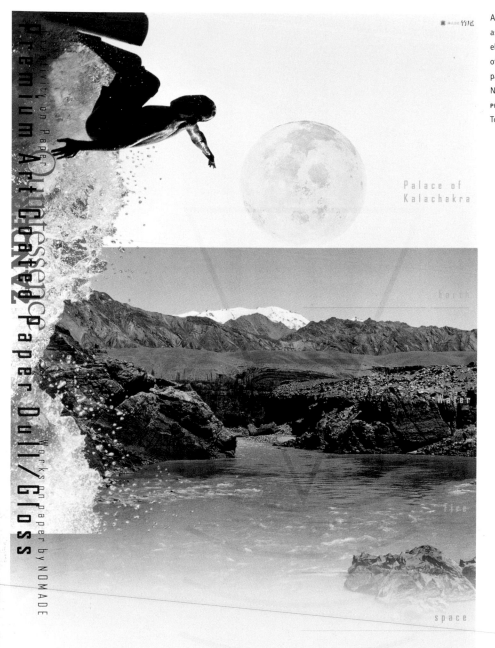

A dense knot of typefaces acts as a multi-textured graphic element on the left-hand side of this promotional poster for a particular kind of paper on which Nomade, Inc.'s design appears.

PHOTOGRAPHY: Toshio Shiratani, Tomomi Mizuguchi

Shiratani's poster for a show of fashion photographs harmoniously unites several typefaces for Roman and Japanese letterforms, along with the exhibition venue's own logotype.

CREATIVE DIRECTOR: G.I.P. Tokyo

PHOTOGRAPHY: Jeanloup Sieff

A poster for a historical exhibition at the Tokyo Metropolitan Museum of Photography makes use of the traditionally powerful graphic design palette of black, white, and red, and of vintage-style typography for the vertically positioned, main headline *kanji*.

PHOTOGRAPHY: Kineo Kuwabara

asian view

エイシアン・ヴュー

躍動するアジア

1996年1月23日[火]－3月13日[水]

東京都写真美術館

Generous letter- and line-spacing, and a sensitive use of gray as an accent color in black-and-white compositions give this poster and a catalog for the Tokyo Metropolitan Museum of Photography a fresh, delicately balanced look.

PHOTOGRAPHY: Thierry Urbain, Wu-gong Hu, Shun-chu Chen

An emphatic red triangle contains part of the book-title headline and suggests an attention-grabbing arrow on the cover of the catalog for a Tokyo Metropolitan Museum of Photography exhibition called *Tokyo, City Photos*.

PHOTOGRAPHY: Daido Moriyama

A relatively simple cover treatment, with big, bold *kanji*, contrasted with colorful images inside, give this program book from one of the Kodo troupe's performances its energy.
PHOTOGRAPHY: Kazuo Yoshino, Masateru Sakaguchi

Nomade, Inc. created this combined computer-screen saver and promotional calendar called Endless Summer for Japan's well-known Dai Nippon Printing Co., Ltd.
PHOTOGRAPHY: Mitsuyuki Shibata

With little more than circular, moon-cycle forms, and a limited color palette, Shiratani's self-promotional Moon Calendar announcing his studio seems to generate its own design.

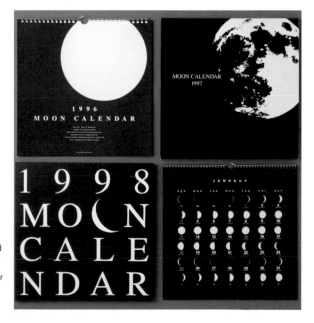

Shiratani's poster for a
performance by the internationally
famous Kodo troupe of
traditional Japanese percussionists
graphically isolates the gesture
that gives their music its
distinctive sound—seconds
before drumstick meets drumskin.
PHOTOGRAPHY: Cliff Watts

さざ波に遊ぶ貝を耳にあてると、微かなさわめきが遠くから聞こえてきます

そして、そっと抱くようなやさしさで私たちを包みます 貝が奏でる調べ、その音がいつも聞く人の心に快く響くのは、

気の遠くなるほどの年月をいくつもの生命を育んできた母なる海、そして私たちの星、地球の歌だからかもしれません。

いつの時代にもそうであったように、その調べは、はるか遠い未来の私たちの耳にもやさしく届くのでしょう

地球が、永遠に美しく豊かな星である限り。

1 9 9 8 C A L E N D A R
Michael Loh / A Rhapsody of Shells

EARTHEON

Michael Loh（マイケル・ロー）
1962年、マレーシアのクアラルンプールに生まれたマイケル・ローは、海をこよなく愛する男である。英国ロイヤルカレッジで学び、証明工学および撮影の為の二つの学位を取得した。学生時代、在米英語の輸入ビジネスから、この組織に合わせられている。プロの仕事の環境として活動的な撮影によるドキュメント。Under Water Colours Networkを設立。その作品として、雑誌プロダクション、Under Water Colours Networkを設立。その作品として、現在はいわゆる世界有数の撮影カード、海洋研究保護組織などである写真は、美しい海に溢れ合うもやさしく学びし成した活発的撮影である。

Photographs © 1997 Michael Loh/G.I.P. Tokyo

A delicate sense of layering
and an overall gentle air distinguish
this calendar featuring photographs
of sea shells.
CREATIVE DIRECTOR: Yasuzo Takemoto
DESIGNERS: Toshio Shiratani,
Etsuro Endo

In this poster for a Kodo tour, Shiratani integrates the group's name *kanji*, which function as a logo, into a photo-based design that immediately conveys the bold, spectacular character of the performances for which these drummers are known.
DESIGNERS: Toshio Shiratani, Etsuro Endo
PHOTOGRAPHY: Masakazu Sakomizu, Ryuichi Okano

A bold logo for an event known as The Month of Photography features thick lines and an abstracted, old-fashioned, twin-lens reflex box camera rendered quite effectively as little more than a black rectangle with two white circles.

PRINCIPALS: Takuya Onuki,
Yasukazu Arai, Taro Terada,
Tsutomu Fujihara, Katsuhiro
Shimizu
FOUNDED: 1993
NUMBER OF EMPLOYEES: 5

Onuki Design, Inc.
502 Villa Gloria
2-31-7 Jingumae
Shibuya-ku, Tokyo 150-0001
TEL (81) 3-3478-7461
FAX (81) 3-3478-7462

TAKUYA ONUKI

The often calculated irreverence—and, sometimes, complete irrelevance of the subject matter depicted—that has become a hallmark of youth-oriented advertising in the MTV era of global pop culture has its Japanese manifestations, too. But to be fair, veteran Japanese-media watchers would point out that, for a long time, there has been a strain in Japan's pop culture that, like the endearing grammatical bloopers that characterize written Japanese English, sometimes doesn't seem to get it right—the cross-cultural, visual borrowings, and references, that is. Thus, as postmodernists enthusiastically note, foreign-derived symbols, names, and images can become dramatically recontextualized when employed in a Japanese environment. But a more informed, unselfconsciously clever sensibility informs the designer Takuya Onuki's advertising posters. In them, striking visual puns abound, as does a contemporary sense of irony in his use of appropriated, generic, commercial images—of kitchens, travel destinations, or suburbia. Onuki has created numerous posters for Laforet, one of Tokyo's best-known outposts for cutting-edge fashion and style. Located in one of the city's busiest retail-shopping districts, the store is both an emblem and provider of the trendy and new, whose hip identity and marketing spirit Onuki's work perfectly captures.

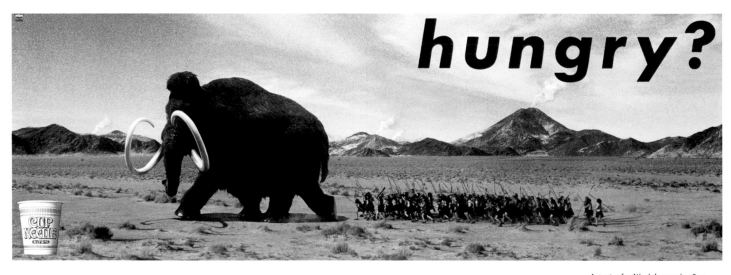

A poster for Nissin's popular Cup Noodle soup snack makes powerful use of a broad, horizontal format and a simple, one-word headline.
ART DIRECTOR/CREATIVE DIRECTOR: Takuya Onuki

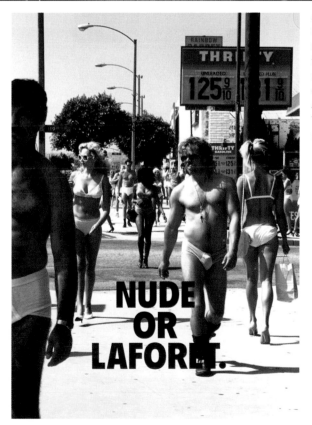

NUDE OR LAFORET.

A set of posters using unexpected images from American locales suggests that Tokyo's Laforet fashion emporium is the only place where in-the-know consumers would shop for clothes.

ART DIRECTOR/CREATIVE DIRECTOR: Takuya Onuki

PHOTOGRAPHY: Shintaro Shiratori

NUDE OR LAFORET.

Laforet
Grand Baza

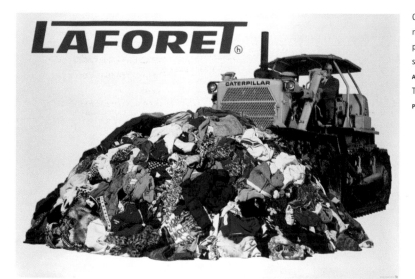

Out with the old, in with the new—fashions, that is, in this poster for Tokyo's hip Laforet store in the city's Harajuku district.
ART DIRECTOR/CREATIVE DIRECTOR: Takuya Onuki
PHOTOGRAPHY: Shintaro Shiratori

An enigmatic Easter Island statue uproots itself and heads off to Tokyo's fashionable Laforet store in this whimsical poster.
ART DIRECTOR/CREATIVE DIRECTOR: Takuya Onuki

WELCOME TO LAFORET

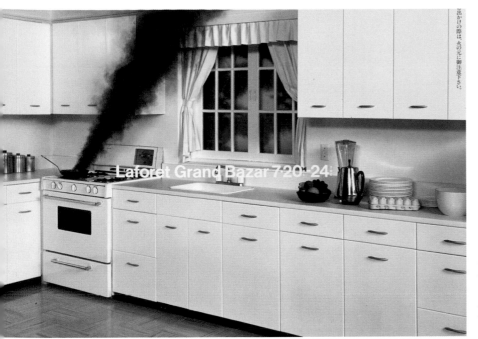

In a poster that makes ironic
use of a generic, kitchen-interior
scene, Onuki suggests that the
action is heating up at a Laforet
storewide sale.
ART DIRECTOR/CREATIVE DIRECTOR:
Takuya Onuki
PHOTOGRAPHY: Shintaro Shiratori

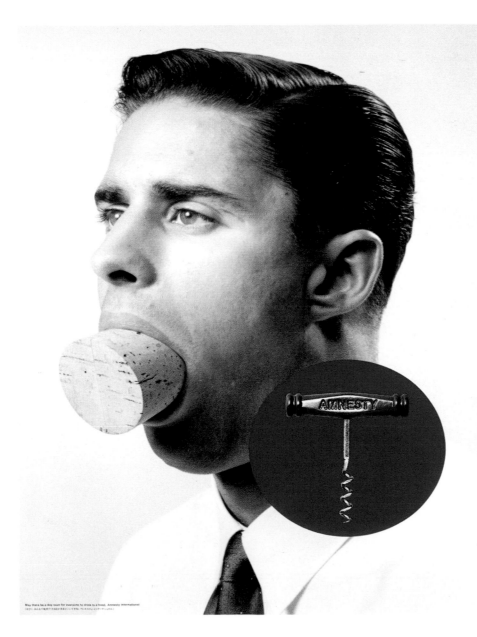

Onuki uses the classically powerful
color combination of black, white,
and red, and a strong visual pun, in
a poster for Amnesty International.
ART DIRECTOR/CREATIVE DIRECTOR:
Takuya Onuki
PHOTOGRAPHY: Shintaro Shiratori

In a poster for the Tokyo Art Directors Club, Onuki uses a simple image and evokes a sense of vastness and enormity through the smallness of dominoes to symbolize the number of people felled by AIDS since 1980.
ART DIRECTOR/CREATIVE DIRECTOR: Takuya Onuki
PHOTOGRAPHY: Shintaro Shiratori

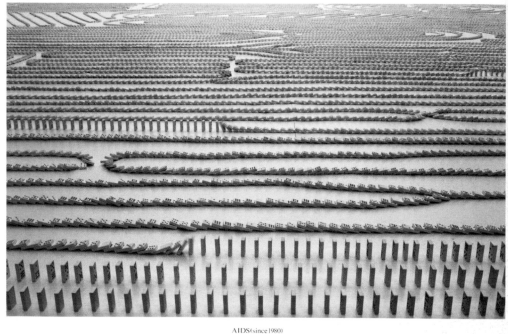

AIDS(since 1980)

A poster for Pepsi Cola highlights the bold colors of the brand's familiar packaging and logo.
ART DIRECTOR/CREATIVE DIRECTOR: Takuya Onuki
COMPUTER GRAPHICS: Industrial Light and Magic

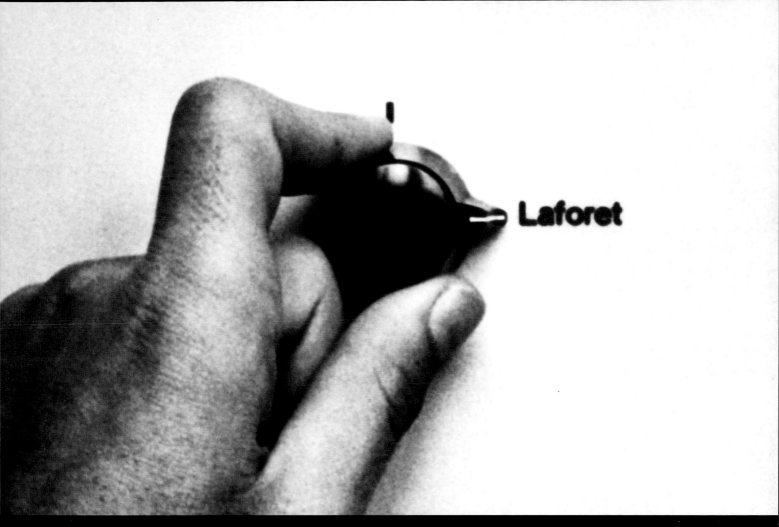

Laforet

A completely nondescript, generic
commercial image subtly instructs
consumers to select Laforet as their
store. Here, Onuki's ironic humor
recontextualizes an image normally

PRINCIPALS: Jin Sato, Seiji
Ozeki, Susumu Honjo,
Masanori Suzuki, Takeshi
Hamamoto, Junichi Kajiwara
FOUNDED: 1983
NUMBER OF EMPLOYEES: 23

The A Company
Sanko Building 9F
4-10-5 Ginza
Chuo-ku, Tokyo 104-0061
TEL (81) 3-3546-8391
FAX (81) 3-3546-8394

JIN SATO

Visitors to Japan notice the fine quality of printed materials that is visible in everything from books to brochures. Impressive, too, is the diversity and daunting volume of Japan's outpouring of print, much of it in the service of advertising. Thus, in addition to posters and billboards, city dwellers are deluged by sales flyers of all kinds, and even the straps that standing commuter-train riders hang onto are emblazoned with advertisers' messages. Out of such familiar forms, of which countless examples can be found in packaging, too, a place's own vernacular design language emerges. Jin Sato's work displays a keen sensitivity to and understanding of such local design norms, including, for example, the Japanese appreciation for——or some would say an obsession with——wrapping and packaging of products like *nori* (seaweed) or tea. This studio has also created layouts for books and magazines, and for promotional materials like calendars. The A Company's Jin Sato brings an elegant touch and the kind of thoroughness and precision to his work that have become widely associated with Japanese graphic design. His layouts for a cookbook called *Mes Desserts Préférés du Terroir Français*, with their color-coded lines of text and section headings sometimes set vertically, with a touch of drama, are a fine example of this tradition.

Bright-red, large numerals pick up the color of the floral border in this poster for the Horsepia Music festival whose pastiche of images serves up a bit of pastoral kitsch.
ART DIRECTOR: Jin Sato
DESIGN: Hiroshi Matsushima
ILLUSTRATION: Keiji Ito

As beautiful as many Japanese consumer-goods packages may appear, actually getting to the products they contain can take some work in an entertaining, adventurous way. Whether elaborate or very simple, Japanese packaging is often smart and elegant, and reflects a traditional preoccupation with form and the quality of appearances. Here, The A Company's packaging for Ishi Nori seaweed offers protection and style for a high-quality product that must be kept dry.

ART DIRECTOR: Jin Sato
DESIGNER: Hiroshi Matsushima
CALLIGRAPHY: Hiromichi Hakomori

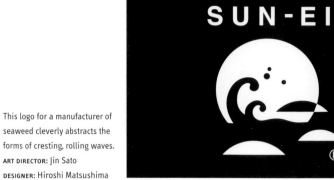

This logo for a manufacturer of seaweed cleverly abstracts the forms of cresting, rolling waves.

ART DIRECTOR: Jin Sato
DESIGNER: Hiroshi Matsushima

The A Company makes an otherwise dry and generic form, the financial-services advertising poster, come alive with an explosion of color and engaging visual puns. The ever-popular cuteness factor is strongly evident, too. These are pieces from a large series of related posters for Japan's National Central Society of Credit Cooperatives.

ART DIRECTORS: Jin Sato, Takeshi Hamamoto
CREATIVE DIRECTORS: Kazutoshi Shobatake, Jin Sato
DESIGNER: Kansuke Yamamoto
ILLUSTRATION: Hideo Ikawa
PHOTOGRAPHY: Mitsuo Nakamura

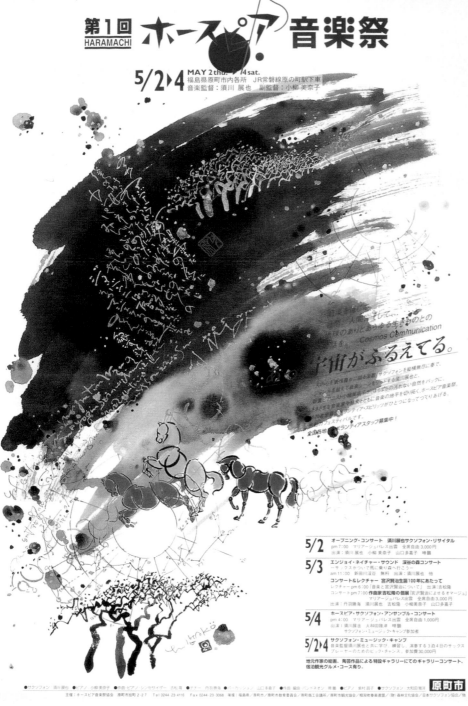

This poster for a music festival makes use of traditionally flavored brush painting with a contemporary touch, against which a block of red type, set at a dramatic slant, catches the motion implied by the illustration. Note the stylized *katakana* characters in the uppermost headline that phonetically spell out the festival's name, Horsepia.

ART DIRECTOR: Jin Sato
DESIGNER: Hiroshi Matsushima
ILLUSTRATION: Hiromichi Hakomori

Jin Sato art-directed the covers of *CAKEing*, a new Japanese magazine full of information for professionals and amateurs alike on the preparation of fine pastries and desserts.

ART DIRECTOR: Jin Sato
DESIGNER: Tomoko Abe
ILLUSTRATION: François Avril/
Cross World Connections (CWC)

A visible sense of thoroughness and precision is often associated with Japanese graphic design. Jin Sato's layouts for a French-dessert cookbook, with their color-coded lines of text, are a fine example of this tradition.

ART DIRECTOR: Jin Sato
DESIGNER: Kumiko Takagi

Most Japanese books and magazines open from left to right; their reading sequence is just the opposite of that of Western publications. For this book about tea, Sato echoed his design in English and Japanese, placing each version on the appropriate "front" or "back" cover.

ART DIRECTOR: Jin Sato
DESIGNER: Akino Takahashi
ILLUSTRATOR: Eri Urabe

DIMBULA
ディンブラ

Handsomely boxed selections of tea, cookies, seaweed, candy, and other fine-food items are popular among Japanese consumers and often serve as welcome presents on annual, nationwide gift-giving occasions such as the New Year and Golden Week holidays. The A Company created these designs for a manufacturer called The Tokyo Tea Club.

ART DIRECTOR: Jin Sato
DESIGNER: Hiroko Murata

PRINCIPALS: Mitsuru Soejima,
Akira Ouchi
FOUNDED: 1994
NUMBER OF EMPLOYEES: 6

1-16-3-504 Hiro-o
Shibuya-ku, Tokyo 150-0012
TEL (81) 3-5423-2985
FAX (81) 3-5423-3497

SILENT GRAPHICS, INC.

"We support the latest creativity and possibility in the underground culture," declares a subheadline on a rock-concert poster designed by Silent Graphics. "We are ready to communicate with the companies that appreciate our thought." Besides being a fine example of the kind of English-language snippet that pops up as much for decoration as for meaning in so much Japanese graphic design, from children's school-notebook covers to, most visibly, advertising for everything from fast food to computers, this quote celebrates the pure-pop sensibility that is at the heart of this studio's fun-loving work. Silent Graphics' own logo shows a skeleton hanging from a key chain; its influences and inspirations lie in a familiar pop-culture stew of colors, shapes, and images from movies, comic books, commercial-art typography, and other generic forms. Its cover and poster for a compact disc by the Japanese band Piranhans, for instance, present the musicians as vacuum-packed action figures. Its cover for a CD by Super Trapp, with big American cars stranded in the Grand Canyon and bombastic, Hollywood film-title lettering commanding the sky, manages to give an air of the exotic to now-exhausted visual clichés. Formulas in Silent Graphics' work are pretty much non-existent. Instead, this studio's modus operandi is more a cheeky and spontaneous outpouring of serious fun.

In a more traditional pop-art spirit, the designers used everyday objects, in this case, a selection of tools and hardware, to create random patterns for compact-disc cover art.

ART DIRECTOR/CREATIVE DIRECTOR: Takuya Onuki

ILLUSTRATION: Bo-Ya

PHOTOGRAPHY: Yuji Matsumoto, Kazuko Tanaka

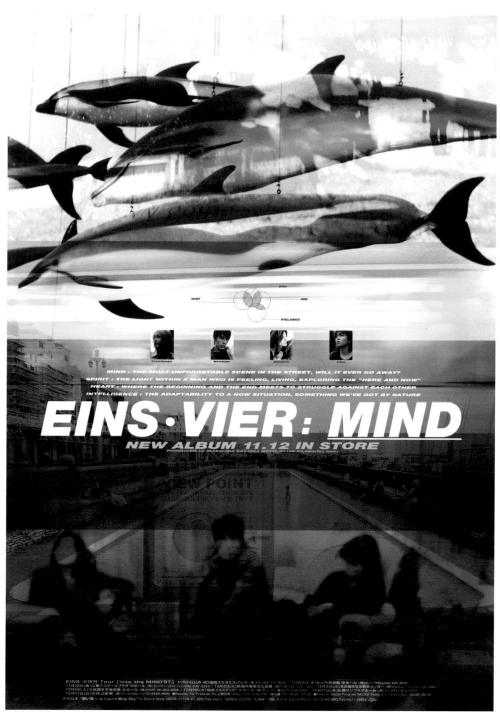

EINS·VIER : MIND
NEW ALBUM 11.12 IN STORE

The designers' imagery for a
CD cover and poster for the
hand Eins-Vier takes a more
techno-surreal turn.

ART DIRECTOR/CREATIVE DIRECTOR:
Takuya Onuki

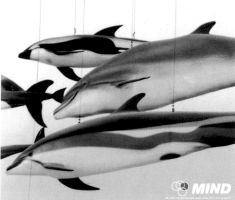

Silent Graphics' groovy repertoire includes nineties-style trippy looks, as in this rock-concert poster, and goofy, cartoon-powered graphics, with appropriate type treatments, as in this CD cover for Jam the Wink.

ART DIRECTOR/CREATIVE DIRECTOR:
Takuya Onuki

ILLUSTRATION: Bo-Ya, poster; Matt Campbell/Cross World Connections (CWC), CD cover.

In many Japanese pop materials, like this cover for a CD by a band called Super Trapp, it can be hard to tell if or when designers are quoting, honoring, or sending up their source materials, like these big American cars stranded in the Grand Canyon and bombastic, Hollywood film-title lettering in the sky. Still, Silent Graphics manages to give an air of the exotic to these now-tired visual clichés.

ART DIRECTOR/CREATIVE DIRECTOR:
Takuya Onuki

PHOTOGRAPHY AND ILLUSTRATION:
Silent Graphics, Inc.

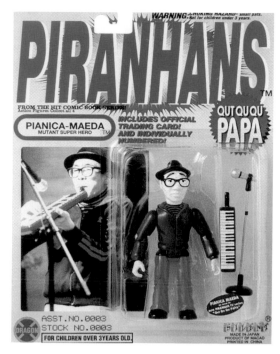

Posters and compact-disc covers about toys based on popular performers—experts in semiotics call such pop-culture connections "self-referential," but for Silent Graphics, it's all pure-pop fun. Here, a poster for the Piranhans presents the band members as vacuum-packed action figures.

ART DIRECTOR/CREATIVE DIRECTOR:
Takuya Onuki

PHOTOGRAPHY: Makoto Kato

ILLUSTRATION: Cool Ken

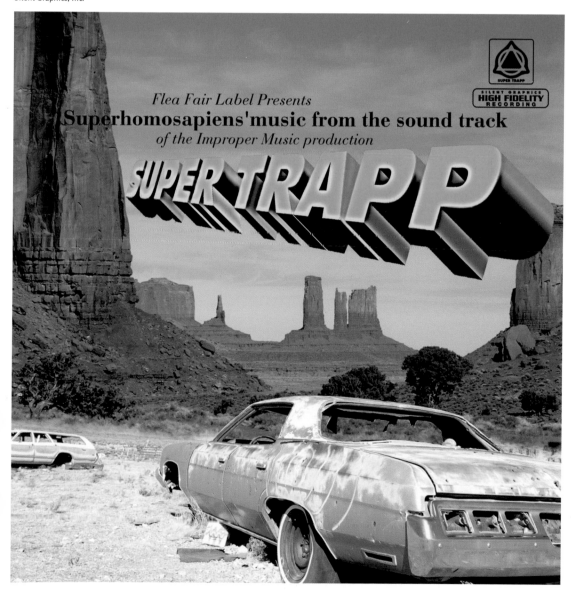

PRINCIPALS: Taihei Saito,
Hiroyuki Miura
FOUNDED: 1989
NUMBER OF EMPLOYEES: 5

T & A Building
6-34-17 Jingumae
Shibuya-ku, Tokyo 150-0001
TEL (81) 3-3409-4090
FAX (81) 3-3409-4033

SLASH, INC.

Ever since their country's long, self-imposed seclusion was forcefully brought to an end in the late 1800s, the Japanese have become well-known around the world for their ability to borrow or copy, adapt or refine, ideas and inventions both technological and aesthetic. In this century, Japanese graphic design has reflected this ongoing, evolving strain of appropriation, assimilation,

and reinterpretation of foreign-derived source material. Likewise, Japanese designers have become adept at working in a range of uniquely hybrid, Eastern-Western styles. This versatility is evident in the work of Taihei Saito and Hiroyuki Miura of Slash, Inc., who have produced everything from perfectly composed, "pretty" advertising posters for mainstream audiences (such as their series for UCC, Japan's coffee-making giant) to wacky, pop campaigns for Parco's hip, style-chasing clientele. Their posters for Bridgestone's Zeke bicycles feature carefully styled images of easy-going Japanese young people visibly expressing more of a sense of fun-loving individualism than their elders probably ever would have known. In these compositions, the spirit of a little fashionable rebelliousness or laid-back leisure, echoed in their unfussy graphic design, goes a long way.

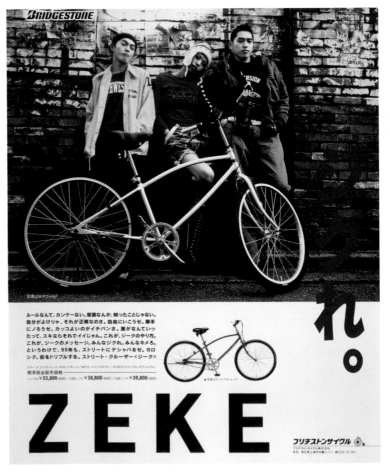

The assimilation of a style becomes a style in itself: Change the youthful models, and these posters for Bridgestone's Zeke bicycles, with their air of fashionable grunge or laid-back leisure, and unfussy graphics, could easily be American, British, German, or French.
ART DIRECTOR: Hiroyuki Miura
CREATIVE DIRECTORS: Akio Naoi, Masashi Fukutani/I & S Corp.
PHOTOGRAPHY: Masumi Harada

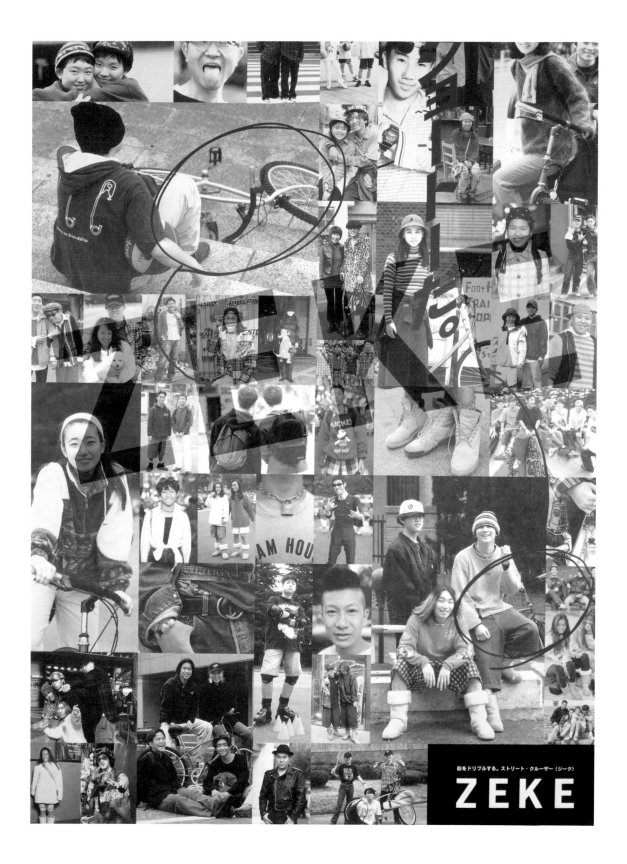

街をドリブルする。ストリート・クルーザー〈ジーク〉

ZEKE

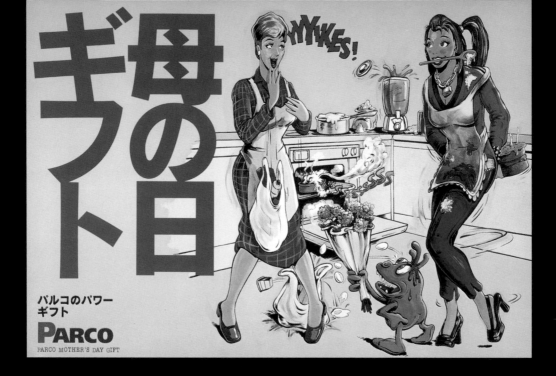

Japan has its own traditional gift-giving holidays that retailers exploit for big sales; stores have also profitably adopted and promoted some Western holidays. In these posters, huge typography and zany cartoon illustrations use offbeat humor to remind Parco's hip young customers to shop for Valentine's Day, White Day, Mother's Day, and Father's Day. Note the Western features of the human characters in the drawings.

ART DIRECTOR: Hiroyuki Miura
CREATIVE DIRECTOR: Taihei Saito
ILLUSTRATION: Stephen Bliss/
Cross World Connections

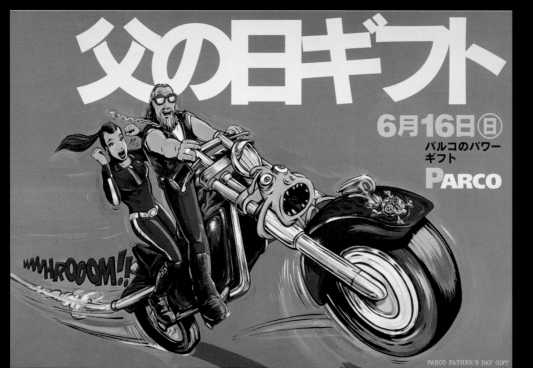

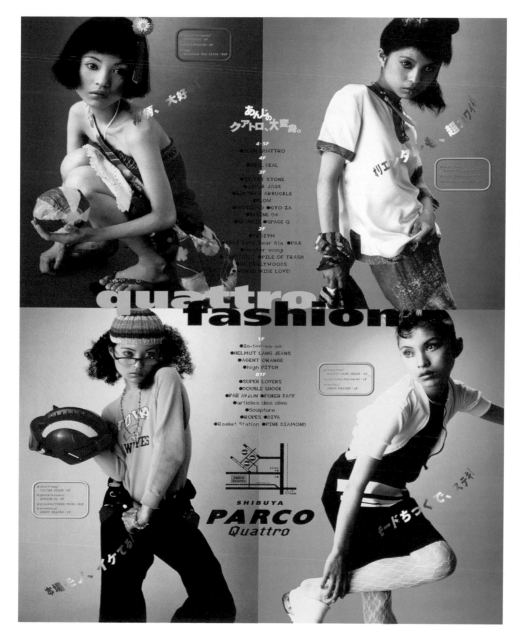

Girls will be girls—and shop, or so assume the marketing masters for this branch of the Parco department store in Tokyo. Note the map indicating the store's address. Such location indicators are indispensable in Japan, where buildings are not necessarily numbered in sequence on streets, which, in turn, often are not named. These maps become important, integral graphic elements of many posters, brochures, advertising postcards and advertisements.

ART DIRECTOR: Hiroyuki Miura
CREATIVE DIRECTOR: Taihei Saito
PHOTOGRAPHY: Yoshihito Sasaguchi

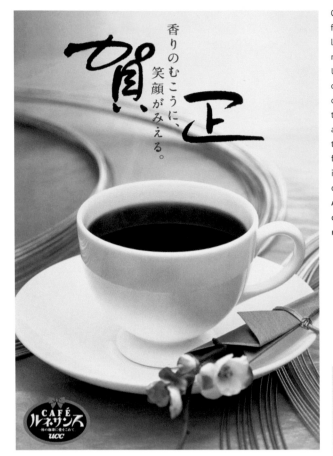

Gold-decorated cups, casually formal calligraphy, and a bilingual logotype, as well as the subject matter itself of these posters for UCC, Japan's leading coffee company, come together to create a kind of cross-cultural, mass-media hybrid that is a genre unto itself in Japanese advertising. The metallic tassels in the image with a white cup and flowers are used for wrapping gifts in Japan and here connote an air of something special.

ART DIRECTOR: Hiroyuki Miura
CREATIVE DIRECTOR: Taihei Saito
PHOTOGRAPHY: Kazumasa Takayanagi

An array of antique cup-and-saucer sets emphasizes the elegant, social aspect of coffee drinking and makes for an elegant poster for UCC.
ART DIRECTOR: Hiroyuki Miura
CREATIVE DIRECTOR: Taihei Saito
PHOTOGRAPHY: Kazumasa Takayanagi

コーヒーは香りと味わいの芸術です。

Three-dimensional signboards, using cartoonish illustrations, promote a summer beverage made with UCC coffee.
ART DIRECTOR: Hiroyuki Miura
CREATIVE DIRECTOR: Taihei Saito
ILLUSTRATION: Chris Long/Cross World Connections (CWC)

PRINCIPALS: Hiroshi Sunto,
Takashi Nakashima, Yoshinori
Kishi, Takayuki Nakazawa,
Hiroshi Yamaji, Akira Fueki,
Takashi Nakazawa
FOUNDED: 1985
NUMBER OF EMPLOYEES: 4

Sunto Office
No. 401 I.T.O. Daikanyama
2-17-8 Ebisu-nishi
Shibuya-ku, Tokyo 150-0021
TEL (81) 3-5489-8941
FAX (81) 3-5456-5429

HIROSHI SUNTO

The huge volume of materials produced by the music industry that requires the services and contributions of graphic designers—record or compact-disc packages, posters, videos, advertising, and promotional items of all kinds—offers Japanese creators ample opportunities to show off their talents and try out new ideas. This kind of work probably forces them to do so, too, since the pop-music world, like that of fashion or art, routinely seeks the new and exciting, and throughout the history of the music biz, graphic design has reflected and helped propel that preoccupation with the next big thing. In the wide array of album covers, posters, and advertisements that Hiroshi Sunto has conjured up for numerous pop or rock acts, this designer has helped shape a distinctly Japanese approach to a design genre that is also international in its sensibility and scope. As the publisher and editorial director of a small-format magazine called *Module* with tall, narrow pages, Sunto also has provided an outlet for design-savvy record reviews and articles about contemporary music. Contributors have included other innovative movers and shakers in Tokyo's forward-looking creative community, such as Yasutaka Kato of Ghost Ranch Studio. Sunto's range is wide, as his logotypes alone demonstrate; they include *Module* techno letterforms and stylized Japanese *kanji*.

Sunto's graphics are sensitively in tune with the music that they package and promote. His cover for Heat Wave's CD maxi-single captures a freewheeling spirit.
ART DIRECTOR: Hiroshi Sunto
DESIGNER: Takashi Nakashima
CREATIVE DIRECTORS: Hiroshi Sunto, Five D
PHOTOGRAPHY: Yasuo Matsumoto

HEAT WAVE
BOHEMIAN BLUE
1.BOHEMIAN BLUE
2.TOKYO CITY HIERARCHY
3.MR. SONGWRITER
POCH-1615

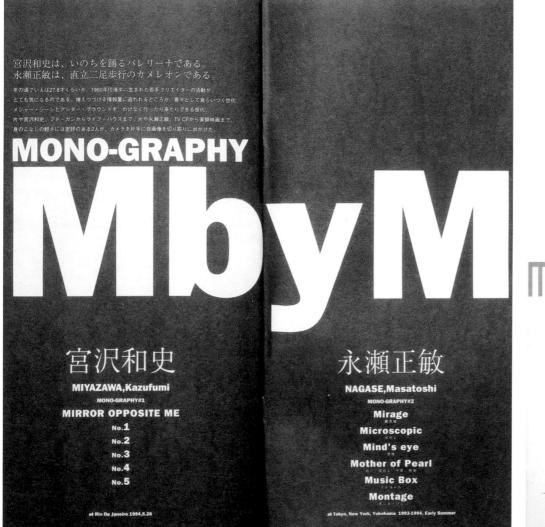

宮沢和史は、いのちを踊るバレリーナである。
永瀬正敏は、直立二足歩行のカメレオンである。

年の頃でいえば27.8才くらいか。1960年代後半に生まれた若手クリエイターの活動が、
とても気になるのである。増えつづける情報量に追われるどころか、喜々として貪らいつく世代。
メジャー・シーンとアンダー・グラウンドを、わけなく行ったり来たりできる世代。
片や宮沢和史、ブドーカンからライブ・ハウスまで。片や永瀬正敏、TV CFから実験映画まで。
身のこなしの軽さには定評のある2人が、カメラを片手に自画像を切り取りに出かけた。

MONO-GRAPHY
MbyM

宮沢和史
MIYAZAWA,Kazufumi
MONO-GRAPHY#1
MIRROR OPPOSITE ME
No.1
No.2
No.3
No.4
No.5

at Rio De Janeiro 1994.5.26

永瀬正敏
NAGASE,Masatoshi
MONO-GRAPHY#2
Mirage
Microscopic
Mind's eye
Mother of Pearl
Music Box
Montage

at Tokyo, New York, Yokohama 1993-1994, Early Summer

Module
音楽生活者のための[モジュール]1997 No.4

Tokyo
Live
Report
by
1997
MODULE

Sunto's *Module* magazine, with its
tall, narrow pages, provides an outlet
for type-driven layout experiments.
ART DIRECTOR: Hiroshi Sunto
ILLUSTRATION: Nakazawa Takayuki

音楽生活者のための[モジュール]1995.No.3

Module
INTERVIEW FILE
音楽との対話=[歌]は今、生きているか?

ただ、これだけ選択肢があると一曲を聴く人の量や
質ってどうなんだろう。
宮沢和史(THE BOOM)
すでに日本はアジアからおいてきぼり
くってるんですよ。あのう本当にヤバイで
すよ。心の歌がなさすぎる。
ヤバイと思う。ドリアン助川(叫ぶ詩人の会
意味をしっかり考えなくちゃいけないと思う。
山口洋(HEAT WAVE)
トイレの片隅でパフォーマ
スしようが、カーネギーホー
ルでやろうが、そのエネル
ギー自体に差はないように思
うんですよね。おおたか静流
日本以外の国にとってはアジア的な部分はある種当たり前のことで、それ
日本にとっては新しいメッセージになったんじゃないか
「コマーシャル・タイアップが全て」であ
ったり、ひとつの方法論でしかない答が
のに、それが全てなんて言語道断
ですよ。佐藤奈々子

自分が憧れていたロック・ボーカリスト
みたいに歌えたら。でも今聴いたら結
構へたなんですね。TAISUKE

Sunto created the logo for *Zola*, a women's fashion magazine for which he also serves as art director.

ART DIRECTOR: Hiroshi Sunto

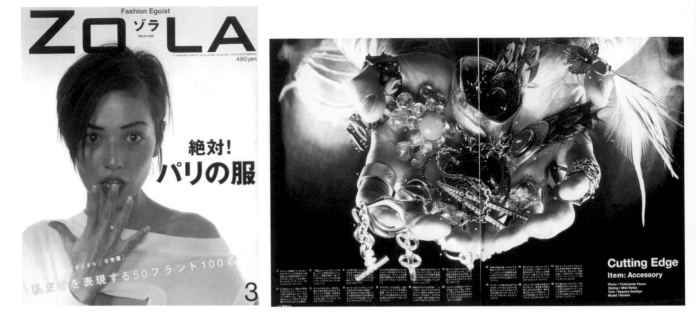

Cutting Edge
Item: Accessory

Sunto and Takashi Nakashima do the art direction for *This*, a beautifully printed periodical that calls itself a "multicultural magazine for individualists." In its pages, the designers work with images of and by the artists and photographers who are the subjects of its interviews and features.

ART DIRECTOR: Hiroshi Sunto

CREATIVE DIRECTOR: Motoharu Sano

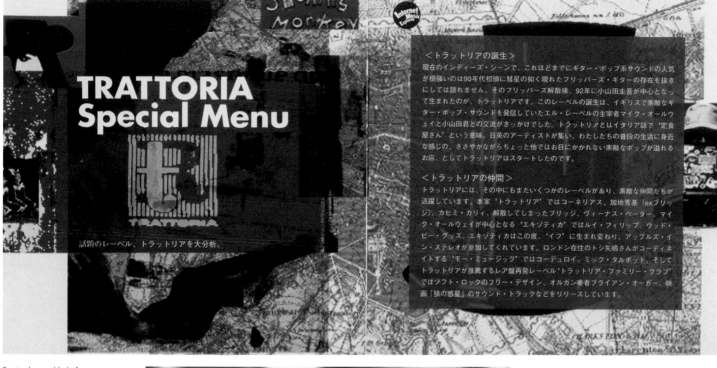

TRATTORIA
Special Menu

話題のレーベル、トラットリアを大分析。

<トラットリアの誕生>
現在のインディーズ・シーンで、これほどまでにギター・ポップ系サウンドの人気が根強いのは90年代初頭に彗星の如く現れたフリッパーズ・ギターの存在を抜きにしては語れません。そのフリッパーズ解散後、92年に小山田圭吾が中心となって生まれたのが、トラットリアです。このレーベルの誕生は、イギリスで素敵なギター・ポップ・サウンドを発信していたエル・レーベルの主宰者マイク・オールウェイと小山田君との交流がきっかけでした。トラットリアとはイタリア語で '定食屋さん' という意味。日英のアーティストが集い、わたしたちの普段の生活に身近な感じの、ささやかながらちょっと他ではお目にかかれない素敵なポップが溢れるお店、としてトラットリアはスタートしたのです。

<トラットリアの仲間>
トラットリアには、その中にもまたいくつかのレーベルがあり、素敵な仲間たちが活躍しています。本家 'トラットリア' ではコーネリアス、加地秀基（exブリッジ）、カヒミ・カリィ、解散してしまったブリッジ、ヴィーナス・ペーター マイク・オールウェイが中心となる 'エキゾティカ' ではルイ・フィリップ、ウッド・ビー・グッズ。エキゾティカはこの度、'イフ' に生まれ変わり、アップルズ・イン・ステレオが参加してくれています。ロンドン在住のトシ矢嶋さんがコーディネイトする 'モー・ミュージック' ではコーデュロイ、ミック・タルボット。そしてトラットリアが推薦するレア盤再発レーベル 'トラットリア・ファミリー・クラブ' ではソフト・ロックのフリー・デザイン、オルガン奏者ブライアン・オーガー、映画「猿の惑星」のサウンド・トラックなどをリリースしています。

Sunto chose a kind of techno-abstract mode for this booklet accompanying an enhanced CD with Internet-access software, and for the cover of an anthology, on videocassette, of short films.

ART DIRECTOR: Hiroshi Sunto
DESIGNERS: Yoshinori Kishi, *video box*; Yoshinori Kishi, Nakazawa Takayuki, *CD booklet*
PHOTOGRAPHY: Hideo Canno, *video box*; Bruce Osborn, *CD booklet*.
ILLUSTRATION: Nakazawa Takayuki, *CD booklet*.

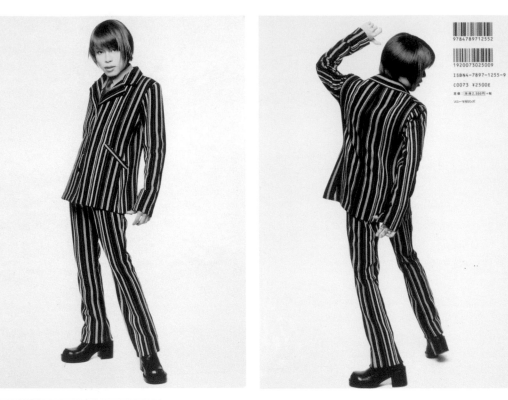

Sunto gives a sense of spontaneous order to the self-indulgent posturing of the self-styled Starman from Miracle Wonder Planet in this hardbound photo album documenting the Japanese teen idol's shenanigans.

ART DIRECTOR: Hiroshi Sunto
DESIGNERS: Sunto Office, Andromeda Studio
ILLUSTRATION: Takayuki Nakazawa/Andromeda Studio
PHOTOGRAPHY: Hideo Canno

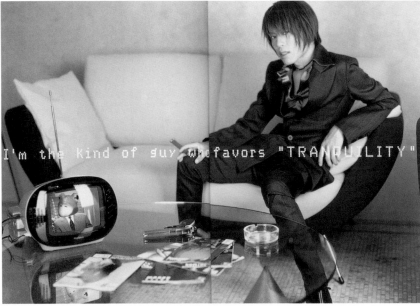

I'm the kind of guy who favors "TRANQUILITY".

This glossy, printed box holds a promotional booklet and videotape describing a satellite-TV service.

ART DIRECTOR: Hiroshi Sunto
CREATIVE DIRECTOR: Tasuku Watanabe/Do the Monkey
DESIGNER: Yoshinori Kishi
PHOTOGRAPHY: Kenji Miura

module

ZO✦LA
Fashion Egoist

A spirit of experimentation and discovery is evident in much of Hiroshi Sunto's work, as this selection of logotypes shows. *03 Tokyo Calling* is a magazine that takes its name from the Japanese capital's telephone area code; *Module* is the design-savvy, small-format periodical about pop music that Sunto publishes. The stylized *kanji* logo is for a Japanese rock band; the *Zola* logo is for a fashion magazine.

ART DIRECTOR: Hiroshi Sunto

PRINCIPALS: Seiju Toda,
Mamoru Suzuki, Koichi Kuno,
Masanori Mizushima, Taku
Nakamura, Takamasa Uomoto
FOUNDED: 1976
NUMBER OF EMPLOYEES: 6

Toda Office
Azabu Toriizaka Building,
Room 505
5-10-33 Roppongi
Minato-ku, Tokyo 106-0032
TEL (81) 3-5770-1533
FAX (81) 3-5770-1531

SEIJU TODA

Seiju Toda is one of the senior talents on Tokyo's graphic-design scene and a still-vital contributor to the visual culture whose liveliness and complexity prompted Roland Barthes to call Japan an "empire of signs." Toda started his career in the in-house advertising section of Takashimaya, the national department-store chain, and established his own studio in 1976. His roster of clients has included Isetan, Suntory, Vivre 21, Burberry's Blue Label, and many other leading national and international brands. Throughout his career, Toda's art direction has spoken the language of graphic design with a sober, sophisticated tone; as an image-maker, he infuses his compositions, many of which employ photos of abstract, sculptural forms, with a stunning sense of the fantastic and the futuristic, as in some of his posters for Vivre 21. Single objects or configurations of forms play important roles—often they seem to be *everything*—in a Toda work. Toda's provocative designs are consciousness raisers as much as they are message conveyors. In contemporary Japan's ubiquitous mass-media din, they are finely pitched visual poems rich in resonant, ambiguous meanings.

Toda concocts a riveting, gothic-fantastic mood with this unusual poster for fashion outlet Vivre 21 in Tokyo. Note the highlighted, three-dimensional effect of the *kanji* in the upper-left corner that spell out the Japanese word *kyukon* (tuber or bulb).
ILLUSTRATOR: Ikuo Takeda
COPY/TYPOGRAPHY: Masayasu Okabe
PHOTOGRAPHY: Sachiko Kuru

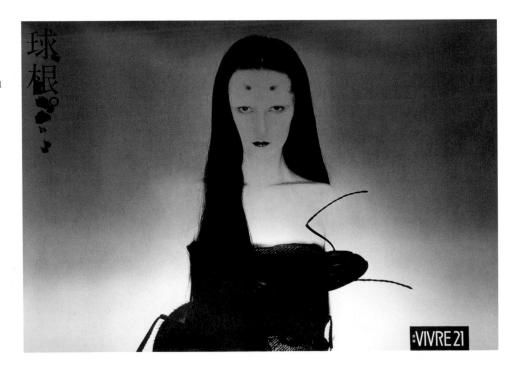

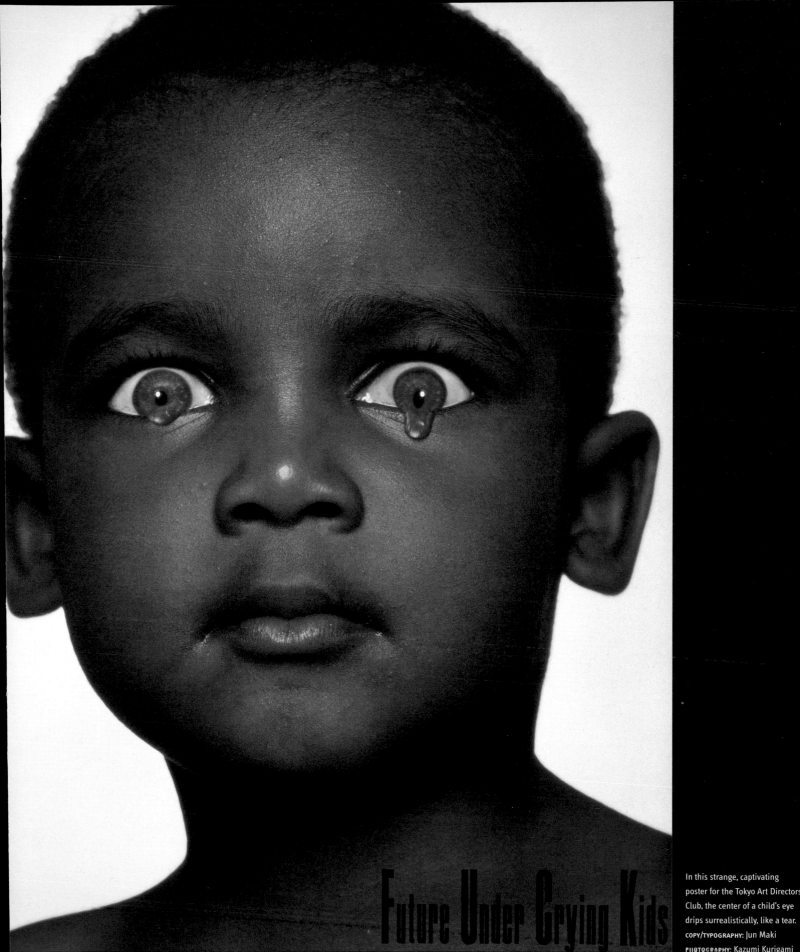

Future Under Crying Kids

In this strange, captivating
poster for the Tokyo Art Directors
Club, the center of a child's eye
drips surrealistically, like a tear.
COPY/TYPOGRAPHY: Jun Maki
PHOTOGRAPHY: Kazumi Kurigami

A sharp (in every sense of the word), chilling, monstrous beauty marks this poster for Vivre 21.

COPY/TYPOGRAPHY: Masayasu Okabe

PHOTOGRAPHY: Kazumi Kurigami

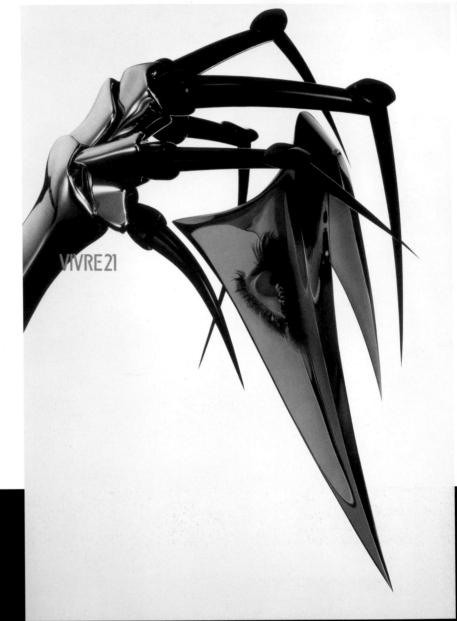

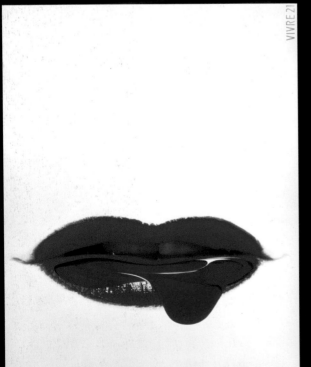

Luscious, seemingly metamorphosing lips woo viewers to this abstract, ambiguous poster for fashion client Vivre 21.

COPY/TYPOGRAPHY: Masayasu Okabe

PHOTOGRAPHY: Sachiko Kuru

Toda uses color and pure form—a series of concentric ovals—in this poster for a theatrical performance called *Straw-rope Pattern Drum*.
CREATIVE DIRECTOR: Sou Sakou

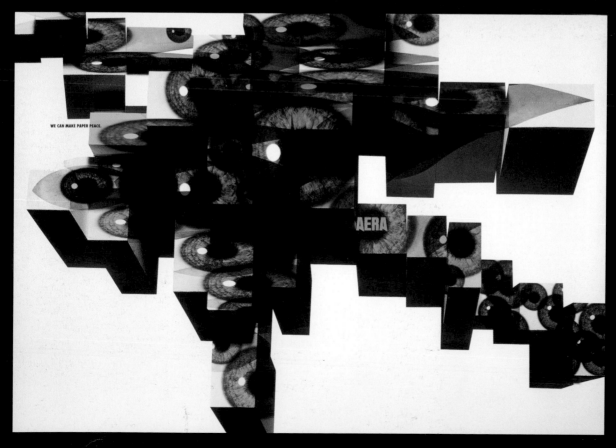

In posters for the magazine *Aera*, Toda creates erratic patterns with a provocative allure with configurations of eyeball-emblazoned, block-like forms.
COPY/TYPOGRAPHY: Jun Maki
PHOTOGRAPHY: Eiichiro Sakata

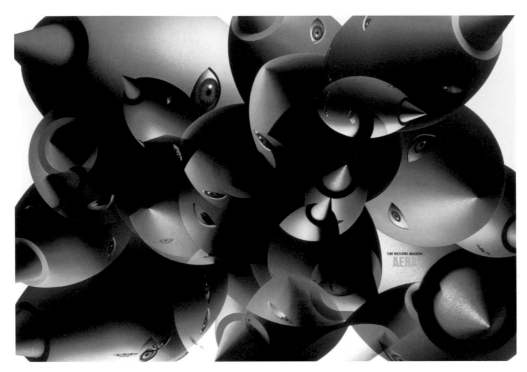

Like schools of fish swirling underwater, bizarre forms with probing eyes are featured in these posters for *Aera*, a magazine issued by the publisher of the national Japanese newspaper *Asahi Shimbun*.
PHOTOGRAPHY: Eiichiro Sakata

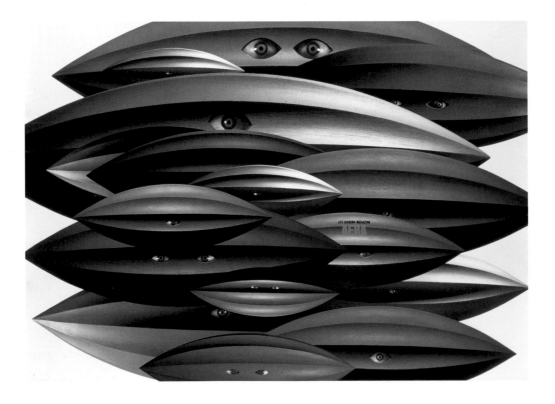

An abstractly rendered mountain range pulsates in this poster for Morisawa Typesetting Co. printed in dark blue and purple on plain, unbleached brown paper. The large *kanji* in the lower-right corner is the character for mountain.

This poster is for an exhibition of drawings by the well-known Japanese film director Akira Kurosawa. **PHOTOGRAPHY:** Eiichiro Sakata

PRINCIPALS: Yuichi Miyashi,
Naoyuki Suzuki
FOUNDED: 1991
NUMBER OF EMPLOYEES: 8

402 Villa Gloria
2-31-7 Jingumae
Shibuya-ku, Tokyo 150-0001
TEL (81) 3-5411-5341
FAX (81) 3-5411-5342

TYCOON GRAPHICS

Somewhere within the great, varied spectrum of aesthetic urges and impulses that inspire artist-designers and help shape their work, there is a point at which the goofy meets the profound, and a deep appreciation of robots seems as necessary as a moment's meditation on the allure of a waifish fashion model with bleached-white hair and high heels. That creative-conceptual place, at once wildly fresh and unpredictable, is the artistic home of Yuichi Miyashi and Naoyuki Suzuki of Tycoon Graphics. Both young designers lived and worked for a while in New York in 1990, where they soaked up the city's restless energy; even today, examining their work, from one piece to the next, is something

of a rollicking ride. Through their Tycoon Graphics studio, Miyashi and Suzuki are active in the fields of packaging (for music CDs and other goods), editorial design, and corporate identity development. "Both idealization of the past and apprehension about the future are nonsensical," this design duo states in a brief, exuberant self-description-cum-manifesto. With unsinkable zest they add: "We are now in a parallel world where anything you desire is available to you.... So let's communicate! Let's promote visual communication! Our motto is: 'Graphic adventure, every day!'"

This unusual poster for the Japanese Édifice fashion label's clothing brings to mind both clip art and technical manuals.
CREATIVE DIRECTOR: Yoshitsugu Nagasaki/Paragraph
ILLUSTRATION: Hiro Sugiyama/Enlightenment
PHOTOGRAPHY: Kiyonori Okuyama/ O.K.Y. Photos

A striking ligature in a heavily weighted typeface with serif accents distinguishes this series of magazine advertisements for a chain of hair salons.
PHOTOGRAPHY: Kazunari Tajima/Tajjiemax Productions, NYC

SOUND MUSEUM
SOUND MUSEUM

Simplicity is beauty in the form of background fields of bright, solid color accentuated with silhouetted photo images or short headlines (one of whose letters are made of punched-out holes) in Tycoon Graphics' designs of CD covers for the DJ-musician-producer Towa Tei.

ART DIRECTION, BOTH DISCS: Tycoon Graphics, Towa Tei

ILLUSTRATION, *STUPID FRESH* CD: Gataro F Man

PHOTOGRAPHY, *SOUND MUSEUM* COVER: Patrik Andersson/Christina Trayfors, Inc./Orion Press

Process colors on white and a light-blue hue give these book covers a gentle, somewhat friendly appearance.

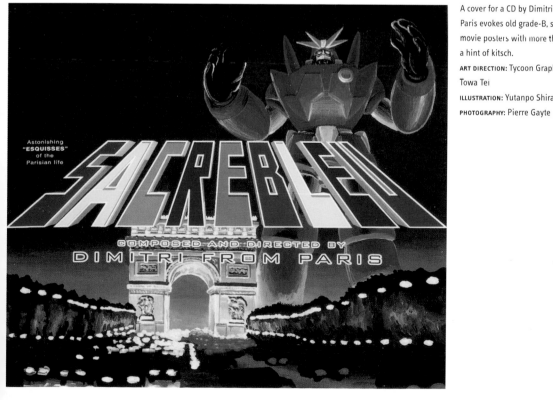

A cover for a CD by Dimitri from Paris evokes old grade-B, sci-fi movie posters with more than a hint of kitsch.
ART DIRECTION: Tycoon Graphics, Towa Tei
ILLUSTRATION: Yutanpo Shirane
PHOTOGRAPHY: Pierre Gayte

GO! GUY

GUYS: TETSUYA MIWA & HIDEYA SUZUKI, PHOTOGRAPH: ITARU HIRAMA, STYLING: TAKASHI KUMAGAI, HAIR&MAKE-UP: YUJI KOJIMA, CASTING: KEN SASAKI, ART DIRECTION & DESIGN: TYCOON GRAPHICS

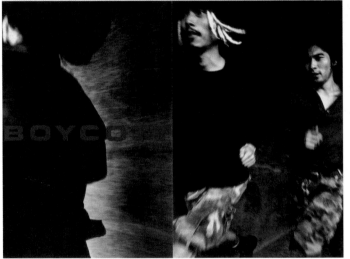

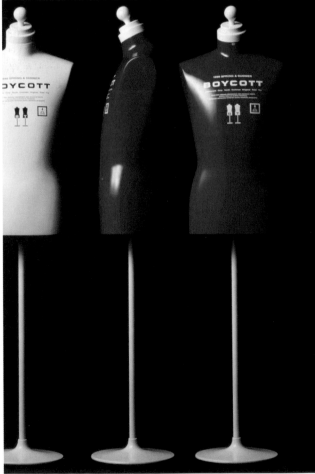

Scarlet red and a placement of plain, sans-serif type reminiscent of the look of unstylized, generic, industrial graphic design appear in Tycoon Graphics' catalog and poster promoting the products of Japan's Boycott fashion label. PHOTOGRAPHY: Itaru Hirama, catalog layouts; Kiyonori Okuyama/Ü.K.Y. Photos, poster.

CREATURE

ASTRONAUT

A series of posters for Toy's
Factory, a record label, celebrates
the techno-aesthetic with
illustrations reminiscent
of mechanical drawings and
a sturdy headline typeface
with a futuristic character.
ILLUSTRATION: Tycoon Graphics

About the Author

EDWARD M. GOMEZ's background is in philosophy and design; he is a former cultural correspondent for *TIME* in New York, Paris, and Tokyo, and senior editor of *Metropolitan Home*. A contributing editor of *Art & Antiques* magazine, Gomez has also written on art and design for the *New York Times*, *Metropolis*, *ARTnews*, the *Japan Times*, *Condé Nast Traveler*, *Eye*, and *Raw Vision*. He is one of the contributing authors of *Le dictionnaire de la civilisation japonaise* (Hazan Éditions).

Gomez, who studied at Duke University, Oxford University, and Pratt Institute, is a visiting professor of design history and aesthetics at Pratt Institute in New York. He has won Fulbright and Asian Cultural Council fellowships to Japan for his work on the history of Japanese modern art, and Switzerland's Pro Helvetia award for his writing on the outsider artist Adolf Wölfli. Gomez has lived and worked in England, France, Italy, Jamaica, and Japan, and is now based in New York.